CREATIVE
DIGITAL
PHOTOGRAPHY

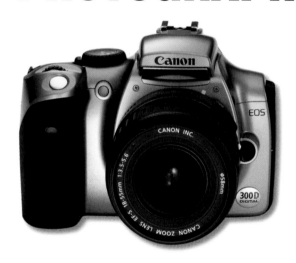

THIS IS A CARLTON BOOK

Text and design copyright © 2005 Carlton Books Limited

This edition published by Carlton Books Limited 2005
20 Mortimer Street
London
W1T 3JW

A CIP catalogue for this book is
available from the British Library.

ISBN 1 84442 425 1

Executive editor: Stella Caldwell
Editor: Jonathan Hilton
Art editor: Vicky Holmes
Designer: Michelle Pickering
Production: Lisa Moore

CREATIVE
DIGITAL
PHOTOGRAPHY

A PRACTICAL GUIDE TO IMAGE ENHANCEMENT TECHNIQUES

PETER COPE

CONTENTS

CONTENTS

FOREWORD...6

1
THE FOUNDATIONS of IMAGE MANIPULATION:::8

2
HARDWARE AND SOFTWARE ESSENTIALS :::20

3
FIRST STEPS :::34

4
MASTERING IMAGE MANIPULATION SOFTWARE:::54

5
DARKROOM EFFECTS – THE DIGITAL WAY:::70

6
IMPROVING SELECTION TECHNIQUES:::90

7
EFFECTIVE
CLONING...112

8
EFFECTS
FILTERS
WITH ATTITUDE:::124

9
LAYERS AND
LAYERED IMAGES:::138

10
SHARPENING AND
BLURRING...150

11
CREATIVE
IMAGE TECHNIQUES:::164

RESOURCES...188

INDEX &...190
ACKNOWLEDGEMENTS

FOREWORD

Digital photography has had an enormous and pervasive impact in a surprisingly short period of time. As I write these words I am musing over press releases from some of the most lauded names in camera design and manufacture announcing the ending of production of what we have come to describe as conventional – or film-based – cameras in several market segments.

Digital photography was for much of its formative years an adjunct to computer technology. Much of the terminology that defines the practices owes more to the computer world than the photographic. Early digital cameras were, in a sense, mere computer peripherals that allowed computers to input imagery. It is only fairly recently that we have begun to see a return to the true values of photography. This is largely down to the simple fact that digital cameras are no longer – in quality and performance terms – the poor relation of the conventional. The digital photographer used to expect to make compromises, perhaps trading ultimate quality for the immediacy of results. Now that we have both quality and results on demand, we can concentrate on producing great images.

This is where the worlds of photography and computers once again mesh, but this time in the most positive of ways. It's hard to credit but in just a few years the personal computer – once characterized by the ubiquitous IBM PC – has changed beyond all recognition in the way that it both displays and handles data. Where we were once amazed at simple word-processing skills (with green or amber symbolic text on a black background), the computer is now equally a business tool and a lifestyle accessory. And its role in both has seen its power and potential multiply year-on-year to the point where the manipulation of the enormous amounts of data that comprise even a small photographic image is easily conducted in real time before our eyes.

There is no doubt that digital photography and digital image manipulation are potent tools in our expanding digital world. But it is wrong to consider them as the preserve of the professional or enthusiast. These are inclusive activities that appeal at so many levels. They allow those who might not otherwise consider themselves as artistic to tap into latent creative talent, and produce truly impressive images and graphics.

The aim of this book is to help you realize the potential and capabilities of digital technology in photography. We'll explore the tools and the techniques. We will come to understand any residual jargon and see how this understanding can help us in our continuing quest to create better images. Perhaps most significantly we'll see that digital image manipulation is neither difficult nor onerous. Whether you have just a few minutes to spare or are well and truly bitten by the digital bug, this book will show you how you can make an adequate picture into a great one. And for good measure we'll explore, step-by-step, how to produce some outstanding jaw dropping effects. It's a bit of a cliché, but the only limit is your imagination; this book is here to provide that imagination with just a little help and encouragement.

Peter Cope

THE FOUNDATIONS

THE FOUNDATIONS OF IMAGE MANIPULATION

THE FOUNDATIONS OF IMAGE MANIPULATION

In this chapter we will:

- Explore why good image manipulation starts with the camera, when we actually take the photograph.
- Examine the key competencies of different digital camera types.
- Look at the digital process and mechanics of the digital image.
- Explore the importance of planning for image-manipulation options when taking photographs.

THE NEED FOR A HOLISTIC APPROACH

"No longer do you need to ensure that you take pin sharp images or that your shots are well composed." "You can forget about the rules of photography and make good your efforts when you edit the photographs later."

Sadly these words are not spoken by some marketing person adding spin to promote the sales of digital image-manipulation software, but by many photographers and writers on the subject. And, more disheartening, many who follow the words get swept along with the hype and believing these sentiments treat them as their mantra. Only later, as their latent skills appear and new skills develop do they realize the error of their ways.

Good photography needs to be considered as a whole – hence our use of the term "holistic" – and it is difficult and unnecessary to divide the art and the craft into separate and essentially disparate elements. We need to approach image manipulation as just the final stage in our image-creation chain. And that stage needs to be built on the strongest of foundations.

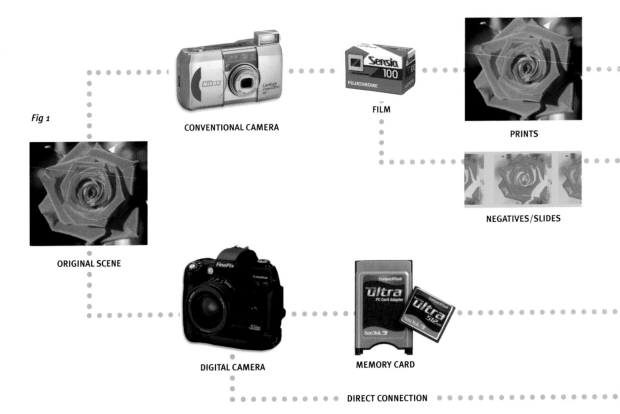

Fig 1

ORIGINAL SCENE

CONVENTIONAL CAMERA

FILM

PRINTS

NEGATIVES/SLIDES

DIGITAL CAMERA

MEMORY CARD

DIRECT CONNECTION

Digital or conventional?

Digital photography needn't be an activity that exists purely in the digital domain. We are able to use conventional cameras to deliver digital images. Likewise many opportunities exist, particularly in the consumer arena, to use a digital camera in much the same way as a conventional one: taking photographs and then delivering the memory card containing those images to a photolab for prints to be made.

Digital-camera technology has moved on apace since its commercial introduction in the early 1990s. Long after the first digital cameras appeared, industry experts were saying that (based on the then current technology) the day when digital cameras would rival their conventional equivalents was a long way off. Though they looked to be right in those early years, time has proved the wisdom of caution. We saw digital cameras quickly rival and surpass the quality of APS cameras and then make their bid to trounce the 35mm compact. In truth, cameras of similar quality had existed for some time, but they were expensive. High-quality, high-resolution cameras were then very much the preserve of the professional with deep pockets.

Now we are at the stage where digital cameras rival conventional cameras in virtually every respect – including price. This does not mean, of course, that digital cameras have swept the board. Many of us have made substantial investments in conventional equipment over the years and without those large professional budgets to play with it is no easy matter to re-equip ourselves.

Those with large SLR (single lens reflex) outfits, fortunately, have been thrown a lifeline. Many camera manufacturers offer at least one digital model that retains compatibility with the lenses, flashguns and most other accessories used by the brand's conventional models.

IMAGE-CREATION WORKFLOW (FIG 1)

Whatever your approach, the photographic process begins with taking a photograph. Whether we use a digital or a conventional camera, the way we see the subject is the same. It is how the image is handled from this point that opens up different paths.

When we take a photograph, although the imaging ability of digital or conventional cameras is equivalent, there are some practical differences. A

SCANNER

INTERNET

CD-ROM

COMPUTER

PRINT

DISK

conventional camera relies on film for recording images. There is a wide range of film types and brands on the market. We can, for example, make a choice on the basis of light sensitivity. We may want a detailed, fine-grain film for shots taken in bright light. Or to record dimly lit events we need to use a more sensitive film. We might choose a black and white emulsion or one of the more specialist – infrared sensitivity, for example – films on offer and we can also opt for films that produce prints or transparencies.

Digital cameras use an integral film sensor. However, we can change the sensitivity of this sensor so giving us the ability to mimic films of several sensitivities. An equivalent sensitivity range of between ISO 50 and 1600 is offered by many cameras.

Digital cameras also allow you to review shots on the inbuilt LCD panel immediately after shooting, or later if you choose, so poor shots can be discarded. This is where, in economic terms, digital cameras score highly. There are no on-going film costs and you can preview images before deciding which to proceed with.

The film that comprises a significant part of the running cost of a conventional camera must be processed before the latent images become visible. Typically most people choose print film, although enthusiasts and professionals are more likely to use reversal films (to give transparencies, also known as slides). These give a more accurate rendition of a scene because processing involves only one stage – developing the film to give a positive image. Producing prints involves two – processing the film to produce negatives and then printing the negatives to give paper prints. The latter stage, printing, can introduce inaccuracies as the equipment has to interpret the image.

Whether you choose prints or transparencies you can have the results digitized by the processor or you can do it later yourself. We'll look more closely at the details later.

Once the images are on your computer you are ready to manipulate. Manipulations can be minor – correcting an image fault, for example – or more significant, involving substantial post-exposure treatment. And this treatment can be photographic

Fig 2 – Basic cameras can easily be carried and are great for grabbed shots on occasions where conventional cameras would be inappropriate.

in nature or artistic. Photographic manipulations include those that enhance the photographic nature of the image – perhaps altering the composition or correcting major flaws in the original – while artistic manipulations use the original image as the basis for the creation of potentially intriguing artwork.

In the flow diagram we have tried to emphasize the progressive workflow. From original, via the camera and computer to end result: a print, a website or CD/DVD-based image collection. But there will be other entrants to our manipulative scheme. We may have images of objects precious to us (or images that have some emotive resonance) that we want to improve or preserve for future generations to enjoy. There may also be images that are not our own (and may be sourced from libraries and clip art galleries) that will contribute in some form to our imaging efforts.

DIGITAL CAMERAS: HORSES FOR COURSES?

The digital camera has come a long way in a short time, at least in terms of the history of photography. The question inevitably arises: "what is the best digital camera?" The smart answer, which doesn't explicitly answer the question, is: "the one that lets you take the most effective images." Let's qualify that slightly. There's an old anecdote about cameras and photographers. A guest at a photographic exhibition turns to one of the photographers exhibiting and says, "These are really good photographs – you must have an

excellent camera!" Of course, we can empathize with the photographer and possibly point to occasions where we too have faced similar situations. At the other extreme will be the photographer who (perhaps despising the latest advances in optical technology) will announce that the camera is immaterial; it is vision, technique and skill that delivers great photos and any camera will do.

You do need the vision, technique and skill, but having a tool that responds to those key criteria is equally important. The ability to control all aspects of your picture taking is crucial if you wish to extend your creativity and develop your skills. So how does this affect our choice of cameras? Does it mean that only the most highly specified machine is worth considering? No. In fact, many photographers today realize that digital technology has made it possible to produce novel cameras that can fulfil many needs without bristling with controls. Moreover, many digital camera users find that to get the best images and maximize opportunities, they may work with more than one camera and will tell you how each has a unique place.

Basic cameras (fig 2)

Characterized by point-and-shoot philosophy (that is, with little or no opportunity to use any controls to set exposure), these cameras have less than two million pixel resolution but are still capable of producing good images in ideal conditions. They also have the benefit of being relatively cheap and

can even be included in a multifunction device. Phones and PDAs are typical examples. Their compact size means they can be carried easily where a better-specified model might be inappropriate. It's worth noting that although the quality of images displayed on a camera phone (or by a PDA camera on the PDA display) look to be of poor resolution, in fact the image quality, once downloaded to a computer, can be surprisingly good.

Benefits:
• Compact
• Multiple uses
• Good image quality (in general)

Drawbacks:
• Sometimes expensive
• Limited control

Compact cameras (fig 3)

Like their conventional equivalents, digital compacts can offer a surprisingly potent specification in a small, easy-to-use package. Most are pocketable and offer a degree of control that is roughly proportional to their cost. The more you pay, the better the specification. Compact models are extensively used by enthusiasts and professionals as an adjunct to their "main" cameras, as they offer much of the quality with only a modest compromise in specification.

Benefits:
• Compact
• High specification of some models
• Very good image quality and resolution

Drawbacks:
• Lacks the ultimate control of more advanced models

Fig 3 – Compacts give a degree more control than basic models yet are still eminently pocketable.

Hybrid cameras (fig 4)

It is only comparatively recently that digital SLR cameras have become affordable for the mass market. In the interim, many manufacturers produced cameras dubbed hybrid designs. These offered the higher quality (over compact cameras) demanded by the serious enthusiast but did not command the high pricing. These models look like small-scale SLR cameras (they are built around smaller CCD imaging chips than SLRs) and offer a fixed lens and (usually) an LCD viewfinder, rather than a direct-vision one. The advent of reasonably priced digital SLRs has put pressure on this market segment but there is still a useful range of models that are ideal for the user who does not want – or need – a full-blown SLR system.

Benefits:
- Compact for specification
- Highly specified (usually)
- All-in-one design

Drawbacks:
- Expensive (comparatively)
- Compacts and digital SLRs are squeezing the market at either end

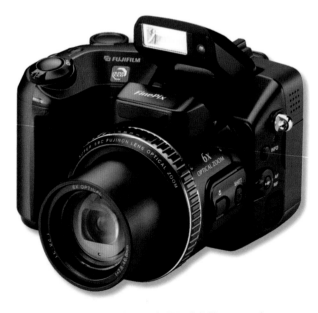

Fig 4 – Looking like downscale SLRs, hybrid cameras give more creative control but without the expense of an SLR.

Digital SLRs (fig 5)

Serious photographers will almost invariably describe the SLR design as their favourite. They offer unprecedented levels of control and versatility and interchangeable lenses, flash units and other accessories make it possible to tailor a system to meet precise photographic needs. They also tend to feature larger CCD imaging chips, making for higher image resolutions and better-quality results. The obstacle is price. Although becoming more affordable, costs are still generally high.

Benefits:
- Versatile
- High resolution
- Very highly specified

Drawbacks:
- Bulky
- Expensive

Medium format

The professional photographer – especially those in commercial photography – would use medium format cameras (such as the ubiquitous Hasselblad) as a staple. Their large image size yield far better-quality images than 35mm, while the cameras remain portable and easy to use. The evolution of camera design has seen many manufacturers offer versions of their medium format cameras that accept digital backs – replacing the conventional film backs. Hasselblad have gone one step further and produced their H1 model. This can accept either film or digital backs.

Benefits:
- Very high resolution
- Superb image quality
- Excellent specification

Drawbacks:
- Extremely expensive

THE MECHANICS OF THE DIGITAL IMAGE

For most people the camera is a black box. Most people realize that it features a light-tight enclosure into which light is admitted via the lens. Few people

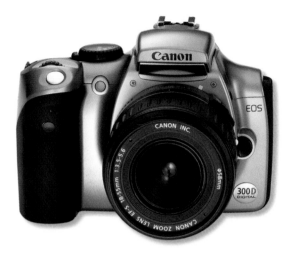

Fig 5 – Digital SLRs look very similar to their conventional equivalents – and many are modelled on conventional designs.

know (or indeed care) about what happens within. The digital camera is even more of a mystery. But it's worth spending a few minutes reviewing digital technology generally and its application to photography.

Digital photography and its associated digital image editing are two of the most popular activities to have emerged over the last decade or so. Why have they achieved this popularity when conventional photography and the photographic darkroom have never appealed to more than a small section of the population?

There is no simple answer. One reason is the proliferation of computers. As our acceptance of the personal computer and familiarity with its capabilities have grown, so has our willingness to adapt its use beyond the somewhat prosaic roles we assign it during the working day.

Another reason is simplicity. Digital photography is easy. Some people may take issue with this, but think about the process of taking a conventional photograph. You need to squint through a viewfinder, set some controls (which for all but the enthusiast are somewhat esoteric in their action) or hope the camera automatically makes appropriate settings for you. You press the button and take the picture. And that is it. If you are prolific in your image taking you might see the fruits of your labours in a few days; others might leave the film mouldering in the camera for months. There is no immediacy or expectation. If results aren't up to scratch, so be it.

With a digital camera you can preview your shots and compose them using a convenient LCD display. This same display lets you enjoy – or examine – the images immediately after you've taken them. Disappointing shots can then be recomposed and reshot and yet none of this requires any more skill or photographic acuity that in the pre-digital days.

The red herring in the exploration of digital photography's popularity is the word "digital" itself. Applying the word as a prefix to any activity seems to imbue it with mystical panache. Digital television is perceived to be something better than conventional; digital communications likewise are better than analogue. The arguments that promote the digital nature are often false; digital television is a delivery method that does not, per se, deliver better television. And digital photography does not necessarily make for better photographers. It does, however, give unparalleled opportunities to become more proficient and more capable and to produce superior images.

The crux of all digital technologies is the use of numbers to represent all variables. With digital telephones, the infinitely varying sounds that we make are interpreted as discrete numbers. These numbers can be transmitted over the air or along telephone wires and even recorded to a computer disk without any degradation. This contrasts with the original sounds, which deteriorate, to some degree, when transmitted, recorded or replayed.

With digital images we reduce the colours and brightnesses in a scene to numbers. Not only does this form of recording as data make the image more robust, but it also allows us to perform modifications. We can alter the numbers mathematically to achieve virtually any form of transformation.

This is beginning to sound an increasingly complex procedure. But it is not. When we record an image in a digital camera and subsequently manipulate that image on a computer we see nothing and, indeed, need know nothing about the complex and extensive mathematics that underpins it. Thanks to modern computer operating systems and image-manipulation software such as Photoshop, we apply changes and observe the results practically instantaneously.

Fig 6 – Conventional Bayer pattern and the modified pattern featuring emerald filters.

Bayer patterns (fig 6)

The individual pixels of a CCD are responsive only to the amount of light falling on them – they are essentially colour blind. To record a colour image, a fine filter is placed over the CCD to make each pixel sensitive to only red, green or blue light. Sensitivity issues with regard to green mean that there are more pixels used to record this colour. Some CCDs, however, use emerald/cyan filters in place of the additional green ones to provide better colour rendition, particularly in difficult areas such as skin tones and skies. The filter pattern is known as the Bayer pattern.

The Bayer pattern filter has an important impact on colour and resolution in an image. It requires three pixels to produce accurate colour information for a discrete part of an image. However, every pixel in a digital image has its own colour value. How can this be so? It's a process that mathematicians call interpolation. To arrive at a colour value for every pixel, even though each records only a single colour, the values from the neighbouring pixels are added together and averaged. The process – to produce accurate colour renditions – is complex, but as photographers we just need to know that it works!

The Pixel (figs 7–9)

To make it possible to describe every image uniquely as a series of numbers we need to break it down into small, discrete elements to which we can assign values for brightness and colour. We call these smallest of image elements pixels (a contraction of picture elements).

Digital cameras' imaging element, that part that records the image (the successor to film if you like), is broken up into pixels – each of which is, in effect, a tiny light-sensitive diode. Complex processing circuitry ensures that on each shot we take, the brightness and colour from each of these can be recorded and later reassembled to create an image. A typical imaging chip (called a CCD or CMOS, depending on the technology used) can have

between two and 12 million pixels. Some professional models have many more.

The image that results mirrors the pixel nature of the imaging chips, with each pixel reflecting the colour and brightness of its respective scene element. But conventional images – photographs, negatives, slides and even artwork – can be digitized using the relevant scanner. All that happens in a scanner is that the original image, from whatever source, is copied into a digital file by breaking it down into pixels. The methods may be different but the end result is the same.

In the next chapter we will look more closely at the computer and software and also explore one of the most important features of digital images – resolution.

Fig 7 – The CCD is a complex imaging and image processing chip. This Nikon model can record around five million pixels and allows shooting at multiple frames per second.

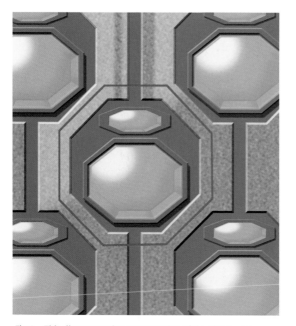

Fig 8 – This diagrammatic representation of the chip from a Fujifilm camera illustrates the individual "photosites" that record pixel information. This design, called the Fourth Generation SuperCCD, has two light-sensitive elements to each pixel to ensure the highest fidelity in both detail and colour.

PLANNING FOR SUCCESSFUL IMAGE MANIPULATION

When we set about creating a great image we will (except on those rare occasions when good images just happen) have a vision. And to realize that vision we need to recognize not only the darkroom techniques that must be employed but also the best way in which the original images should be recorded. This becomes even more pertinent when we seek to produce very specialized types of image. Let's take a sideways step for a moment to consider all the issues that go to make the images recorded in the camera the highest – or, at least, the most appropriate – quality.

Resolution and quality (fig 10)

Resolution and quality are undoubtedly two of the most important issues in recording digital images. Newcomers to digital photography, constrained for years with the finite capacity of a film camera, are often surprised by how many images they can record with even a modest memory card. But that surprise

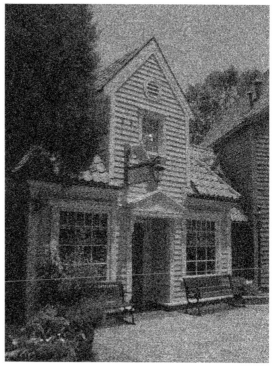

Fig 9 – The pixel nature of images is clear when you view them close up. In essence, however, this is no different in resolution terms from the grain structure visible when conventional film stock images are viewed close up.

Fig 10 – It is surprising the quality that can be achieved using digital images, but that quality is soon compromised if low-resolution or low-quality settings are used. These details come from a section of images recorded with a five million pixel camera. One was taken at full resolution (left) and the highest quality. The next at full resolution (middle) but low quality and the final one (right) at one million pixel resolution.

often turns to consternation when they examine the results and discover that their unique, unrepeatable images prove impossible to print with any clarity. They have fallen victim of the trap of using a low-resolution image file storage format.

Just about every camera will give the option of saving images in one of several formats. Top of the tree is the uncompressed, unfiltered and unprocessed Raw format that we examine on page 43. Beneath this in terms of quality come a number of options, each offering the opportunity to save greater and greater image numbers. Often these, nominally, offer the same ultimate resolution. But the names given to each – "Fine" "Good" and "Normal" – give the game away. As you move through the list, image files are stored with greater and greater amounts of compression. The "Normal" option, for example, would rarely be acceptable if you wanted to produce a quality image.

Of course there will always be compromises. Choose to store your images in Raw format and you'll get great results but be able to record only a very limited number of images before the memory card gives the "CARD FULL" message. My advice would be to stick to the "Fine" format as much as possible, straying to lower quality only when absolutely essential. Make sure you carry more than

enough memory cards with you and you'll never be caught short.

As for the lower resolution image storage offered, steer well clear. Even if your argument is that your images are for web use, take care. If you find you've a potentially great shot on your hands, you won't be able to do much more than view it on screen.

The drawback with digital cameras, despite the on-going growth in CCD pixel numbers, is that most cameras (including digital SLRs) tend to offer a more modest resolution. That's no great problem, unless you consistently need to produce very large prints.

Shooting panoramas (fig 11)

Panoramic photography – shooting sweeping vistas or extreme vertical shots – has moved from being a specialized task to the mainstream thanks to digital photography. It's now simple to join adjacent shots to produce a panorama (of up to 360 degrees) but it is important to record shots accurately in the first place. We'll explain more about the practicalities of this later but, as a prerequisite, ultimate accuracy will depend on using a tripod.

Shooting 3D (fig 12)

Another technique experiencing a digital renaissance is three-dimensional (or stereo)

Fig 11 – Large, high-resolution panoramas were once the preserve of the specialist photographer but are now easy to produce digitally. It's important to ensure that the consecutive images that comprise the panorama are precisely recorded, making a tripod an essential piece of equipment.

photography. Photographers have long struggled to give their photographs true depth but have often been hampered by cumbersome viewing equipment and the need for very high levels of accuracy. New tools, such as Photo 3D's photo kit, make it easier to get the shots needed to build three-dimensional images. They'll work with different viewing tools.

Filters

On-camera filters are often rejected in the digital world. Effects can be applied later, avoiding the need to compromise the original image (for, once recorded, the action of a camera filter can't be removed). But some filters should stay in your gadget bag – polarizers, for example. Removing reflections and boosting colour saturation can be done digitally but why put yourself to the time and trouble when a little forethought can remove the problem at source?

We can re-create graduate filters digitally, too. But sometimes it is still crucial to get a balanced shot where the brightness of the sky does not compromise overall image quality. Being able to hold back the sky (by reducing its exposure) is the raison d'être of the graduate (and we're talking here of the grey, or neutral-density, graduate, not the polychromatic alternatives) and these are still a useful – if not crucial – tool.

Now we have established the rationale for and the means of creating digital images, we need to take a closer look at some of the other stages in our holistic approach to digital-image manipulation. In the next chapter we'll examine the hardware credentials and also those of the crucial software. We'll also follow through on the concept of resolution and see why this is so fundamental to much of digital imaging.

Fig 12 – Photo 3D's kit provides a mini tripod for recording stereo image pairs accurately aligned. The companion software allows you to combine the pairs for viewing with specialized glasses. The software can also be used to align images precisely for use in other viewing systems.

HARDWARE
AND SOFTWARE

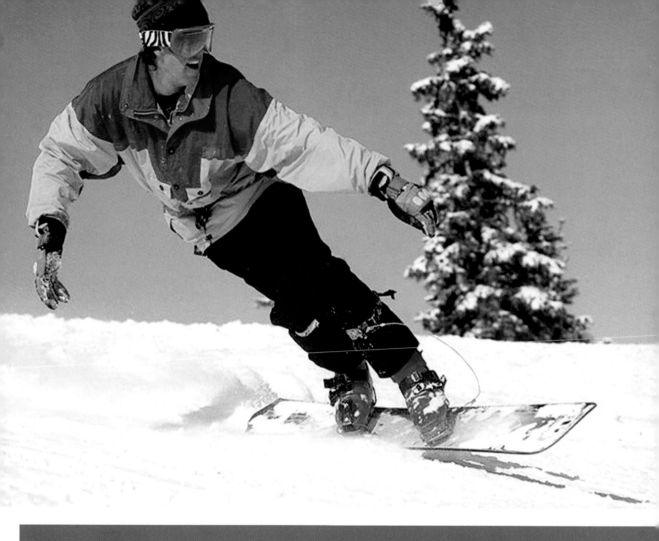

HARDWARE AND SOFTWARE ESSENTIALS

HARDWARE AND SOFTWARE ESSENTIALS

In this chapter we will:

- **Look at the opportunities to produce digital images without resorting to a computer.**
- **Examine the requirements in a computer system to embark successfully on image-manipulation projects.**
- **Examine the software applications required not only to manipulate images, but also to become an effective and organized digital photographer.**

The key to successful digital imaging is having a digital darkroom that not only meets specifications in terms of hardware and software but also allows effective, efficient workflow. We don't want to spend time looking at an hourglass or a stopwatch icon as our edits are enacted on our images. Neither do we want (nor need) to hunt menus and submenus for an often used but elusive feature. Over the next few pages we'll explore the requirements for an efficient light room. For those of us whose first love is photography it is easy to be misled or misguided when it comes to computer hardware and, to a lesser degree, software. So we'll adopt a rather cynical approach and take an objective view about what we do need and what we don't.

DIGITAL IMAGING WITHOUT A COMPUTER (FIGS 1 & 2)

Do we need a computer at all? Most photographers, even many professionals and enthusiasts, never owned nor wanted to own a chemical darkroom when they worked exclusively with film. They would rely on laboratories to process their film stock and likewise to produce prints and finished artwork. We can still do that with our digital images but there is another option, a "third way": the bespoke direct printer.

Direct printers connect to your digital camera and allow you to print selected images without any other intervention. These printers often work with the camera attached, using its LCD display to preview and select images for printing.

Regard these printers in the same light as those Polaroid instant printers that were once used to make fast prints from slides. They are great for getting prints quickly from the camera, but are suitable only for proofing or delivering prints on location. You could, for example, use one at a wedding reception to produce saleable instant prints. Add a quality folder frame and you can tap into that impulse-buy marketplace.

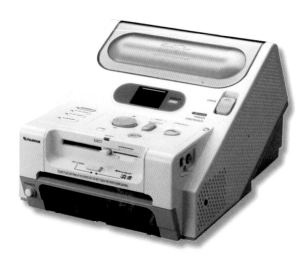

Fig 1 – Suitable for operation as a computer printer or using memory cards directly, this Fujifilm model can also connect to a television for reviewing the contents of a memory card prior to printing. Print size, as it is for most printers in this class, is small but the quality is invariably very high.

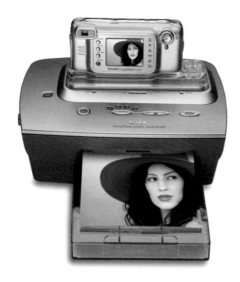

Fig 2 – Can it be any more simple? Plug the camera into the dock (which also recharges it) and select the images to print. The downside is that the printing unit (in this case a Kodak one) is matched to a particular camera.

GETTING THE BEST FROM YOUR COMPUTER

Computers in recent years have offered – and delivered – such incredible computing power that the warnings we once gave about ensuring you have sufficient memory and computing speed to use the demanding requirements of image-editing applications are now somewhat superfluous.

In fact, it's interesting to see how the specifications for software have evolved over the years. When Adobe released their Photoshop CS it had, compared to the computers available at the time, rather modest hardware demands. We can compare this to an earlier version of the same product whose requirements demanded the use of a very well specified machine. Here are those requirements for a Macintosh (the original version of Photoshop was not available for the PC), for comparison, separated by a decade:

We have seen with the most recent launches of Photoshop (and its peers) that there is something of a tailing off of the specifications required for each subsequent release. Of course, we can always gain by having a computer that is better specified than is demanded. And the other applications we may choose to run will undoubtedly ensure that we keep upgrading our computers long before they suffer any form of mechanical failure.

Buying new

If you're in the lucky position of upgrading to a new computer or buying a new machine outright, is it fair to be guided by, say, price alone, or are there other issues to be aware of? Probably the best way to evaluate the capabilities of a computer is to examine the recommended specifications required by the software you intend to run on it. This may be your image-editing software (which has traditionally been the most demanding), but it could be that an additional application, such as movie-editing software or DVD-creation applications, is even more voracious in its demands.

It is important to make the distinction between minimum specifications recommended and the (rarely published) desirable specifications. Historically it was important to the sales of a software product to define the minimum specification under which the software could run. This was real baseline stuff. Run Photoshop 3 under the bare minimum specification and you'll find it painfully slow. Much of this is due to the computer needing to copy parts of the image to and from the hard disk when editing. If the computer cannot retain the whole of the image currently being edited in memory it needs to use a part of the computer's hard disk as a so-called "scratch disk" for temporary storage. Copying and retrieving data in this way is

	Photoshop 3	Photoshop CS
Processor	Macintosh II 68020	Power PC G3, G4, G5
Operating System	System 6.0.7	Mac OSX 10.2.7
Recommended RAM memory	8MB	256MB
Hard disk space	32MB	320MB
Monitor resolution	640 x 480 pixels	1024 x 768 pixels

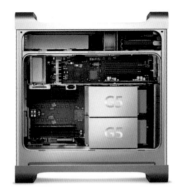

Fig 3 – The innards of any computer can be daunting to even the most stoic of technophiles but follow simple instructions and you'll be able to install additional memory, graphics boards and even disk drives.

much slower than using RAM memory. This alone is a good reason for adding as much RAM memory to your computer as possible.

Memory (fig 3)

Adding memory is perhaps the single simplest and most effective improvement that can be made to any computer destined to become an image-manipulation workstation. It's a case of never being able to have too much. It's also getting easier to add new memory – in the form of chips – to your computer. Macintoshes have, for many years, made it possible to upgrade memory without resorting to special tools or specialist knowledge. Now an increasing number of PC makers are seeing the advantage of making this process simple for the user. Have 500MB or RAM memory and you'll be ready to fly.

An ideal system?

To be asked to define an ideal image-manipulation system would be to ask for trouble – and condemnation – if not today, then during the shelf-life of this title. But it is possible to describe a system that will be adequate for some time to come. So what would this comprise?

The computer would need a fast processor, optimized for graphics-intensive work. For a PC, this would be a Pentium 4 running at 2Ghz. For a Macintosh the equivalent would be a G4 or G5 processor running at 1Ghz or better. But remember: specifications lower than these are still capable of good results.

Hard disks are where all your programs, documents and images are stored. And the more storage space you have the better. A large amount,

100GB or more, is useful but not essential unless you are also heavily into digital video production. Around 100GB will be sufficient for you to maintain a healthy range of applications along with extensive image libraries.

Finally, a display. Not so long ago we would have without hesitation recommended the use of a cathode ray tube (CRT) display. Only these were capable of displaying images to a level of authenticity (in brightness and colour fidelity) necessary to ensure perfect results. Now LCD panel displays have successfully matched their bulkier counterparts in quality (at least to the satisfaction of the vast majority of users) and allowed us to free up so much more desk space for other uses.

I have deliberately steered clear of suggesting whether you should select a Macintosh or PC platform for the core of your digital darkroom. Partly this is because you might have no say: if you have peripherals or software, or an old computer you are upgrading, that decision has already been made.

Desktop or laptop (fig 4)

A more intriguing argument today is not Mac or PC, but laptop or desktop? Again, this is an area where the balance has shifted. Laptops would be avoided for image manipulation because they were perceived as being underpowered (at least compared with their desktop counterparts) and as having inferior viewing screens. It is still true that for raw power the desktop machines deliver the goods, but the

Fig 4 – Laptops are often perceived as being inferior to desktop computers, but many models are more than up to the task. You also have the advantage of being able to take the computer with you on trips, downloading your camera's memory card whenever and wherever possible.

difference between those and a corresponding laptop is narrowing. Screens, too, are improving to the point where they are viable to use even on moderately exacting colour work.

Communicating with your images

How you get your digital images on to your computer depends on the nature of the originals. Digital camera images can be imported directly by connecting the camera to the computer. It's normal to find a USB lead as part of the camera kit (sadly there is little in the way of standardization in camera connectors). Some better cameras may include the faster FireWire connection, which will download the larger memory cards typically found on these cameras at a much faster rate. Other cameras come complete with a dock, which is a cradle that makes connection simpler and handles housekeeping duties (such as recharging the camera's batteries and deleting the images from the downloaded memory card) automatically. Or you can choose my preferred option – a dedicated memory card reader. It is quicker and less demanding on camera resources (see fig 5).

Scanners are required to digitize conventional images and flat artwork. These, too, connect via a USB lead. Originals can be scanned either by pressing a button on the scanner (which automatically launches a digitizing application) or from within an application such as Photoshop. Getting the best from scanned images involves a little remedial work and we'll be looking more closely at how later (see fig 6).

Fig 5 – This memory card reader can accommodate up to six different types of memory card – ideal when you're using more than one type of digital camera.

The final method of delivering images to a computer is on disk. Conventionally this is a CD-ROM, but larger images and larger collections of images are making DVDs a more viable option. Both of these have the benefit of being compatible with the drives on most computers on sale today. They also score by being relatively cheap, with blank disks of either type being substantially cheaper than many of the less common proprietary disk systems (see fig 7).

SOFTWARE APPLICATIONS

To create a successful digital image-manipulation workstation from your computer you need some key software application resources. These include products from two crucial software categories: image-editing applications and asset-management applications. Over the next few pages we'll take a look at these and establish which applications are essential, which desirable and which can safely be sidestepped.

Fig 6 – Scanners come in all shapes and sizes. This curious model from HP not only conserves desk space by standing upright, but also has a transparent lid, ideal for digitizing transparencies and transparent artwork.

Fig 7 – CD-ROMs and DVDs are ideal for backing up images, storing images and sharing them. The widespread availability of DVD/CD drives has made them cheap and efficient.

Fig 8 – *Photoshop's interface is daunting but, come to understand it and you'll find it's been beautifully conceived and is a great example of good ergonomic design.*

For me, choosing computer software for image editing is not so much like choosing equipment for the darkroom but choosing a camera system. When we choose a camera we are looking for something that will give us all the tools we need, and all those that we think we will need as our skills and abilities improve. But it needs to offer this in a package we feel comfortable using. We need controls that, with just a little practice, we can use swiftly and with little conscious thought. But how does this relate to software applications?

When we use any computer software we are using nothing more than a tool, a device that makes it possible to use the computer for a specific task. That task may be word processing if we are using an office application, creating music or editing videos. When we want to edit and manipulate images we want to do just that – without undue thought about the mechanics of the computer. For optimum workflow, we need to be able to navigate the software as fluidly as possible. This is why it is so important to choose the most effective software for our needs.

Extending the camera analogy even further, once we have bought a camera we tend to set our sights on accessories that will make our system even more potent. With hindsight, we discover that some of these accessories are of more use than others; some will be with us every day, others are unlikely ever to see the light of day as they languish at the bottom of the gadget bag.

There are plenty of software applications that will, in a similar way, vie for our attention and budget. Some will be well-nigh essential to our image-creating objectives. Some will seem just as relevant but are unlikely ever to be used beyond an initial flirtation. Realizing what is good and what is bad is one of those unsung skills the digital darkroom worker must learn.

Image-editing applications (figs 8–10)

But first, the key application. It's the image-editing application that we'll spend most of our time sitting in front of, so it's essential that we choose one that delivers all the tools we need. For most enthusiasts and virtually all professional photographers, choice is limited to one application – Adobe's Photoshop.

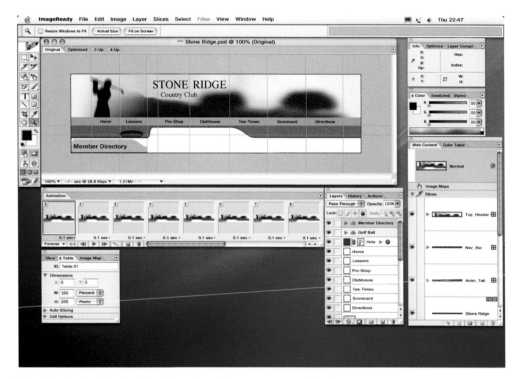

Fig 9 –Two for the price of one! Buy Photoshop and you get ImageReady for free.
This is a fully specified image editor in the mould of Photoshop but designed for
producing web graphics. Learn Photoshop and you'll quickly pick up ImageReady.

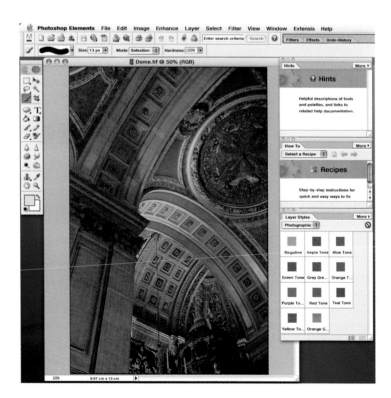

Fig 10 – Hints and recipes
characterize Photoshop
Elements. Otherwise it has
the same look and feel as
Photoshop itself.

Those new to digital photography will often ask: why? Is Photoshop the best application? Is it the most comprehensive? The easiest to use? And why does it cost so much? Let's take a look at these questions in turn.

Often the most pervasive product in a category gains prominence for a variety of reasons, not necessarily for being the best. You could take a look at video recorders, for example. By general consensus, the VHS format was a poor relation in quality terms but by keen pricing and great marketing it gained a substantial foothold among an audience that was, for the most part, not particularly discriminating. Is it also the case with Photoshop? Thankfully, no. Photoshop is undoubtedly the most effective application for the serious photographer. I've carefully skirted the use of the term "best" here because that term will depend to a degree on a user's needs. It is fair to say that the interface and working environment of Photoshop are the most slick and most effective when it comes to working day in, day out.

Any drawbacks? Of course there are. And this brings us to answering the last question: why does it cost so much? To many enthusiasts the price is the obstacle to owning and working with Photoshop. It's unfortunate but, as a tool notionally designed for the professional user, it is priced accordingly and is used – for the most part – by those who don't foot the bill.

Neither is it the most welcoming nor forgiving of applications. Those who come fresh to Photoshop will know to their cost that it does not ease the newcomer in, in the way that some image-editing applications do. Though the help menu is copious, it is very dryly presented and there are no other assistants – certainly nothing in the form of the wizards and shortcuts seen in lesser products. Learning Photoshop from scratch is an uphill struggle, but it's one that, through this book, you should find easier.

Adobe has long been mindful of the professional nature of Photoshop and has offered junior products, such as the trimmed down Photoshop LE (offering a similar interface but a cut-down toolset), and Photodeluxe, a basic step-by-step application designed for the burgeoning consumer market. Although both these applications have been successful, Adobe still recognized a need for a product that had much of the scope of Photoshop, that operated in much the same way, but had a friendlier face.

Hence the introduction of Photoshop Elements. It looks identical to Photoshop in most respects but under the skin are a number of shortcuts and recipes that ease the newcomer through the initial days and weeks of image editing. Users can, at their own pace, move across to using the full features of Elements. All the key features of Photoshop are included, though some have been curtailed. Those that have been removed tend to be the features used by pre-press photographers and designers and have proved (given Elements' success) a good trade-off against the substantially lower cost of this product.

You might be forgiven for thinking I am in the employ of Adobe with the continued references to their products on these pages. Not at all, I don't even

Fig 11 – Extensis's Portfolio has a simple thumbnail interface by default that belies the power that lurks beneath. When correctly configured and with images appropriately tagged, it makes image retrieval a cinch.

get a complimentary copy of any of their products. But it is a fact that Photoshop is the reference standard by which all other applications are judged and is the best (thanks to its pervasive nature) to use for demonstrating. But we've not forgotten that there are many other competent applications besides those offered by Adobe and you will find a rundown of these in the panel below.

Fig 12 – Portfolio Express can be invoked in any application, making it easy to integrate image identification and editing.

The wide world of image editing
If, for whatever reason, Photoshop isn't your thing, here are some alternatives to consider:

- *Corel DRAW:* Ostensibly a graphics application, it includes the module Photo Paint, which is a very comprehensively specified image-editing application.
- *Paintshop Pro:* Another well-specified application that's bundled with a simple web animation package and cataloguing application.
- *PictureMan:* An idiosyncratic application that's available online (see Resources, page 188) and contains many novel features. Different in approach to many image editors, but no less effective for that.
- *Painter:* Nominally a natural media painting application, Painter is also an image editor. Best suited to those who want to produce artworks from their images.

Plug-ins: extending choice
Even an application such as Photoshop can't cover every need and eventuality. That's where plug-in filters come in. These are miniature programs in their own right but have been designed, as the name implies, to plug in to an image editor. Going back to our camera kit analogy, these are like conventional filters, in spirit if not implementation. Some are useful and can be used regularly. Others are less useful and some so bizarre as to defy logic. Fortunately most are available on a trial-use basis so you can discover how useful they will be to you before spending any money.

Later in this book we'll take a look at some specific examples and see how even some of the most obscure can be used in creating powerful images.

The one-trick ponies
There's a class of image-editing applications designed not for all-purpose image manipulation but rather for very specific techniques. Two obvious examples are panoramic software applications and software for creating three-dimensional images. Often you don't need these applications but, if such techniques are likely to figure heavily in your workload, they can prove to be great timesavers. And there is no doubt that armed with them you'll be a lot more successful in your image making. We'll be taking a look at panoramic software and 3D photography later, too.

Fighting the forces of chaos: organizing images (figs 11 & 12)
I rarely count the number of images that I edit or manipulate each day, but say between 25 and 50 and you'd not be far out. And I'll save them all away, perform the necessary backups absolutely convinced that, when the need arises, I'll be able to track down any image from memory. Of course, I've been proved wrong time and time again. That's how I learned the hard way about the importance of good image management. The nature of the digital image is that, unlike conventional images where there will only ever be one prime copy of each shot you take, you may have many copies, each manipulated in some way to make them originals, too. Time is precious and whether we manipulate images for a

job or for pleasure, you want to make the best of that time. Hunting through your hard drive for images shouldn't figure prominently in our schedule.

Image-management software is another of those "must buys" that rarely figure on people's shopping list. For some people it is the belief (like mine) that your memory is up to the task. Others regard it as frivolous expenditure. Yet more appreciate the need but think that the process of cataloguing and organizing images will be time-consuming and boring.

For the typical – if there is such a thing – user of Photoshop, the corresponding asset-management application would be Extensis's Portfolio. Like Photoshop, this is an application that has grown and flourished over the years and now provides the most comprehensive set of management tools. Again like Photoshop, there are many features that you would be unlikely to use day to day, but will be very pleased you have when the need for them arises. Key features (which also apply to other, similar packages) are the thumbnail catalogues and keywords. By applying keywords to each image (the job that many perceive as time-consuming) you can then instantly identify an image or set of images simply by calling up the appropriate keywords.

Where Portfolio scores over most other applications is in the extent of its use – not only is it a virtual industry standard but it supports network and multiple users. Several people can simultaneously work on the same catalogue without any fear of loss of data or data integrity.

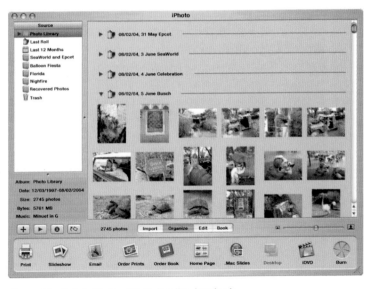

Fig 13 – Simple but effective, iPhoto handles downloads, image storage and basic manipulation.

Photoshop Album and iPhoto (fig 13)

These two spiritually similar applications (the former is for PC, the latter for Macs) provide a bridge between simple file browsers and image-management applications. Each allows you to view and select images easily using keywords or visual thumbnail arrays. They also make it simple to download images from digital cameras organizing downloads according to date (giving another simple retrieval method). Unlike image managers, they tend to work with those images stored on the computer and don't manage non-image assets.

The application iPhoto includes some simple image-editing tools, but these really are very basic and not the sort of resource most photographers would use. Fortunately, like Photoshop Album you can specify Photoshop as your image editor and have this application automatically invoked when you want to edit.

Archiving and backing up

The natural extension to asset management is archiving and backing up. It is useful to have access (made simple by your management system) to your images direct from the computer's hard disk but what if that disk, or some other crucial part of the computer were to fail? Failures do happen but, fortunately, not very often. Of course this reliability does tend to lull us into the proverbial false sense of security. It's often

only when we experience a failure that we realize the importance of keeping copies of all our work.

But first, let's distinguish between backups and archives; though the mechanics may be similar, the detail is quite different.

Backups are made regularly of the files on your computer that are currently in use. Those images that we are working on, the most recent downloads from the camera and, of course, any other new or changed files on the computer. In contrast, archives contain those files – again of any nature – that you've finished using on a day-to-day basis and don't anticipate needing immediate access to.

Think of both as you would insurance: something you don't want to think about, don't want to spend any time sorting out, but will be so grateful that you did should the worst happen.

For archiving important files you don't really need any special software. You can drag and drop the relevant files to a recordable DVD or CD and burn them. For good measure, always take a couple of copies and, if the material is valuable (in emotional or financial terms), store each in a different location. Avoid using rewritable media, which can be a bit more idiosyncratic when it comes to playback in different computers.

Backups can also be done by dragging and dropping files on to removable media but can also be written to another disk drive. An external disk drive makes an ideal medium for your backups: write speeds are fast and you can back up frequently (perhaps several times a day) when working on important material.

Both Windows XP and Mac OS offer applications for automating your backups called Briefcase and Backup, respectively.

RESOLUTION

Resolution is one of those terms we all know a little about but often really don't have a thorough understanding. This is partly because the term is bandied about in several aspects of digital photography and each has a slightly different slant. For our purposes, we need to become familiar with the relationship that takes in the pixel dimensions of an image, how that image appears on screen and how, ultimately, it will be rendered in print or, say, on a web page.

The amount of detail in an image is determined by the pixel count for that image. We often describe this pixel count as the resolution, particularly if we extrapolate backward to the imaging sensor that produced the image.

When we view an image – on a screen or printed out – the resolution of that image is described as the number of pixels per inch (ppi). That's an absolute term used irrespective of whether units as a whole are described in imperial or metric terms. Now we also describe the size of the image by its pixel dimensions – a CCD chip that has a resolution of six million pixels may have pixel dimensions of 3,000 x 2,000.

As we manipulate our images we'll come to see that by using an image-editing application we can change the resolution in pixels per inch at will (in web-authoring applications, however, such as ImageReady, you'll generally find that resolution is maintained at 72 ppi, which is a standard for online, onscreen media).

How does this translate into printed images? A high-resolution image will contain a greater number of smaller pixels than one printed to the same paper size at lower resolution. The higher-resolution image will also be able to resolve (and reproduce) more subject detail.

Resolution and file size

Clearly a high-resolution file, containing more pixels, will deliver a larger file size, all other parameters being equal. This means they will take up more disk space and take longer to manipulate and print. This is almost a classic trade-off. You can have more quality, but you'll lose disk space, put more pressure on your computer system, and take longer working. Or you can compromise on quality, but you'll increase your storage capacity and be able to work more quickly.

For professional users the answer is clear cut: it must be quality every time. They can't afford to make compromises, so it's no contest. The rest of us should follow their lead, although economics and practicalities often dictate otherwise. The best advice is probably to strive for the maximum quality and compromise only where or when you need to.

Fig 14 – Displayed at the same pixel resolution, this image takes up most of this 43 cm (17 in) display when the display resolution is 800 x 600 (left) but is presented considerably smaller at the higher resolution of 1200 x 928 pixels (below).

Fig 15 – Larger monitors also give more space to work. Even though the image has been displayed at the same physical size on these three monitors, it virtually fills the 38 cm (15 in) screen (right) yet offers plenty of additional workspace when displayed on a 53 cm (21 in) screen.

Monitor resolution (figs 14 & 15)

Only a few years ago most computers came with small, about 38 cm (15 in), monitors that offered limited resolution. Now many of us use 43 cm (17 in) or even 51 cm (20 in) displays that are capable of commendably high resolutions. Visually this means that an image viewed on a low-resolution monitor will appear larger than that same image displayed to the same pixel scale on a similarly sized high-resolution monitor. Both are illustrating the image "correctly". Fortunately zoom controls in the image-editing software let us explore details of an image in close-up no matter what our resolutions.

Printing and changing resolution (fig 16)

We measure printer resolution in terms of the number of dots per inch (dpi). We can treat dpi and ppi as synonymous in many respects. And, at the risk of being drawn into printer semantics, the dpi values may not correspond with the actual printing resolutions offered by the printer. The printing method, such as that of inkjet printers, will give on demand an effective 300dpi resolution, say, even though the printing method delivers dots of a different size.

We can change the resolution of the image using the application's Image Size dialogue (Image┈┈> Image Size...) We can change either the physical size or the pixel size and can specify a resolution. Though we'll explore the rationale later, it's usual not to increase the file size above the original size, either by changing the physical size or the resolution. If you do, there's a risk of losing quality and the gain will only be in file size, not in image detail.

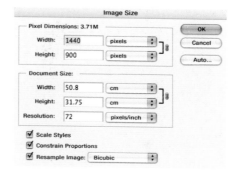

Fig 16 – LAt the Image Size dialogue we can give new pixel dimensions for the image, new physical, document sizes, or alter the resolution. With the Constrain Proportions box checked, you need change only the width or the height – the other dimension will be changed accordingly. The Resample Image option gives us the possibility of changing the sampling method if the image size or resolution is altered. We can use different mathematical calculations (which are handled invisibly for us) determined by whether we want to preserve the maximum quality or produce the fastest results.

Vector graphics

The images we produce from scanning original artwork or import from a digital camera are often described as bitmap images on account of their discrete pixel-based nature. But there is another type of graphic that we see increasingly in computer-based graphics programs. These are vector graphics. Any vector graphic features lines, curves and shapes that are described not by pixels but by mathematical formulae. As such, they can be resized, moved or otherwise altered without any loss of quality. When we enlarge a vector graphic – or rescale it in any way – there is no deterioration.

Photoshop features vector graphics tools, such as the Shape tool. The vector graphics it produces can be combined with pixel-based imagery. Only when we commit the vector graphic to the image does it become converted to a pixel-based image element.

What's in a name?

Resolution is a precise term often imprecisely used and with multiple interpretations. Here's a summary, starting with taking a photograph and ending at the output print:

- *Lens resolution:* described in terms of line pairs per millimetre (lpm), it is a measure of the fineness of pairs and lines that can be discriminated by the lens.
- *Sensor resolution:* described in terms of total number of pixels (normally megapixels), it is the total number of pixels that contribute to a digital image (usually slightly less than the total number for a CCD sensor).
- *Input resolution (ppi):* describes the fineness of the details scanned in an image or artwork.
- *Output resolution (ppi):* describes the spacing of the pixels in a digital file output from (say) a scanner.
- *Device resolution (dpi):* describes the actual resolution from a printer or other output device (not the maximum dots per inch that can be printed).

:::::::::FIRST

FIRST STEPS

FIRST STEPS

FIRST STEPS

In this chapter we will:

- Look at getting the best from our computer system – whether it's the latest all-singing, all-dancing model or something more modest.
- Examine the alternatives when digitizing images.
- Look at how we can output images to the web, introducing the concept of image optimization.
- Gain an understanding of colour management, to ensure that the colours we record in the real world are reproduced accurately when we consign our images to print or the web.

We all have the urge, when taking on something new, to pay scant regard to the instructions (and any advice we may be given) and launch straight in. It's often the same with digital photography and in the digital darkroom. We tend to load our software and start manipulating images. Such is the power and efficiency of computer systems you can be guaranteed a good level of success straight away. OK, so skills may need to be nurtured and developed but simple edits will be forthcoming. So can we now begin to set out on that skills learning curve? No. We need to spend just a little time understanding the capabilities and limitations of our computer system and how we can make that system perform everything demanded of it.

We also need to study the relationship between cameras, images and computers and what we can do with those images once they have been through our darkroom manipulations. These – and more – we'll discuss in this chapter.

OPTIMIZING PERFORMANCE

When we set about creating a conventional darkroom it's something of a major undertaking. We may, if we are lucky, have the opportunity to devote a room to our hobby, configuring electrics, plumbing and lighting to deliver the most efficient workspace. If we don't have a dedicated room we may need to be more ingenious, devising a darkroom that can easily pack away when the room reverts to its original purpose.

In the digital domain we rarely encounter the need for such domestic upheaval. The computer at its heart is the same one that sits in the corner of our lounge or on the desk in our study. And, truth be told, this is often the appeal. You don't need to turn your house upside down to accommodate it; you simply turn on the computer and you're ready.

But we can carry out a few minor tweaks to make our experience more comfortable and to ensure we spend as much time as possible creating great images. How we interact with the computer becomes much more important when dealing with images than it does with text-based documents.

Creating an optimum environment

To get the best results – from yourself and your computer system – follow these simple guidelines.

Lighting Subdued lighting is best. Avoid lighting that reflects directly on the computer screen. Not only will it make it hard to see the image (obviously) but it can affect any manipulations you make on screen. The best lighting is bright shade. Desk lamps provide a convenient source of indirect lighting, but ordinary bulbs can affect your ability to judge colours accurately on screen. The reddish hue of tungsten light bulbs will make a neutral screen appear cool and bluish (see fig 1).

Desks A large desk is pretty much essential. It gives you the space to position the monitor (or monitor and computer) and for any peripherals (scanner, printer, and so on), as well as any books or reference material. It is easy to compromise on desk space but it's a saving that will come back to haunt you time after time as you struggle to juggle everything you need.

BRIGHT

TUNGSTEN

NEUTRAL

COLD

Fig 1 – The background lighting to your screen will affect the way you view an image. A bright background will result in the image appearing dimmer than it actually is. A warm background (such as that from tungsten lighting) will give the perception that the image is more blue than it actually is. Conversely a blue background (such as results from illumination from a blue sky) gives a warmer interpretation. The best is a neutral grey.

Desk space should also include room for food and drink. We're often told to keep these well away from the computer but I certainly live in a real world where long image-editing sessions are fuelled by endless amounts of coffee. It makes sense to accept this and make allowances.

Ergonomics A stand for your monitor is not only a wise precaution in case of coffee spills, but it also serves as a means of ensuring that the monitor is in an optimum position. Ideally, the top of the screen should be approximately level with your eyes, or slightly higher if you are blessed with a particularly large monitor screen.

It's worth investing in a good-quality chair. It's not for image or status that executive chairs offer high comfort and a myriad of adjustments. Long stints at the computer can take their toll on our bodies, so it's essential that you have a chair that you can adjust to the best position in relation to your desk and monitor. Look for one that also keeps your back straight and

don't be afraid to try these out in the store before buying. It's like buying a bed. So many people do this purely because of the design (or even the colour of the mattress) even though the most crucial thing is ensuring a long, comfortable night's sleep.

Good sense Digital image manipulation is all-engrossing. It doesn't simply become addictive, it can become obsessive! Consequentially, you really can spend many hours at the screen honing and refining images in the quest for ultimate perfection. But it's a good idea to pay attention to those who have studied the health and safety of office workers who must, as part of their job, spend a long time sitting in front of a computer. They recommend that at least once an hour you take a break from the screen – just a few minutes will do – and take a walk around. Every two hours, take a longer break. This time, spend a few minutes allowing your eyes to rest – preferably by looking at distant objects. This avoids the stress on your eyes caused by constant close focusing.

Good practice

Given their complexity, computers and computer systems are remarkably reliable and can run continuously and trouble-free for years on end. Here are a few tips to make sure your computer runs in its optimum state:

- Computers are increasingly resilient to electrical surges and spikes in the mains voltage, but a rogue event can still reap havoc. It makes good sense to install an electrical-protection system. These are relatively cheap and can be built into multi-way adaptors.
- Install, use and update virus software. Viruses are an increasing problem both in number and ingenuity. Together with, the increasing amount of time people spend on line and you've another recipe for potential disaster. Most viruses are Windows based, but Mac users shouldn't be complacent.
- Back up the contents of your computer regularly and document files (which include images) more often. Make sure you also do this before installing major software upgrades, such as new operating systems.
- Ensure your computer will support software upgrades. It is tempting and desirable to install the latest version of your favourite software to take advantage of the current enhancements, but if the new software's recommended specifications exceed those of your computer, performance will be compromised.
- Keep your computer clean. Dust is a real problem, particularly around disk drives. You can clean the computer's interior periodically but only if you know what you're doing. A gentle but precise suction cleaner is best to use, but if you are concerned about potentially causing damage – resist the urge to clean.
- Don't move desktop computers unnecessarily and avoid jolting either desktop or laptop machines.

Optimizing your computer system

It is ironic that the main sales feature used by computer vendors is increased speed and capacity. Ironic because most of the computers sold require little more computing power than that offered a decade ago. Image manipulation, conversely, requires every scrap of power your computer can muster.

Fortunately, as we have already commented, most computers are ready to run image-manipulation applications straight out of the box. But we can make operation even swifter with just a couple of enhancements.

The first is to ensure the computer has as much RAM memory as you can afford. Most computers are well endowed now when it comes to RAM provision for digital images, you just can't have too much. More RAM means you can work with larger images without recourse to the "virtual-memory" option on the computer hard drive.

The second enhancement is application specific and involves no additional expense. Instead, we need to work with the Preferences menu of our chosen imaging application, ensuring that we have these configured ideally for our computer. Here, "ideally" does not necessarily imply we are configuring our computer for the most powerful implementation of the software. If we are using a computer that does not have the ultimate in specification, it can be self-defeating to set the highest level of functionality in the preferences. This can put intolerable demands on the computer and will drastically curtail performance. It is always better to set workable limits. You may not have, for example, a huge number of history states recorded (which lets you backtrack a specified number of steps), but this compromise alone will free up a substantial amount of memory for other tasks.

Understanding Preferences

So, configuring the Preferences can improve computer performance. But what changes should we make? Preferences vary according to the application, and even different versions of the same application, but here are some guidelines based on

Photoshop CS. Activating the History log causes further memory attrition so if you can live without it, do so. Don't know what the History log is? Then you can certainly live without it!

General Preferences dialogue History states gobble memory at an alarming rate. The default is 20 and you shouldn't need to increase this. If you find that you can live with fewer, you'll be able to grab back some more memory.

If Export Clipboard is checked, speed and performance can be compromised. Just a little, but every kilobyte or millisecond you can claw back goes toward better performance (see fig 2).

File Handling dialogue The Image Previews on offer in this window can also slow down your computer, but not to have them can be a hindrance when searching through your directories for images. The best compromise is to select Always Save and tick the Icon box rather than Full Size.

The Ask Before Saving option for TIFF files is a useful reminder if disk space is at a premium. This will prompt you to acknowledge that you are saving a layered file, which is often many times the size of a flattened file (see fig 3).

Display & Cursors dialogue It won't improve speed or performance but the settings here can help workflow. Selecting alternate cursor types helps with precision in selecting and brush work by replacing the iconic cursors with precise cursors or brush-sized cursors that give a better indication of the actions being undertaken (see fig 4).

Memory & Cache dialogue Here you can force the computer into using a determined amount of RAM. This can either ensure a large amount is dedicated to the application or, if this might compromise overall computer performance, you can set a deliberately lower figure.

This computer has 768MB of RAM installed. Of this around 100MB is consumed by other processes and here 50% of the remainder has been allocated to Photoshop (see fig 5).

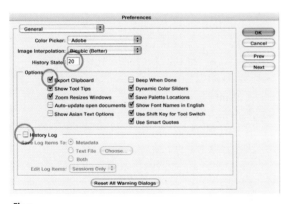

Fig 2

Fig 4

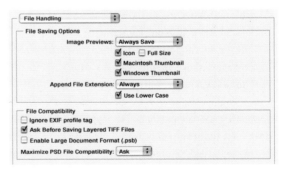

Fig 3

Fig 5

DIGITIZING IMAGES BY SCANNING

Despite the proliferation of digital cameras, most image archives are still based on traditional film originals. But before we can digitally manipulate these hand prints taken from original negatives or the original film stock itself, we must first produce a digital file from them.

Though we have it instilled in us from the earliest days of our photography that we should always work from an original (such as a negative or transparency) in preference to any copy made from it, it is often easier and better to scan a print produced from that original. This largely comes down to the dynamic range of the image – the range of brightness between the lightest and darkest elements.

A print has a dynamic range equivalent to six stops, where a difference of one stop is equivalent to doubling the brightness. For an original that transmits light, such as a transparency, you can expect the range to be closer to 12 stops. It is far more effective to encode an image with a six-stop range than 12. It is also simpler to arrange a lighting and optical system to scan a print than a transparent original, a situation that is made more pointed given the high density of many contemporary films.

But how do we go about getting the best quality from a scanned image? Though the scanner itself will have a bearing on the ultimate quality delivered, much comes down to the way we configure it. It's probably fair to say that most scanners today are capable of producing very good scans; the more sophisticated (and expensive) are capable of excellent ones. In the following we've not discriminated between flatbed scanners or slide scanners as the process of scanning is the same for both.

Bit depth

The bit depth describes the number of bits used, across the red, green and blue colour channels to determine the amount of detail in the data recorded. Good scanners can offer a bit depth of 48, most 36. This equates to 16 and 12 bits per channel respectively. Quality considerations aside, it is always better to use the highest setting possible and particularly where there is a wide dynamic range.

If you are using a slide scanner then 48-bit is a must – and it's a good idea to preserve this data in the final digital file: some scanners, by default, may produce a 24-bit file by downsampling the original data. By "downsampling" we mean taking a high resolution image and creating one of lower resolution by creating a smaller number of pixels, each formed from the average colour and lightness values of the original. Though we may decide later to downsize, it makes sense to preserve as much quality as possible at the outset. Initial image manipulations and corrections can often be done on 48-bit files, which can then be saved at 24-bit.

Sharpening and filtration

Many scanner software applications feature a range of filters designed to modify the digital file by making corrections during the scanning process. Sharpening and colour correction are often offered. I'd recommend bypassing these. Unless you've good reason to do otherwise, record a straight scan and

Fig 6 – This section of a twilight image is dominated by very dark colours that correspond to dense sections of the original transparency.

then perform any sharpening or colour corrections later when you've loaded the image into the image-manipulation application. It's the same argument we use about camera filtration. Do you apply a strong filter to the camera lens (indelibly applying the effect to the image) or apply it later, on the computer? In the latter case, if the effect doesn't "work" you can change it; in the former, you are stuck with it.

It's also quicker to record an unfiltered image than a filtered one, which can lead to quite a time saving if you have multiple images to scan.

Dust and scratches

One type of filter that you may want to give more consideration to is that which removes dust and scratches. It's inevitable that films and prints attract dust and that the dust will then be scanned along with all the other detail on the image. Even when we take every precaution with our originals they will still attract dust or show minuscule scratch marks.

Though we could postpone the removal of such marks until we have scanned the image it's better to remove the problem at source. Many scanner software applications feature an automatic dust and scratch filter. Unlike software filters (which are rarely satisfactory and can often compromise image sharpness) the scanner software works by shining infrared light across the image to detect blemishes; these can then be mapped and a high-resolution scan performed taking the blemishes into account.

Using multipass scanning (figs 6–8)

Slide scanners often provide, either straight out of the box or by means of upgrades to their software drivers, the option to do multipass scanning. In this system, the scanner will scan the original several times squeezing the best results out of your transparencies. It's a technique that is particularly useful for high-contrast transparencies, such as the colour photographer's favourite, Fuji Velvia.

Fig 7 – A detail of the scan (marked in white on the main image) shows some noise around the edges of the leaves, but otherwise the noise is well suppressed. This is an example of a multipass scan.

Fig 8 – The single-pass scan has handled noise less effectively. There is considerable noise in the blue sky and the leaves have been lightened (though not obvious on the printed page) thanks to the high noise levels.

The nature of such emulsions means that very little light gets through the denser parts, which means a much lower signal is produced. At low signal levels noise (electronic noise, not the audible type) – due to random electronic fluctuations – becomes much more significant and can compromise image quality. By repeating the scan, the scanner is able to interpret the best signal information and reduce noise levels. Drawbacks? Just the one. It takes longer to complete a scan.

Multiple image scanning

If you have a large scanner or a number of small originals you can scan them all together using a single pass of the scanner. Once scanned, you can use the Rectangular Marquee tool to cut each out and paste it into a new document.

After choosing the first image with the Marquee select Copy, then New File and then Paste. New files are always created to the dimensions of the image copied to the clipboard. If your images weren't quite square on to the scanner head you will also need to straighten them – see Rotating skewed scans – accurately (below).

In Photoshop CS, Adobe have thought about the demands of multiple scanning and have given us Crop and Straighten: apply this to your multiple scan and each image will be cropped and aligned if skewed and then save each to a separate file.

Rotating skewed scans – accurately

If you've scanned multiple originals at a single pass, or have not been diligent about the alignment of your original, you may find the image is skewed when you display the digital file.

Here's a simple way to rectify this problem that does away with arbitrary rotations or using the Transform┈┈⟩Skew command.

1. Select the Measure tool from the toolbar. You won't see this straight away as it shares a space with the Eyedropper tool. Click on the Eyedropper tool to reveal the pop-out menu and then select Measure (see fig 9).
2. Use the Measure tool to measure along one side of the skewed image. It's easiest to click on one corner and then the next (see fig 10).
3. Now open Image┈┈⟩Rotate Canvas┈┈⟩Arbitrary. Rather than having to guess the amount of turn required you will find the rotational amount has been entered automatically. Accept the amount (see fig 11).
4. Your image is then rendered perfectly straight (see fig 12).

It's a good idea to make every effort to keep your images square on to the scanner head to avoid this process. Not only is it time-consuming but small rotations can cause image softening as pixel colour and brightness values are interpolated to produce the new pixel structure in the rectified image.

FILE FORMATS

Image files can, as we are aware from using digital cameras, be stored in different formats. A consumer digital camera, for example, will store images in the widely used JPEG format. It's a convenient and portable format that scores well in being able to store relatively large files in a compressed state. However, this compression involves data loss and we may choose (if the option is available) to store the images in an alternate format such as TIFF. TIFF files, too, can be compressed (though to a more modest amount than JPEG files) but without loss of data.

But for the purist, both of these formats are unsatisfactory in as much as they require the camera to process the raw data received from the imaging chip before storage. There is a degree of averaging and approximation involved in this processing that can compromise ultimate image quality. Raw data will also be free of any image-processing filtering and other in-camera settings (such as white balance). So many cameras (mostly those

Fig 9

Fig 11

Fig 10

Fig 12

designated for the professional, or "prosumer") also allow the storage of the raw data directly from the CCD. Post processing – necessary to produce an image – can then be handled in Photoshop.

Raw data is not strictly a format, as the nature of the data varies from camera to camera, but the plug-in for Photoshop (designed to read this data) can interpret data from most currently available cameras along with an increasingly large number of superseded models. Adobe also releases periodic updates so that data from new cameras can be used. Some camera manufacturers also release software to handle the data from their models.

Using raw data will certainly deliver the best results but there are drawbacks. File sizes are large (often much larger than the nominal resolution of the camera) and so memory cards fill up fast. And it is usually impossible to replay the data in the camera.

Saving image files

Once we have loaded an image into our application (whether it originally was a TIFF, JPEG or raw data format) we will need to save it, along with all the editing and manipulation we've carried out on it. Photoshop, like most applications, allows images to be stored in upward of 20 different formats. We could save back into the original JPEG or TIFF format (though not raw), although our exact choice will be dictated by the nature of the image and how we want ultimately to use it.

Take a look at the Save options (you'll see them when you select Save As... when saving an image) and you'll see the full list of options available to you. Many of these are of specialist use or are there for reasons of historical compatibility, but here are the most important and significant formats for everyday use (detailed descriptions of the other formats are given in Photoshop's help

Fig 13 – JPEG images feature a compression system that divides the image into blocks of pixels and then averages the image information in the block. This is not obvious when viewing an image in its entirety but becomes very obvious in close up, especially at high-contrast transitions such as edges.

Fig 14 – Though JPEG image files can give acceptable results, the compression routines introduce artefacts that are accentuated each time an image is saved. In this image, modest edits were performed and the image saved. This was repeated a further four times. Overall the "after" image appears a little softer than the original. Close up, the JPEG artefacts are very obvious and make the image unacceptable except for the most undemanding of uses, such as a small website image.

and the corresponding documentation of other applications). Here's our shortlist and, following, a more detailed analysis of their use:

- JPEG
- JPEG 2000
- TIFF
- Native/Photoshop Format (PSD)
- PDF

JPEG Named after the Joint Photographic Expert Group, this has become the de facto standard for simple image distribution. It is used where constraints (in image file size, or time and bandwidth – such as on the internet) prevent the use of other formats. Files can be reduced to a fraction (a few per cent) of their original size, but the greater the compression the more data is discarded. This has consequential problems when the image is displayed and is compounded when the image is resaved and opened repeatedly. The benefit is that a modest amount of compression does not unduly

compromise image quality and allows a great number of images to be stored in a comparatively small space (such as on a CD or a camera memory card). If your camera delivers JPEG files, select the highest quality option on the camera and save the files in the TIFF format when downloaded and edited. JPEG files will not save image data such as alpha channels or layers (see figs 13 & 14).

JPEG 2000 Created to answer the objections to the use of JPEG format files in exacting applications, JPEG 2000 has the option of "Lossless Compression", which means that files can be compressed without data loss. It also incorporates a Region of Interest (ROI) feature that allows the photographer to specify crucial regions in an image that can have the image quality preserved absolutely and those areas that can be heavily compressed without affecting overall image quality. JPEG 2000 is not universally available on all computers (unlike JPEG) and in Photoshop CS it requires the installation of a (provided) plug-in.

TIFF The Tagged Image File Format is supported by virtually all computers and supported in all painting, image-editing and even page-layout applications. The way the data is stored differs between Macintosh and Windows computers and you will need to specify a byte order when saving a file. Photoshop will also preserve image layers (although when an image is opened in another application the layer structure may be lost and the image opened in flattened form). A lossless compression is possible when saving TIFF files.

Native/Photoshop PSD Each image-editing and painting application features its own native file format, a format that retains the maximum image editing data. Layers, channels and other information will be retained, along with any other application-specific data. For Photoshop files, this is the PSD format. PSD files can also be opened by most other Adobe applications preserving most of the Photoshop features. Because the functionality of Photoshop has increased over the years, and with each new version, you may need to select

an alternate format to maximize compatibility if you are exchanging files with someone using an early version.

PDF The Portable Document Format is another Adobe format that allows documents with embedded images and text to be shared across platforms and computers, even if those computers don't contain the necessary fonts normally required to display the text correctly. Files saved in this format are known as Photoshop PDFs, but Photoshop can open PDFs from any source.

File compressions

Most file formats have the option of at least one compression technique to reduce the file size. These can either be Lossy (where data is actually discarded in the compression process) or Lossless (where no data is lost). Here are the key compression types:

- *JPEG:* The lossy technique used in JPEG files but also selectable for use on TIFF and PDF files. Photoshop offers a slider (with a range from 0 to 12) for selecting the image quality required and, consequently, the amount of compression.
- *LZW:* The Lemple-Zif-Welch technique is lossless and is supported by TIFF and PDF files. The amount of compression varies according to the content of the image with the maximum compression offered where images contain large areas of a single colour (in skies, for example)
- *ZIP:* Another lossless system for PDF and TIFF files and offering a similar compression strategy as LZW.
- *RLE:* Run Length Encoding. A lossless system limited to some Windows formats.
- *PackBits:* Supported only in ImageReady, PackBits is a lossless RLE scheme used with TIFF image files.

Image size

Though it is not an issue for most images, most applications, including versions of Photoshop prior to CS, could not handle images greater in size than 2GB. In Photoshop CS larger files can be stored in Large Document Format (PSB), Photoshop Raw or TIFF formats.

Large Document Format needs to be enabled prior to use, using Photoshop Preferences.

CREATING IMAGES FOR THE WEB

Once, not so long ago, image-manipulation books would all conclude with – or at least feature somewhere – a section on outputting your images. And invariably this would discuss the printing options available. Though printing still comprises a significant element of image outputting – we still enjoy passing prints around friends and family, for example, or perhaps displaying them on a wall – we are now equally likely to want to use our images as an email attachment or even as part of a website.

For some time, image-editing applications have reflected the need to provide output images for printing, reproduction in books and magazines and on the web. In Photoshop, as we've already mentioned, we have the companion ImageReady application devoted to web image creation and web graphics. But the pervasive nature of the web has led to many of the tools we might expect an application such as ImageReady to host making the transition to the elder sibling.

There is nothing difficult about creating web images. Even perceived complex tasks such as the creation of web image galleries is now reduced to an automated task, requiring us, as creators, only to specify a look and to provide the necessary words and captions. Let's take a look as some of the essential tools for adapting images for a life on the web. We will then look at how Photoshop's Web Photo Gallery can give you an easy route to a web presence.

Image optimization (fig 15)

"Bigger is best" is the mantra for digital image resolution. But big images take a long time to transmit over the web, even when you have fast connections. Although quality must always be paramount when creating original images, when you want to send copies of those images over the web we need to compromise.

We can convert our images (or, rather, a copy of our images) from a robust format such as TIFF to JPEG. This allows us to compress the image and send it faster. Clearly there will be quality issues but these are offset by the time (and resource) savings. Many photographers also prefer JPEG for web images because of the image degradation: it makes it less likely that images will be stolen from the website.

Both Photoshop and ImageReady feature optimizing tools (Save For Web in Photoshop, the Optimization palette in ImageReady) that will allow you to set compressions and observe the effects on the image prior to exporting it.

Slicing

Image slicing, once a web-exclusive tool that can now be found in Photoshop, lets you cut an image into rectangles each of which can be compressed in different ways. We take a look at this when we explore the selection tools on page 58.

Rollovers and animation (fig 16)

Neither rollovers nor animations are strictly image enhancements, but they do contribute to the experience of visiting a website. The tools for both features are strictly web-based, so they will be found in ImageReady. Here you can set rollovers (which determine how an image will react to a mouse rolling over it, clicking on it etc) using the Web Content Palette. Typically (as you'll recall from visits to most websites) rollovers are used to highlight parts of an image or button by making it lighter, surrounding it by a glow or (in the case of a button) to look as if it has been pressed.

Animations – created in the Animations palette – let you create simple animations from a sequence of images. Animation creation is really outside the scope of this book, but if you have, say,

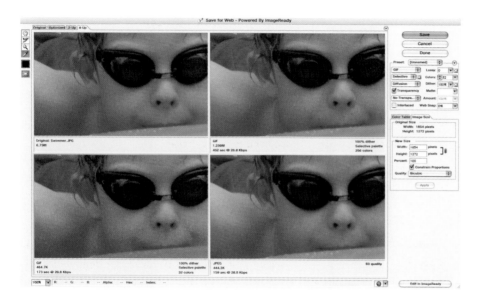

Fig 15 – Photoshop's Save For Web compares an original image with compressed copies of the same image. You can vary the compression ratios and observe the effect. Photoshop will even calculate approximate download times for various Internet connection speeds.

Fig 16 – To communicate to visitors to your website that parts of an image are active – and will lead to a subsidiary webpage – rollovers are essential. When the mouse rolls over this part of an image, an outer glow (a Layer Styles effect) appears indicating that clicking with the mouse will initiate some action (usually a link to another page).

Fig 17 – The Web Gallery Dialogue seems onerous, but it is pretty straightforward. Enter details of where Photoshop can find your images, where to store them and how you want the gallery to look. Other information – such as captions and descriptions – is essentially optional, but for visitors to get the best out of the site it should be comprehensive without being verbose.

time-lapse images that you want to run as a short movie, this is a convenient place to assemble the production. You can then export the result either as a GIF file (an image file format that supports animation) or a Flash SWF file, the format used extensively for web graphics.

Web Photo Gallery (figs 17 & 18)

Photoshop's Web Photo Gallery will create a web gallery from a selected range of images. These need to be images that have been sorted, edited and optimized. By "web photo gallery" we mean a website that includes a home page – the front page of a site – that displays thumbnails of all the included images and then numerous gallery pages that can display each of these thumbnails in a larger form. Any visitor to the website would arrive at the homepage, click on a thumbnail of interest and get to see the corresponding image, full size.

There is a wide range of styles for the gallery included in Photoshop and you can find similar facilities in many other applications. You'll even find

some third-party designs on the web that you can import to give your creation a less obvious style.

Creating a gallery is very straightforward. You'll find the option to generate the gallery at File--->Automate--->Web Photo Gallery. You will need to provide a folder containing the original images (which should be sorted into the order you wish them to display, if this is important) and follow the onscreen instructions. It's important to give some thought to the naming of images, captions and any other words you want included. Once the automated process begins, all this information is indelibly embedded in your web gallery and a change will mean recompiling the whole project.

Once that process has been initiated you've no need (nor any chance) to intervene. The process can take a few minutes, depending on the number of images, but once complete it will have created a folder with JPEG versions of your images, HTML code to describe the page layouts and text upon them and the JPEG thumbnails to populate your homepage.

So, is that really all there is to it? No, not quite.

We've created the website on our own computer. To make it visible to the whole world (or, at least, to the web-connected world) we need to upload all the files generated to our filespace. This is where your Internet Service Provider, or ISP, will come to your aid. You'll need to make contact and see how much filespace you have, how much you need and the preferred method of uploading. Again, this is not difficult or complex.

PRINTING AND COLOUR MANAGEMENT

There is no doubt that the web has given us many opportunities to distribute, share and show off our images. But printed images are still the way most of us prefer to display our work. And this is where attention to detail will show its mettle. Printed images show – sometimes cruelly – any shortcuts or deficiencies in the image. So it is important not only that we make our images as perfect as possible in the first place, but that we also ensure our efforts are accurately reproduced and no additional problems are introduced.

Understanding colour management (fig 19)

Newcomers as well as some seasoned users of digital imaging technology are often disappointed that the images they see onscreen rarely look the same when printed. Some of this is unavoidable: the brightness range – or dynamic range – of the screen is greater than that of paper, so a screen image will always look brighter. But part of the difference in appearance also arises because of variations in colour interpretation at different stages. A monitor will interpret colours in one way and a printer in another. Differences are small but significant. There are no absolutes in colour rendition: in the same way that you can choose how your TV displays colours, contrast and brightness, so you can with your computer monitor.

If we are to get results that are consistent from screen to print, we need to ensure first that each component is calibrated so that it conforms – as far as is practical, because we will never achieve perfection – to a standard. Then we need to use a colour profile. Though colour profiles themselves

Fig 18 – It may not be groundbreaking, but as a convenient showcase for your best images Adobe's gallery options are just fine. When you become more demanding, you can look at other web-authoring applications that allow you more freedom and flexibility.

Fig 19 – The difference between a screen and a print image can be quite marked. Here, the screen image (which, necessarily, has been simulated here) shows the greater chromatic and brightness range possible. The printed image is similar in terms of colour but has a more compressed brightness range and less contrast.

are rather complex (and their management often takes entire volumes to explore), we can consider these in their most basic form as a data tag that is passed from an image file through our computer system to ensure colour consistency.

Monitor calibration

Calibrating your monitor so that it displays authentic, standard colours is the most important step. This will make it conform to an accepted standard. Brightness, colour and contrast will all be taken into account. We can then use our calibration to define a colour profile for the monitor. Our software applications will recognize this and manage colours accordingly.

There are various calibration routines on offer. Some can be found as part of the computer's operating system, others are supplied (on a disk or online) by the monitor's manufacturer. Photoshop includes Adobe Gamma, while Mac OS X computers feature a calibration routine as part of the Monitors option in the System Preferences.

Printer calibration (figs 20–23)

Printer calibration can be more problematic because printers use different paper and media as well as different inks. In addition, the place where you correct colour and brightness inconsistencies can

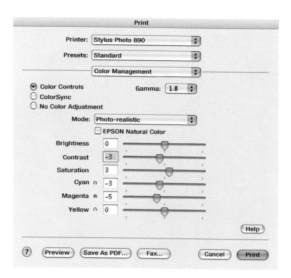

Fig 20 – ColourSync ensures colour fidelity.

vary depending on the application being used. The example shown here is a simple option provided as part of a printer driver. Adjustments can be made by moving the sliders to compensate for differences between the print and the screen. In this Mac printer driver we can use Apple's proprietary ColorSync to ensure (with a fair degree of automation) accuracy throughout the image chain (see fig 20).

Calibration becomes more problematic at the printing stage because we can introduce more variables here than we would normally tolerate.

Fig 21 – An image from a well calibrated system using an Epson Stylus Photo 890 printer and matched media. Colours are vibrant and the definition sharp. Compare it with the two shots overleaf.

Fig 22 – Substituting a generic ink cartridge produces a print that is very similar but the reds are less vibrant. This may be due to the ink or an incompatibility between the ink and the media.

Fig 23 – Printing on third-party paper that is described as compatible with the printer produces an acceptable print but this time the colours in general (and the yellows in particular) are paler.

Calibration is all about defining and implementing standards: a standards regime that applies across the board.

Our printer will require to be fed both inks and paper. Inks (or pigments in the case of some printers) are generally produced by the manufacturer of the printer to a precise chemistry. This ensures – as far as is possible – that when used with the recommended media the colour will be consistent. As many users find, however, this combination of printer and authorized media can be very expensive and many turn to third-party, generic products. Savings can be substantial but you will notice a quality difference. And, more significantly, there will be colour issues that will nullify some part of our hard-won calibration.

Purists will argue that we should never stray from the recommendations of the printer manufacturers. But most of us do not have unlimited budgets and, in the real world, I certainly find it acceptable to reserve the high-quality, high-cost, media for my best prints and use cheaper alternatives for day-to-day printing.

Getting it right

Monitor calibration is a stepwise process that establishes the best (or optimum) characteristics for the monitor.

1. This calibration routine (from the Mac OS X operating system) has normal and "expert" modes. The expert mode adds extra controls but for most users the basic set of adjustments is sufficient (see fig 24).
2. The first correction is the gamma setting: this adjusts the contrast to match typical screen types. Often, as here, there is a default setting that can be retained (see fig 25).
3. The White Point determines the tint of the screen. Native or D50 are normally the recommended settings. Once you've made these adjustments you can store the settings as a new profile (see fig 26).

Fig 24 – Display Calibrator Assistant takes users through calibration steps.

Fig 25 – The gamma setting determines overall contrast.

Fig 26 – White Point sets any colour tint required.

MASTERING
IMAGE MANIPULATION

MASTERING IMAGE MANIPULATION SOFTWARE

MASTERING IMAGE MANIPULATION SOFTWARE

In this chapter we will:

- **Get a grounding in the key image-manipulation tools.**
- **Gain an insight to the concepts of masks and channels.**
- **Look at how brushes are used throughout Photoshop to apply effects and colour.**
- **Develop an overview of filters, effects, histograms and levels sufficient for us to begin developing our image-manipulation skills.**

MAKING SELECTIONS

We make selections in image manipulation when, logically enough, we want to apply some manipulation to a select collection of pixels. Those pixels may be those that comprise a contiguous subject, a collection of diverse subjects in the same image or even those of a specific colour. Making a selection and then performing an edit are essential elements in our workflow.

Photoshop, in common with most image-manipulation applications, provides a range of tools for making selections, each of which can take more than one form. Let's take an overview of them

The Marquee (figs 1–3)

The Marquee is, by virtue of being at pole position on the toolbar, the first. In a photographic sense it is one of the less useful tools. We rarely need to draw rectangles or ellipses on our images other than when cropping or creating vignettes. And, that, in essence, is the point of this tool. It's for defining regular selections and works by clicking at one corner and dragging across to the opposite.

The Circular Marquee works in an identical way. Despite the name, the default shape drawn is an ellipse. To constrain the dimensions and draw a perfect circle, hold down the shift key when dragging. Holding down the alt key (with regular or circular marquees) will change the mode so the respective selection expands from the centre.

Two little-used modes of the Marquee tool are the Single Column and Single Row. Again rather

Fig 1 – Though the visual effect is powerful (at least among the general, consumer market) the vignette is easy to achieve. Select the Elliptical Marquee, drag a selection across the image, invert the selection and press delete. By varying the background colour and the Feather amount (in the Options bar) different effects are easily achieved.

Fig 2 – This is a variation on a theme. By creating a new layer (Layer···⋄New) and painting in the selection with the same colour paint we can use Layer effects (Layer···⋄Layer Effects). Here the Bevel and Emboss effect has given the vignette the appearance of having been cut from thick card.

Fig 3 – We can add texture to the Bevel and Embossed image to give a pseudo-leather effect. There are a range of preset textures that can be varied in extent from the subtle to the overt.

Fig 4 – With a low Tolerance setting (here, 20) a limited colour range is selected.

Fig 5 – Increasing the Tolerance to 60 appends a greater number of pixels across a wider colour range. But with the Contiguous box selected, all the pixels comprise a single, contiguous selection.

Fig 6 – At the same Tolerance (60) but with the Contiguous option deselected, pixels that conform to the tolerance throughout the image are selected.

obviously, these will select a single column or row of pixels. So what use is this? It's very useful for trimming away the edges of selections. Where you have used the Marquee to crop and image you can use one of these to nibble away at the edges to get the selection precise.

The Magic Wand (figs 4–6)

If you want to identify areas of similar colour in an image, the Magic Wand is the tool. It identifies the colour of the pixels in the area you click and then appends all those of the same or a similar colour to the selection. The amount of similarity in colour is defined by a Tolerance setting. A high setting will append a broad range of tones, a lower setting a smaller range. By pressing the shift key when selecting areas we can add non-contiguous areas of colour to the selection. You can also toggle between contiguous and non-contiguous selection by clicking on the button in the Options bar.

Color Range (fig 7)

An evolution of the Magic Wand is the Color Range command. You'll find this in the Select menu. It allows you to select a single colour, as with the Magic Wand, but a selection will be made of all parts of the image of a similar colour. By sliding the Fuzziness control you can broaden the colour range that is included in the selection.

The Lasso

The Lasso tool is essentially a freehand selection tool. You can describe any shape by drawing

on-screen and once the line is closed – by connecting with the start point – all pixels enclosed will be selected.

The Lasso has two variants. The Magnetic Lasso will automatically follow the edge of a subject. You need only follow the edge approximately for it to snap to the edge precisely. This does need a degree of fine tuning to get right, however – it can sometimes follow a nearby stronger edge or wander aimlessly where contrast is low.

The Polygonal Lasso draws polygonal shapes by clicking where you wish to place a corner. Polygons can have as few as three sides through to many hundreds.

You can use the Alt key to switch between modes as you describe a selection: pressing Alt when in polygonal mode switches to normal Lasso;

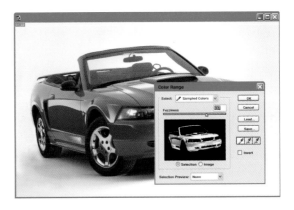

Fig 7 – The Color Range dialogue makes it simple to see the extent of a selection across the image. The selected area is shown white against a black background. Greys indicate partially selected pixels.

Fig 8 – This image has been sliced. When used on a web page we can change the compressions used to ensure that details (such as the text) are not compromised, while other areas that are not so crucial can be, cutting down on the downloading time. This example can be found in Photoshop's "samples" folder.

the Magnetic Lasso will change to Polygonal and with the normal Lasso active pressing Alt switches to Polygonal.

Slices (fig 8)

Slices are a more specialized selection tool that come into their own if you work extensively with web imagery. We use the slicing tool to cut up an image into smaller rectangles each of which can be regarded, for the purposes of web downloading, as an individual image. We can then apply different compression regimes to each, preserving the quality in important areas and compressing heavily in others. In this way we can optimize the time and quality of image downloads.

Efficient selection (fig 9)

Of course, when it comes to making a real-world selection we find that none of these tools – except in exceptional, undemanding circumstances – delivers a perfect selection directly. Selection shapes never precisely conform to the criteria of specific tools and more importantly we may need soft edges rather than the abrupt edges delivered by selection boundaries.

Fortunately all these problems are addressed in Photoshop.

First, we need not confine ourselves to the use of a single selection tool. It's quite possible to use multiple tools – for example we could use the Magic Wand to select an area of reasonably flat colour and then the circular Marquee to "mop up" any unselected pixels within the boundaries (though we will learn that there are better ways to attend to these problems).

We can also use the Boolean buttons on the Options bar. These four buttons allow us to perform operations on the current selection. The default New Selection setting means that each time we use a selection tool a new selection is begun and all previous selected areas are discarded.

In Add mode any selection made when this button is pressed (no matter what tools were previously used to make the selection) is added to any existing selection. This is the mode that many people tend to use as a default, bearing in mind that most selections tend to involve multiple selection events.

Subtract mode removes areas from a selection. Drawing a circular marquee inside a larger circular selection will result in the centre being deselected, leaving a toroidal selection.

The final Intersect mode generates a new selection using the intersection of a previous selection and a new selection.

Going soft

We don't always want the edge of our selection to be sharply defined. If, for example, we are copying an image element to be pasted into another image, a sharp edge will not look convincing when the action is carried out. The sharpness of the edge should match the sharpness of the image, and we can alter the sharpness of the edge by feathering it. By setting a value of just 1 or 2 on the Feather box on the Options bar we can get a softer edge that makes selections more effective.

Fig 9 – The selection tools' buttons, on the Options bar, are important allies in creating complex selections and represent, from the left, Normal mode, Add to Selection (selected here), Subtract from Selection and Intersect with Selection.

Note, too, that selections do not have to be solid. You can create a selection where some pixels are 100% selected and some less, giving soft gradients when montages or effects are applied.

BRUSHES: NOT JUST FOR PAINTING (FIG 10)

Back when computer-painting and image-manipulation tools were in their infancy, brushes were seen very much as tools for applying colour. And little else. Mind you, in those long gone days the simple ability to paint over the surface of an image or create your own digital artwork was viewed with the same enthusiasm as contemporary exponents view the subtle offerings from the latest version of Photoshop.

Now, although brushes can be used to apply paint ad hoc, they are actually more pivotal to many of the tools in our arsenal. We can apply masks, sharpen parts of an image, change local saturation and even clone elements using the same humble brush. Humble, however, is perhaps an inappropriate term. The brushes we have access to today don't just come in a range of sizes, but also shapes and textures. And should we find that there is nothing in the default selection that fits our precise needs, we can create a bespoke brush of our own.

Brush dynamics

No matter where we choose to use brushes, there are certain parameters that apply in all cases. We call these the brush dynamics. Here are the key ones that you will use increasingly as your skills develop.

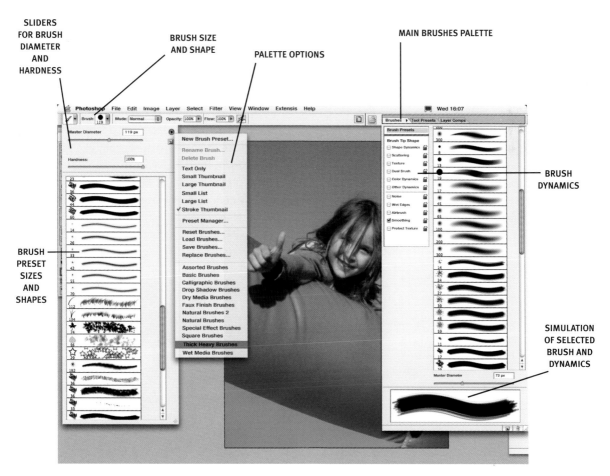

Fig 10 – The Brushes Palette: The extensive brush palette controls let us select any of an enormous range of preset brushes and also to modify any of these for a specific purpose.

Opacity This is a simple one. We can vary the opacity with which we paint (and for simplicity here we use the term "paint" even if we're using a tool or effect other than paint itself). At a low opacity we will build up density or apply an effect very slowly. When we use brushes to apply effects such as the traditional darkroom favourites of "dodge" and "burn" the term "opacity" is replaced with "exposure". We will look more closely at dodge and burn (the digital equivalents of the darkroom techniques for lightening and intensifying parts of an image) on pages 84 and 85.

Flow, wet edges and airbrush Photoshop used to feature an airbrush tool but, given the plethora of other techniques now available, it's been relegated to the dynamics palette. Here too you'll find other controls such as flow (which simulated the paint flow from a paint brush, becoming weaker the more you drag the brush) and wet edges. The latter gives the illusion that you've laid down a puddle of wet paint that's more dense at the edges (see fig 11).

Colour dynamics The colour dynamics comprise a set of controls that can be set to vary the colour saturation and brightness of a selected colour. This swathe of maple leaves (see fig 12) was produced by selecting the maple leaf brush and setting a modest amount of "jitter" for the colour, saturation and brightness. Though obviously not photographic, the result can be charming and informal.

The best way to understand the way brushes work in each of their incarnations is to experiment. Use them to overpaint your images in natural textures. Or create new artwork using some of the more esoteric brush types and brush dynamics.

CLONE AND RUBBER STAMP (FIG 13)

It has entered the realm of photographic folklore, but still it happens. You take a photograph that is well composed, perfectly exposed and "right" in every respect – until you examine the image later and find that your subject has a tree (or telegraph pole, flagpole or signpost) appearing to sprout from his or her head. The time when this caused a degree of merriment has long passed, especially when you have friends – or, worse still, clients – anxious to examine the prints.

Fig 11

Fig 12

Fig 13 – For many users the Clone tool is used to remove unwanted elements from a scene. Just imagine that otherwise chocolate-box country cottage blighted by a TV aerial or satellite dish, or spoiled by modern street signs and lighting outside. The Clone tool makes it easy to take adjacent parts of an image and obscure any offending subject elements.

But with digital techniques such problems are no longer of any significance. In fact, it was the ability to hide or (more impressively) move selected parts of the image that grabbed the headlines when the embryonic image-editing software first entered the public domain. Now the simple Clone tool (sometimes called the Rubber Stamp) has blossomed from a simple hide-or-move tool into a set of corrective and creative features.

The reason that cloning drew so much attention in the early days of digital image manipulation was down to the drama of the action. You could (as far as the lay person was concerned) take pixels from one place and magically drop them into a new location. Of course, this was neither magical nor was it an actual move. In cloning we merely copy the pixel values from one area and paste them to a new location. Where we perform the apparently impossible – removing an unwanted element from a scene – we are actually painting over it with background image elements and pixels copied from elsewhere in the scene (or even another scene).

HEAL AND PATCH (FIG 14)

While the public as a whole was being wooed by the magical abilities of the Clone tools, the more intensive users of early image-manipulation software were finding a more practical use: as a digital cosmetic. In fashion and commercial photography it was crucial that models in magazines and promotional material looked as near perfect as possible. Cloning would seem an obvious solution to achieve this – and it will work to a degree – but the delicate texture and equally delicate gradations in colour required for realism can make the operation very difficult. The slightest variation in texture or colour can mar the effect.

With traditional cloning techniques we could achieve successful results by careful use of the tool in concert with blending modes. For example, if there is a red spot or birthmark to obscure, setting the blending mode to Color before cloning ensures the brightness is unaffected but the colour is removed.

Circumventing this process, a newer variation of the Clone tool has arrived. Dubbed the Healing

Fig 14 – This charming portrait is, in every respect, perfect. But for the commercial market the small spot on her right cheek would not be acceptable. With the Patch tool we can select an area of unblemished skin from nearby and pull it over the spot. Instantly the spot disappears and her skin is flawless.

Brush in Photoshop, this is essentially a one-stop corrective tool that overcomes the shortcomings of the Clone tool for dealing with, particularly, difficult skin areas. With the Healing Brush we can paint with the texture of one part of the image over another, blending the new and original pixels together.

The Healing Patch tool takes this a step further. Using a Lasso you can select a region of clear skin, say, and drag this over a blemish. When you drop the patch into position the pixels are blended but in an intelligent way: dark spots and marks are diminished before being overlaid with the new texture. The result is a very clean repair.

SELECTIONS MASKS AND
CHANNELS (FIGS 15–17)

Though not selection tools per se, masks can be considered alongside them because the process of masking protects areas of an image from any effects enacted on the image as a whole. Only unmasked areas will be affected. Unmasked areas are, effectively, selections. Photoshop offers several masking tools, of which Quick Mask is an ideal adjunct to the selection tools. When you create a Quick Mask you can instantly convert it to a selection and back again.

This is a great way to produce complex selections that can't be produced easily with one of the selection tools. We've just seen that it's possible using the Boolean buttons on the Options bar to contrive selections that can be added to, subtracted from or even intersect with an existing selection. But sometimes even this is not enough.

Switch to Quick Mask mode and the original selection becomes a clear area on the image. The non-selected area has (by default, though it can be changed) a translucent red overlay. When we are in this mode we can see details of the selection that are not visible when the selection is marked by the dashed "marching ants" line. We can, for example, see feathered edges to the selection shown as a transitional area where the opacity of the mask diminishes in concert with the feathering.

More significantly we can now modify the mask by using the painting tools. We can choose a painting tool and, with black paint selected, add to the mask. Conversely, with white paint selected we can remove areas from the mask. Use intermediate greys for semi-transparent masking.

This is a potent way of refining the edge of a selection, particularly those made using the Magic Wand or Magnetic Lasso, which can often have a

slightly ragged edge. Choose a paint brush and paint with black paint and you can add to the mask. Paint with white paint and you subtract areas from the mask (that is, add to the selection).

We'll work more with the Quick Mask on page 98–100.

Alpha channels

We can also save a selection as an alpha channel mask, more often described simply as an alpha channel. This overcomes one of the problems with selections: they are transient and exist only for as long as the image is open on the desktop. Close the image and the next time it's reopened you have to start again. Even if you make a new selection in the image without closing, the prior selection is lost.

In some cases – where the selection is modest and easy to re-create – this is of little consequence, but if you have laboured long and hard, perhaps using multiple tools and the Quick Mask, then it can be much more frustrating. Alpha channels get us around this problem.

You can save a selection by choosing Select→Save Selection. The Save Selection dialogue prompts us to give the selection a name (see fig 18). You can have numerous selections saved for each image.

When you hit Save, you can open the Channels palette and see, appended to the conventional colour channels a new, alpha channel, illustrating your selection. The black area indicates that part of the image outside the selection (see fig 19).

Fig 15 – Selecting a boundary, such as the edge around this bird, is normally a role reserved for the Magnetic Lasso. With optimized control settings you can describe an accurate boundary.

Fig 16 – But zoom in and you'll see that some errant pixels have not been included in the selection and that some pixels in the background have also been appended.

Fig 18

Fig 17 – When we switch to Quick Mask mode we can instantly correct deficiencies by simply painting on more or less masking using black or white paint respectively.

Fig 19

When you need, at some later time, to reapply the selection, you can regain it by choosing Select⋯⟩Load Selection and then choosing the name of the alpha channel.

FILTERS AND EFFECTS

For many users of image-manipulation applications, filters and effects comprise a slightly frivolous aspect. While adjustments of tonality and colour could be described as corrective (even if such changes do more than compensate for shortcomings in the original image or scene), filters and effects tend to be perceived in a more jaundiced way because they distort (sometimes very literally) original scenes.

Part of the contempt in which filters and effects are held is due to the way they are often used. Newcomers to digital photography will often slap a filter on to an image and proffer the result as "art". To those with only a modest knowledge of digital imaging, the nature of the effect will be all too obvious and the artwork will be paid scant regard.

So should filters and effect be given short shrift and passed over for something more "serious"? No. Filters and effects can be extremely useful. The skill comes in knowing which ones are important and how they can be used to improve an image.

It's probably worth stressing here that there is a distinction between the filters we will be familiar with from traditional photography (some of which can also be used in the darkroom for creative effects) and those found in image-manipulation

applications. Filters here have a much broader interpretation and you'll find none of the effects you'll be familiar with from traditional filters.

Filter collections

All image editors feature extensive collections of filters and effects. To make navigation simpler you'll find them grouped into collections. Names for the collections may differ between applications, but in general you'll find the following.

Sharpen filters You can't regain the sharpness and detail lost through camera shake or incorrect focusing but you can improve the perceived sharpness in an image using these filters. You'll find several options, including Sharpen, Sharpen More and Sharpen Edges, but the Unsharp Mask is the only tool that we will concern ourselves with. This is a controllable sharpening tool that can be tuned to match the needs of the subject, ensuring that sharpness effects are applied only where required (see fig 20).

See more about sharpening on pages 152–154.

Blur filters The complement of the Unsharp Mask is the Gaussian Blur, a filter that lets us add a controlled amount of sharpness to an image. In this collection you'll also find options such as Motion Blur (which gives a streaked effect in the direction of implied motion) and Radial Blur (which is ideal for creating zoom and rotational effects). (See fig 21).

See more about blurring on pages 152 and 156.

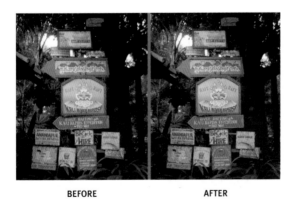

BEFORE AFTER

Fig 20 – The Unsharp Mask can't restore detail not recorded due to incorrect focusing or camera shake, but it can give the perception of sharpness in an image that is not critically sharp.

BEFORE AFTER

Fig 21 – Blur filters can help enhance depth of field and make good the tendency of some digital cameras to keep too much of a scene in sharp focus (check the background).

BEFORE AFTER

EXTRUDE EMBOSS

Fig 22 – Artistic filters can be rather obvious in their effect and demand careful selection and application for a convincing effect.

Fig 23 – The Extrude and Emboss filters (from the Stylize collection) are examples of extreme filters that are quite obvious in use. But even these have their place in your arsenal, particularly when you are creating graphic (rather than photographic) images.

Artistic filters Perhaps it's stating the obvious, but artistic filters give your images the look of being artwork rather than photographic. This may be by re-creating the image in the form of a watercolour or pastel drawing or the filter may just apply brush strokes. Used with care they can produce fine-art images. Overuse can lead to clichéd results. Many third parties produce specialized filters (artistic and otherwise) to extend the range. In Photoshop there are additional collections of Brush Stroke filters and Sketch filters (see fig 22). See more about artistic effects on pages 126–129.

Noise filters This eclectic collection of filters is designed to add noise (useful for adding texture to painted areas of colour) and remove noise, dust and scratches.

Distort filters Because digital images are essentially interpretations of numerical sequences, it becomes easy to apply operations to those sequences that can transform the image in a myriad of ways.

Further collections include Render filters (which feature a comprehensive suite of lighting effects), Pixellate (used for enhancing pixelation or creating mosaic-like images) and Stylize (which is another eclectic collection of very extreme effects). (See figs 23–24).

UNDERSTANDING HISTOGRAMS AND LEVELS

The histogram, which is displayed as a palette in Photoshop CS and is also the key feature of the Levels dialogue, is great for giving your images a quick health check. The bar chart graph shows the relative distribution of tones in the image, from

BEFORE AFTER

BEFORE AFTER

Fig 24 – You can use lighting effects filters to change the lighting of a scene either subtly or more overtly.

Fig 25 – The Lens Flare filter does what lens manufacturers have striven long and hard to combat: adds lens flare to an image!

Fig 26

Fig 27

black at the left through 255 levels of brightness to white at the right. In a typical image we would expect to see a constantly varying graph with entries at every one of the levels, rather like the one shown here (see fig 26).

The Photoshop CS Histogram palette can give us more detailed information, showing us how each colour component contributes to the distribution. Select the pull-out menu by clicking on the small arrow at the top right of the palette and then choose

All Channels view. We can now see the red, green and blue tonal distributions separately (see fig 27).

You can analyze the image in more detail by making a selection from the image using any of the selection tools; the histogram will change to reflect the new selection. We can also easily diagnose problems in the image. If the tonal range is compressed we will see areas at the extreme ends of the histogram that do not have any levels data and it will take on a compressed appearance.

We can restore full tonality to these images by using the Levels dialogue. Select Image⋯⟩ Adjustments⋯⟩Levels to open this dialogue. The histogram here is identical to that shown in the Histogram palette.

Adjusting the tonal range

Where an image suffers from a compressed tonal range (that is, it does not have a histogram that stretches from black through to white), we can make corrections relatively simply.

1. This image is lacking in contrast and has a correspondingly reduced number of levels (see fig 28). There are obvious parts of the histogram at the extremes where there is no data. This indicates there are no true blacks or whites (see fig 29).

2. Move the left and right triangular sliders beneath the histogram until they are under the start and end of the histogram curve respectively (see fig 30).

3. The image's tonality has been restored, with the lightest parts represented in white and

Fig 28

Fig 29

Fig 30

Fig 31

Fig 32

Fig 33

AFTER

BEFORE

the darkest shadows black (see fig 31). If we now check the histogram again we can see that the levels curve has been "stretched" to fill the whole width (see fig 32). When we stretch the original number of levels (which will be less than 255) to fill the full width of 255 there will inevitably be some levels that don't contain data. These are represented by the white vertical lines visible in this dialogue. Discrete empty values like these will have no effect upon the image.

4. The middle slider represents the midtones in the image. This can be slid to the left or the right to alter the tonal balance. This is a subjective adjustment.

Using the eyedroppers

We can also make corrections using the eyedropper icons. These additionally allow us to make corrections for the colour balance of the image. Click on the left eyedropper and then click on a point in the image that is (or should be) bright white. Do the same with the rightmost eyedropper and the blackest point in the image.

The middle eyedropper is used to identify a neutral tone in the image. This can be of any tonal value, but it is best to use one that is a midtone. Take care when selecting a neutral element; if the colour of the target point is not neutral you'll see the image take on a very severe colour cast. If this happens, don't panic! Click on another point (another neutral) and you've another chance. Here a slight magenta cast has been removed along with the improvement to the tonal range (see fig 33).

Modifying the tonal range for printing

Now that we've extended the image's tonal range, we've a problem. Though the images will display well on screen, when we print them we find that this range is too great for the paper to reproduce.

For this problem, use the sliders on the lower greyscale bar in the palette. Move them in a modest amount (around 10%). This will make the image appear to lack the edge in contrast when viewed on screen but will result in a better print (see fig 34).

High and low key

High-key images are ones in which the lighter tones predominate and where there are few, if any darker ones. The technique is often used in portraiture. In such cases, we will see a histogram that is missing components at the darker end of the graph but is well populated toward the right. Don't make any corrections to these images as restoring the tonal range will entirely remove the effect; similarly for low-key images, where dark tones predominate.

Note that overexposed and underexposed images will give similar graphs to high- and low-key images, respectively. Corrections are quite acceptable here.

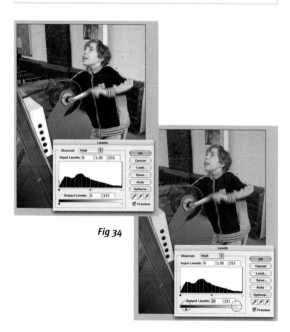

Fig 34

Fig 32 – Original Image

Fig 33 – Auto Levels

Fig 34 – Auto Contrast

Fig 35 – Auto Color

Using Auto Level and Color Correction (figs 32–35)

Listed in the Image⸱⸱⸱⸱⟩Adjustments submenu, just below Levels, are the tantalizing trio of Auto Levels, Auto Color and Auto Contrast. Photographers tend to have a somewhat ambivalent attitude toward these controls. On the one hand they offer a quick fix that circumvents the adjustment necessary with the Levels palette. On the other, their automated nature does not give sufficient leeway for image interpretation. They will apply an absolute correction irrespective of whether you wish a particular parameter to be corrected.

So should we give these a wide berth? No, as they are actually more useful than many photographers realize.

Let's take a look at the Auto Levels function first. This automatically adjusts the black and white points of an image in much the same way that we did when moving the sliders in the Levels palette. The lightest and darkest pixels of each colour are adjusted to become black or white. As a matter of course, the extreme ends of the histogram are clipped by 0.5% to remove any anomalous bright or dark pixels.

Auto Contrast works in a similar way for contrast. Auto Color adjusts both the colour and contrast in an image by identifying shadows, highlights and midtones. But it also neutralizes any colour bias in the midtones.

Do each of these corrections give nominally similar results? Here's an image that has been taken using a digital camera on fully automatic. We've then applied Auto Levels, Auto Contrast and Auto Color, individually. The results are indeed similar but still subtly different.

Though these controls offer a quick-fix approach, the way in which this fix is enacted can be modified by using the Auto Color Correction Options. You'll find this by clicking on the Options button on the Levels dialogue (see fig 36).

To customize these controls for your own use, this is what you need to do:

1. In the Algorithms pane, select an algorithm. Enhance Monochromatic Contrast will clip all the colour channels identically, which means there will be no modification of the colour balance; changes will be limited to making the shadows deeper and the highlights brighter. Enhance Per Channel Contrast treats each colour channel individually. This has the effect of producing a more obvious correction but at the risk of introducing a colour cast from channels that are more heavily modified. Find Dark and Light Colors identifies the lightest and darkest pixels and assigns these as the lightest and darkest parts of the image.

2. Click on the Snap Neutral Midtones button to identify automatically and use a neutral midtone for colour correction. This is the technique used by Auto Color as default.

3. In Target Colors and Clipping we can specify how much of the extremes of the histogram we want to clip. Nominally, as we've already mentioned, this is 0.5% but you may want to increase this amount if there is a greater amount of anomalous pixel levels at each end.

4. Assign colour values to the shadows, highlights and midtones by clicking on the box for each option in turn and choosing a swatch. If you want to use these new values for all future Auto commands, make sure that you click on the Save as Defaults button.

Now you've auto controls that will do just what you want them to. Okay, so the full manual approach will always give the most precise results (when used correctly), but the modified Auto controls will give much better results than the default settings on the same commands.

Fig 36

::DARKROO

DARKROOM EFFECTS – THE DIGITAL WAY

DARKROOM EFFECTS – THE DIGITAL WAY

In this chapter we will:

- **Discover how conventional darkroom techniques are implemented digitally.**
- **Examine the often overlooked but crucial aspects of perspective control.**
- **Produce a workflow sequence for correcting brightness, colour and contrast deficiencies.**
- **Take a look at a simple but effective way to boost colour in lacklustre images without introducing artefacts.**

Many people who make the jump from the conventional darkroom expect the digital equivalent to merely replicate the tools and effects that they have used in the past. While it is true that although in our digital world we can achieve very much more, many basic techniques are common. The reason is that these are fundamental to producing good images. Through this chapter we'll take a look at

these and discover how, digitally, we can extend and develop basic techniques.

CROPPING AS A COMPOSITIONAL AND CORRECTIVE TOOL (FIG 1)

It's surprising how little we crop images to improve composition. Composition, so the manuals tell us, should be established and refined at the time of taking the photograph. Though we may pay lip service to this principle, the truth is that, due to time constraints or other distractions, most of us don't. And even where we do compose our shots, discrepancies between the viewfinder and recorded image may still require some remedial action.

The Crop tool makes it simple to trim an image into any regular shape we require. And we can base this trimming on our personal preferences or on some simple and – in some cases – rather obvious rules. The caveat in all cases of cropping is that you need to bear in mind the original resolution of an image. If you want to crop away a substantial part of an image, what's left over may be of very low resolution.

Tips for cropping to improve composition (fig 2)

There are some "rules" for composition. Like most rules, obeying them to the letter can lead to rather predictable results. But it is good to be mindful of them nonetheless.

- Crop away any unwanted, distracting elements at the edge of the image.
- Don't let horizontal or vertical lines divide the image into two. It's better to position such lines off centre. This is a corollary of the Rule of Thirds (see page 74).
- It's usually a good idea not to place the principal subject dead centre in the image. The best place is to the left or right, above or below the centre line. This is a loose interpretation of the Rule of Thirds, a strict, but effective compositional device that originated with Renaissance artists (see box page 74, bottom left).

Fig 1 – You can use the rectangular Marquee or the Crop tool to select a crop area. The Crop tool has the useful benefit of dimming the cropped area, making it easier to concentrate on the composition of the selection.

ORIGINAL

Fig 2 – The original shot of some runners includes a lot of wasted space. We can crop this down substantially. As we noted in our rules, it's better to trim down in front of the subjects so that they appear to be entering the scene. This gives more impact than when we crop in front and behind equally.

CROPPED EQUALLY

CROPPED BEHIND RUNNERS

- The horizon should always be horizontal, verticals should always be vertical. The exception here is that if you are aiming to dramatize or emphasize the height of, for example, a building, you may need to tilt the camera back slightly when shooting so that the building's vertical sides appear to converge.
- Subjects – whether people or vehicles – seen in side view should have more space in front of them than behind: their position should imply they are entering the scene rather than leaving it.
- Be prepared to break any of these rules for deliberate and effective creative purposes. Rules represent good sense in image creation but don't necessarily extend creative thinking.

The Golden Section (fig 3)

The question often arises "what is the best format for an image?" Many people will say A4, or 25 x 20cm (10 x 8 in), mostly because they have become conditioned by the formats of commonly available photographic paper. Artists, architects and even philosophers over earlier centuries devoted a considerable amount of time to the question and, analyzing the greatest works of antiquity, arrived at the proportions of 1:0.618 as being the most pleasing. This they described as the Golden Section. You can see examples of it in ancient Greek architecture (the Parthenon is built on a sequence of Golden Sections, for example), medieval cathedrals and in many paintings. Should you use it for all your

Fig 3 – To assess the value of composing to the Golden Section, the photographer here has produced an overlay using a template in the proportion 1:0.618. This was created by making a new image of these proportions and adding a Stroke line (Edit⋯Stroke). This can be copied and pasted as a layer on to the new image.

photographs? No. Be guided by what looks best for each image. But you'll probably find most landscapes and portraits will have more impact when displayed at this ratio.

Rule of Thirds (figs 4 & 5)
One of the most overused but still very compelling compositional tools is the Rule of Thirds. This rule insists that we divide an image into three roughly equal sections horizontally and three vertically. Where the dividing lines intersect we place our principal subjects. Other important image elements – the horizon, for example – should follow these dividing lines.

LINEARITY AND PERSPECTIVE
Linearity – keeping vertical lines vertical, horizontal lines horizontal and each at right angles to the other – is crucial if you want to record accurately real world scenes. The ability to manipulate them makes it possible to correct errors – or exaggerate them for dramatic effect.

Unless aiming for the deliberately creative or absurd, when photographing a scene we are endeavouring to make an accurate record. But it is all too easy to compromise that accuracy in a way that becomes obvious only when we see the shots in print or on our computer screen – a sea horizon, which should (by definition) be horizontal, tilts drunkenly, and buildings swagger across the landscape in precarious ways that would defy engineering.

Even when we exhibit utmost care there can be issues beyond our control. We may use a level to ensure the camera is mounted accurately square on to a horizon, but the vertical sides of buildings will often appear to lean inward toward the top. We call this effect converging verticals and it is, for conventional optical systems, inevitable.

Tilted horizons and leaning verticals
Of course the simplest way to achieve perfect linearity is to spend a few more seconds at the viewfinder. Many digital cameras' LCD viewing panels feature vertical/horizontal overlays that can

Fig 4 – Cropping this image has placed the principal subject at the intersection of two dividing lines.

Fig 5 – Even when we crop to a square shape, we can introduce more impact by using the Rule of Thirds. Here it is the pup's eyes that define the intersection.

Fig 6

Fig 8

Fig 7

Fig 9

be used to ensure that principal lines in the image are accurately aligned. But when we don't have the luxury of this time – when we are going for those grabbed shots – or when we don't realize our error, there's a simple digital solution to correct the deficiency.

1. Identify the approximate amount of tilt. We can drag a vertical or horizontal guideline from the edge of the image frame to overlay, say, the horizon (you can toggle the visibility of these guides by selecting View····}Show····}Guides) (see fig 6).

2. Select Image····}Rotate Canvas····}Arbitrary. A dialogue box opens and prompts us to suggest an amount of rotation. Here 2 degrees clockwise should be sufficient (see fig 7).

3. Apply the rotation. Check, using the guideline (which will remain horizontal) that the rotation has been successful. If not, repeat with another rotation amount (fractional degrees are

permitted) (see fig 8).

4. Trim the image to remove the additional border areas that have been introduced by rotation (shown in blue on the previous image) (see fig 9).

The Measure tool can also be used to correct tilted images – as we demonsrated with skewed scans on page 43.

Go for colour

After you rotate an image it is enclosed by a new rectangle. It's much easier to trim away the rotational triangles if they're shown in a bright colour rather than the normal black (the default background colour). Change the background colour to blue, as here, and accurate trimming becomes a cinch.

Fig 10

Fig 11

Fig 12

Fig 13

Converging verticals

The problem of converging verticals has plagued photographers since the earliest of days. An in-camera solution is provided by tilt-and-shift lenses. Because converging verticals are due to the tilting of the camera (so that the recording medium is no longer parallel to the subject), which often occurs when you tilt the camera back to include the top of a tall building, these lenses allow the camera to be held squarely to the building. Rather than tilting the camera back you shift the lens upward – a process that involves shifting the optical path through the lens – to ensure the full height of the building is recorded.

The drawback with these lenses is their high cost. In the large, old-style plate cameras, in which a flexible bellows separated the lens and camera body, shifting the lens relative to the film was simple, but with solid cameras, such as those today, achieving this same effect requires a dedicated and expensive lens.

For those who could not afford this specialist lens, the darkroom provided an alternative correction facility. Enlargers can be equipped with tilting baseboards (on which the photographic paper is placed) that can counteract image convergence. Only limited corrections could be made in this way, however, as there was a risk that – unless a very small aperture was used on the enlarger lens – the image would become progressively out of focus the more the baseboard was tilted.

The digital solution to convergence is altogether different and uses a variation of the simple Crop tool. The Crop in Perspective option lets us trim the image and correct the distortion. Here's how.

1. Bear in mind that the correction removes some of the surroundings of the scene. If you are aware of this when shooting the image, leave

larger margins than you might otherwise (see fig 10).

2. Select the Crop tool and ensure the Perspective button is checked. Drag the Crop selection over as much of the image that you can. If you plan to crop the image slightly at this stage you can make an appropriately smaller selection now (see fig 11).

3. Click on the top corner points of the Crop selection and move them inward so that the sides of the Crop selection converge to the same effective point as the verticals in the image (see fig 12).

4. Hit the Okay button to apply the crop. You'll notice that the areas outside the crop are discarded, but also that the shape of the selection – which was trapezoidal – has been corrected to rectangular. In this way our converging verticals have also become "true" (see fig 13).

Fig 14

Working in two dimensions

The Crop in Perspective tool gives you free range to correct perspective problems in two dimensions. You can rectify a rectangular image element no matter what shape it adopts in your images.

1. We can apply this to three-dimensional objects too. Let's use Crop in Perspective to get a square-on view of this desk (see fig 15).

2. Apply the Crop tool over the area of the desk and, as before, drag the corners so that the sides of the cropped area correspond to the vertical and horizontal dimensions of the room (see fig 16).

3. Perform the Crop. We get a square-on view. Notice that the image has become slightly softened by the process. In "stretching" the image to the new dimensions there has been a degree of pixel interpolation. To correct this you could apply a modest amount of Unsharp Masking (see pages 153–154). Don't sharpen too much or you will generate digital artefacts (see fig 17).

Using the grid (fig 14)

Gauging the degree of convergence is difficult to do objectively but you can overlay a grid on your image that makes identification simpler. In Photoshop, select View····⟩Show····⟩Grid. This grid appears only on screen; it will not print or be saved with your image. You can change the look and number of lines comprising the grid in Photoshop Preferences.

Fig 15

Fig 16

Fig 17

In the following example we can see how the Crop in Perspective feature differs in its results from a transformed selection:

1. This is the image we want to correct. We want to crop in on the horse shop sign. The photographer originally took the photograph at an oblique angle because she realized that converging verticals would compromise an upright shot (see fig 18).
2. The simple way to trim the image would be to draw a rectangular selection around the sign and then rotate the selection using the Transform command. The result looks okay, but the sign is still at an oblique angle (see fig 19).
3. Using Crop in Perspective we can correct all these angles and get a square-on result. Although the sign is still obviously up high we get none of the foreshortening or distortion produced by a simple trim (see fig 20).

It's important to make a crop in a single move. If you realize after cropping that you have either over- or underestimated the corrections, use the step backward facility to undo your error and repeat the trimming again. Repeated use of perspective cropping causes too much pixel interpolation leading to a lowering of image quality.

MANIPULATING BRIGHTNESS, COLOUR AND CONTRAST

Brightness, contrast and colour modifications were a staple of darkroom manipulation. By mainly using filters and by making exposure compensations (either generally or selectively) we could improve colour rendition, correct uneven exposure and remove colour casts. Digitally, we can do all this and more.

The simple way to make corrections to the brightness, contrast and colour of an image is to use the basic commands such as Hue/Saturation and Brightness/Contrast. Each can make a great improvement to deficient images. But it is better to see each of these corrective measures in the context of overall image improvement.

Establishing a workflow

When you have a potent tool set at your disposal, as Photoshop and other image-manipulation programs offer, getting the right tool for the job can require a little thought. It can also be tempting to make minor, ad hoc adjustments using one or more tools. To make our work efficient and to ensure that we don't compromise image quality (which is always a risk when working haphazardly with multiple controls) we need to establish a logical workflow. This will also ensure that we don't apply techniques or make adjustments at one point that conflict with others

Fig 19

Fig 19

Fig 20

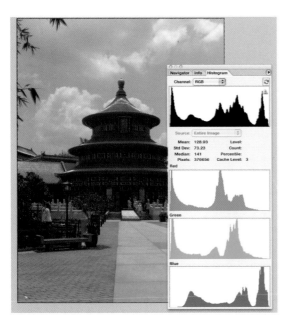

Fig 21

we may make at a later stage. As a step-by-step process, here are the key stages.

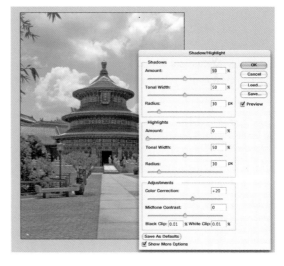

Fig 22

1. Any analysis will begin with the histogram (see pages 68-70). Here we can study the tonal range of the image in each of the colour channels for any obvious flaws that need attention. Here this image shows (both visually and by studying the histogram) a blue colour bias and compressed tones (see fig 21).
2. We need to remove colour casts and adjust the colour saturation, if necessary. This is where things could get tricky as there are more than 10 different features in the current Photoshop release concerned with colour modification. They are detailed in the side panel (see side panel on page 80). Some, like the Auto Color command, will take care of much of the guesswork but at the cost of an ultimately non-rigorous correction. Others, such as Channel Mixer and Curves, offer a baffling amount of control. It's a good idea to stick with a core set: Hue/Saturation, Replace Color and Color Balance, say, to begin with, as these will serve the majority of needs. Explore the other options as opportunities arise (see fig 22).
3. Adjust tonal range using the Levels command. Adjust the input sliders (those immediately

Fig 23

beneath the histogram) as we discussed earlier. The balance between shadow and highlights can be adjusted using the Shadow/Highlight command (Photoshop CS). The Shadow/Highlight command here has lifted some of the darker shadows and darkened some of the overbright areas (see fig 23).

Fig 24

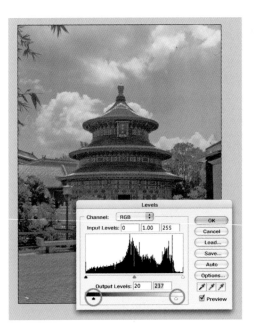

Fig 25

4. Sharpen the image. It's often said that sharpening should be the final stage of any process, but in this case we need to apply any necessary sharpening prior to making any adjustments to the levels. This is because the sharpening process can often produce small (and acceptable) image artefacts that could fall outside the printing or display gamuts (the range of colours that can be successfully printed or displayed) (see fig 24).

5. Levels adjustments. To prepare our corrected image for print we now need to adjust the output sliders (the lower set) to reduce the levels of the extreme highlights and shadows so that they can be accurately printed (see fig 25).

There will, of course, be exceptions to this workflow. For example, when we look later at some remedial corrective work on old photographs we'll see that it would be difficult – where the print is faded – to make accurate colour judgements without first adjusting the tonal range. So in these cases we would reverse steps 2 and 3.

Tools for adjusting colour

Photoshop offers numerous tools for adjusting colour – some we've already explored. Here's a summary. Each has their uses and benefits and they are ranked here in alphabetical order:

- *Auto Color* A quick-fix tool that corrects overall colour balance in an image. You can fine tune the method employed to correct colour balance – see page 96
- *Channel Mixer* Used to modify the individual colour channels and make unique colour changes.
- *Color Balance* Allows the mixture of colours in an image to be changed manually using complementary colour pairs.
- *Curves* Enables the input-output correlations of colour and brightness to be varied by reshaping the curves graph.
- *Hue/Saturation* Permits the hue, saturation and brightness (lightness) of the image to be adjusted manually. A drop-down menu allows selective corrections to individual colours.

- *Levels* Allows the pixel distribution to be adjusted for individual colour channels and for colour biases to be corrected.
- *Match Color* A feature introduced in Photoshop CS that matches the colour balance of one image with another, or one layer with another. Colour ranges and luminance (brightness) are also adjusted. A great way of equalizing colour balances between image elements used in montages.
- *Photo Filter* Simulates the effect of solid-colour photographic filters, mostly equivalent to the Kodak Wratten series; ideal for correcting colour balance problems with daylight/indoor film stock
- *Replace Color* Replaces user-specified colours across an image or selection with new colour values.
- *Selective Color* Allows the amount of process colours in an image to be varied.
- *Variations* The simple visual version of Color Balance that enables changes to be made by comparing thumbnails.

Channel Mixer (figs 26–32)

The Channel Mixer command can appear somewhat abstruse in the way it affects images and severe in its application. But its operation is logical if you appreciate the result of moving the sliders. You can drag any source channel's slider to the left to decrease its contribution to the output channel or to the right to increase it, and you can view the results live on the image.

The Constant slider will add a black or white channel to the mix (moving to the left, black, to the right, white). This will be interpreted as an overall colour cast of the colour of the input channel.

Corrective measures will normally only involve small adjustments to the settings (10 % or less), but larger corrections can produce wilder colour

Fig 28– Result of applying large channel adjustments.

Fig 26 – Original image.

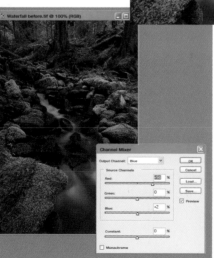

Fig 27– Channel Mixer dialogue.

Fig 29 – Result of a more subtle adjustment.

Fig 30 – Colour image prior to conversion to greyscale using Channel Mixer.

Fig 31– Greyscale image produced with Channel Mixer, optimized to render blues and reds dark.

Fig 32 – Simple greyscale image produced by desaturating the original image.

changes, as here, that are hard to duplicate using other tools. Perhaps most significantly, or perhaps ironically, the Channel Mixer comes into its own for producing greyscale – black and white – images. You can alter the contribution of channels to the greyscale image to produce results that emulate the sensitivity of specialized monochrome films, such as orthochromatics and even infrared.

UNSHARP COLORATION

Boosting the colour saturation in an image is something that has long been exploited. The travel industry, particularly, has been an exponent of the technique, realizing that it could achieve greater interest in its holiday destinations if it depicted them in supersaturated colour. The perfect blue skies and vibrant landscape colours prove too tempting to consumers burdened by predominantly overcast weather.

This is a technique we can all use to add interest to shots that are a little washed out. It would also seem a simple process: open the Hue/Saturation dialogue and nudge the Saturation slider until we get the desired result. But, sadly, the results produced in this way rarely prove satisfactory, with coloured artefacts generated and an unpleasant graininess affecting image quality.

Much of this is due to the small-scale structure of the image. Look very closely at the pixels in an

image and you'll see that, even in broad areas of constant colour, there is a degree of variation. And there will be anomalous pixels of colours totally at odds with the main. Boost colour saturation and these colours become rather more prominent.

This problem is exacerbated if we subsequently attempt to sharpen the image. Anomalous colour gets treated by the sharpening routines as image structure, with the net result of enhancing (in a negative sense) these artefacts. Add to this the probability that there will be compression artefacts (which further enhance colour variation) and you can see that we need to find an alternative solution if we are going to enhance successfully the colour in digital images.

A better alternative is to use unsharp coloration. It's not a technique you'll find in most imaging dictionaries, but it is one I've found works particularly well over a range of subjects and colours. Here's how we can apply it to shaded scene to give more memorable results.

1. Our start point – a fine array of tulips – should be spectacular, but shaded light in a marquee gives rather dull results and colours that are less saturated than we would expect in full sunlight (see fig 33).
2. Begin by creating a copy of the image in a new layer by selecting Layer····⦂Duplicate Layer. We will

be increasing the saturation in this layer copy of the image (see fig 34).

3. Increase the saturation of this layer using the Hue/Saturation dialogue. You can increase this by between 10 and 20 %. Don't worry if results look rather garish, but don't increase the saturation so much that coloured artefacts appear (see fig 35).

4. Apply the Gaussian Blur filter to the layer. Aim to blur the image so that the form of the subjects is still visible but the details are obliterated. This will vary according to the resolution of the image, but start with a setting of between 5 and 10 pixels (see fig 36).

5. Using the pull-down menu on the Layers palette, change the blend mode of the layer from Normal

to Color. Now only the saturated colour of the layer is blended with the background. We have the saturation of the layer and the sharpness of the original (see fig 37).

6. Adjust the opacity slider on the palette until you have a saturation level that is appropriate. Compare the saturated image with the original to ensure you don't end up with an oversaturated result (see fig 38).

Why does this work? The blurring masks all the colour variation, giving smoother gradations. Although blurred, the new colour layer appears to our eye as a close match to the original. Only under the closest inspection do we see colour extending beyond the boundaries.

Fig 33

Fig 34

Fig 35

Fig 36

Fig 37

Fig 38

Going further

Sometimes you can boost the colour in your image using unsharp coloration in this way and still not achieve a satisfactory result. Remember you are only boosting the colour that already exists in the image – if that colour is insufficient or is not appropriate, boosting it could make matters worse.

Skies often prove to be the most contentious of subjects. Boosting a pale sky will always give more saturated results, but if the original tone is tainted – say, by high cloud or even poor colour rendition in the camera – you may need to take more drastic steps:

- You could select the sky (using the Magic Wand) and then the Hue slider (from the Hue/Saturation dialogue) to alter the colour to a more appropriate one.
- Replace the sky using a colour gradient. Select two colours, a deep blue for the sky and a slightly lighter one, making the deep blue the foreground colour. Then draw a gradient down the selected sky area using the Gradient tool.
- Replace the sky using a skyscape from a different image. We do this for an image shown on page 105.

DODGING AND BURNING

If there is a darkroom technique that could be described as a "classic" then it must be dodging and burning. It has long been used by photographers to overcome the limited dynamic range in printing media. When faced with an original image (usually a negative) with a high dynamic range between highlight and shadow areas it would prove impossible to print the image and retain subject detail in both. But by increasing exposure of the printing paper in certain areas those parts of the image could be darkened (burning, or burning in). And by reducing exposure of the paper (often by shading it with the hand or impromptu screening tools) areas of the subject could be lightened – or dodged.

Photographers needed to use their skill, experience and judgement to get good results because they were working blind – not in total darkness but with only a latent image on the paper. In the digital world we are more fortunate – we can see the results of our actions immediately and, unlike our predecessors, can backtrack if our actions have been misplaced or are too severe.

Although we can reduce dynamic range using these tools it's still important to get the exposure right when taking the photograph. Highlights, for example, if washed out cannot have any of the original detail restored by any amount of burning.

Fig 39

Fig 40

There is simply no detail there to burn in.

The Dodge and Burn tools operate in three modes: Highlights, Shadows and Midtones. You can select the relevant mode from the Options bar. In the default setting, the Dodge tool will operate in the Highlights mode and burn in the shadows.

1. Dodging and burning is all about making a good thing better. Here's a great portrait taken against the light but with some foreground reflection. The nature of the reflection means that there are some modest but essentially unflattering shadows. We'll begin by lifting there. Select the Dodge tool and set the exposure to no more than 10 %. Anything more than this will produce very abrupt corrections (see fig 39).

2. Let's turn our attention now to the midtones. Use the selector on the Options bar to select Midtones and continue to work on the shadows in the cheek and the area under the eyes. Again, use a low exposure and multiple strokes to build lightness in the shadow areas (see fig 40).

3. Finally the highlights. The neck is disproportionately dark, as are the areas around the nose. Lightening these slightly makes for a more even result. Better? I think so (see fig 41).

The Sponge tool

A spiritual cousin to the Dodge and Burn tools (though not one that featured in the conventional darkroom worker's arsenal) is the Sponge tool, sometimes called, more descriptively, the Saturation Sponge.

This has the same brush attributes as the Dodge and Burn tools but can be set to Saturate or Desaturate, and the rate at which it works is set using the Flow option.

If you are working in Greyscale mode, the Saturation Sponge increases or decreases the image contrast when applied.

Fig 41

Fig 42 – The Highlight/Shadow command helps even the apparent exposure in scenes with a high dynamic range. Here the child, lit from behind, has been lightened without compromising the colour or contrast.

Highlight/Shadow command (fig 42)

Auto-correction tools were provided with a new fix not unlike dodging and burning with the release of Photoshop 8. It is called the Highlight/Shadow command. This automatically evens the exposure across an image, lightening shadow areas and suppressing overbright highlights. Recognizing that automatic corrections are not always appropriate, there is also a dialogue that accompanies the facility to vary the parameters of the command.

BLACK AND WHITE

Black and white photographs differ from colour in that it is form and texture, rather than colour, that dominate the images. Many photographers consider black and white a more significant medium because of this: it needs us to view a scene more subjectively and see through what we might call the chromatic veneer. It is rather contentious to say – as many exponents of black and white photography do – that black and white images are somehow more powerful and more significant (their words, not mine). I would rather we put down the difference to one of preference. Many people, myself included, like taking colour images but also enjoy conceiving black and white ones, too.

Whatever the reasons or philosophy, how do we get black and white images from the colour ones produced by digital cameras? There is a surprising range of options. Which you use depends on the amount of control you need over the final result and the time you wish to spend on the conversion process. Here are our options ranked from fastest to slowest, in terms of speed of action. As we will see, as we convert this image of fishing boats to black and white, speed is inversely proportional to quality (see fig 43).

Desaturate (fig 44)

The Desaturate command is instantaneous in its effect. It merely strips away the colour information in the image, leaving only the brightness information. The result is certainly black and white and the image shows a full contrast range. Yet the image is unremarkable. We might equate this to machine-printed black and white imagery: technically correct but without emotion.

Greyscale and Lab Color (fig 45)

Change the Image Mode (Image⋯⟩Mode) to Greyscale and you'll get a similar result to desaturate. The Lab Color mode will split the image into four channels, but rather than the conventional (if you use the default RGB mode) red, green and blue you'll get Lightness, a and b. Click on the Lightness channel (in the Channels palette) and you'll get a black and white image. Again, similar to Desaturate but with slightly less flat results.

Channels (figs 46–48)

If we don't change mode and remain in RGB, we can split the image into the channels that correspond to viewing the scene in red, green and blue light. In red light, red objects look bright and blue and green dark; likewise for the other channels. We can then split the image into the constituent channels. The red channel is ideal for dark skies (in the same way that we would use a red filter in black and white photography), but the blue channel gives very pale skies. Noise – and artefacts due to image compression – is often very significant in the blue channel.

Fig 43 – Original colour image.

Fig 44 – Desaturated original.

Fig 45 – Greyscale image.

Fig 46 – Red channel.

Fig 47 – Green channel.

Fig 48 – Blue channel.

Channel mixing (fig 49)

In splitting the image into channels we are getting results that could be described as more "interesting". But, when you inspect the individual images separately you'll probably conclude that the best black and white image might contain the sky of the red channel image, vegetation of the blue channel and red objects viewed in the green channel. It's possible, you probably won't be surprised to hear, to combine elements of each channel using the Channel Mixer dialogue

Fig 49 – Lightness channel.

Fig 50

Fig 51

Fig 52

Fig 53

(Image····⟩Adjustments····⟩Channel Mixer).

Click on the Monochrome box and adjust the sliders to mix the channels. There's no right or wrong with regard to the settings, but you'll get best results when the arithmetic total of the channel values adds up to around 100. Here we've set Red to 65, Green to 50 and Blue to -20.

THE HISTORY BRUSH –
AND THE HISTORY PALETTE

The History Brush is a difficult tool to categorize. It's one of the unsung heroes of digital image manipulation. It made its appearance with little fanfare in one of the later incarnations of Photoshop but ask many users – even those who use Photoshop daily – what precisely it does and how it works and you'll get a look of puzzlement. Which is something of a shame as this is a very powerful tool indeed.

It is best explained by describing its companion, the History palette. Every action you perform in Photoshop is recorded. And each action is also displayed, sequentially, in the History palette. Not only does this give us a convenient overview of the stages of your manipulation, but it also allows us to backtrack. If we arrive at an image that doesn't look entirely as we intended, we can click on a previous history state and return the image to that state. You can think of it as a shortcut through multiple levels of Undo. The number of History (or Undo) steps is finite. You can specify the number in the Preferences but specifying too many can compromise computer performance – each state needs to be stored and takes up a lot of your computer's resources.

The History Brush lets us backtrack in the same way – but selectively. Set the History Brush to the required state by clicking on the small icon next to the appropriate history state. Now, when we paint with the Brush (having selected any paintbrush type or opacity) we paint with pixels from the image at the corresponding historical state. Here we use the History Brush to modify an image's depth of field. This is something we would normally do using a combination of selection and blurring tools (see chapter 10), but is something we can achieve simply using the History Brush. In this example we can emulate the look of a Soft Spot filter.

1. This image, taken with a compact digital camera, shows a commendable depth of field. As such, it does not give sufficient emphasis to the subject (see fig 50).
2. Begin by blurring the entire image using the Gaussian Blur filter. This is a useful blurring tool because we can precisely control the amount of blur applied (see fig 51).
3. We now need to make the subject sharp. We could have used a mask or selection to protect the area,

but by using the History Brush we can get a more gradual build-up of sharpness. Click on the History state of the image prior to blurring (see fig 52).

4. The finished image has the sharpness of the original restored. Those regions near the subject have been partially sharpened, giving a soft-focus result (see fig 53).

Don't change the scale

There is a caveat to the History Brush. It won't work if, at any point between the current state and that which you want to paint from, you've changed the scale of the image. The History Brush, though powerful in effect, only actually copies pixel values from the historical state to the corresponding pixels of the new state. Change the scale and this correlation becomes impossible.

The Art History Brush (figs 54–56)

Photoshop, ostensibly a tool for the photographer, also panders to the needs of artists who might want to use images as the basis for their work. Photographers, in general, shy away from some of these overtly artistic effects because of their dubious photographic merit – too much of the original image can be lost. The Art History Brush is one, but as it offers considerable control it is worthy of mention in a darkroom title. In fact, results can emulate those of Polaroid-based media.

Unlike the History Brush you don't need to specify a particular history state before painting, but you do need to ensure that you are working with an 8-bit image. You can set this in the Image⋯⋗Mode submenu.

Now just paint away, selecting a painting type from the Options bar. There are no rules about how to paint, but the best results seem to come by using a broad soft brush first and then painting over using a finer brush, which restores some of the final detail.

Fig 54 – Choose a simple image as your original as these tend to work better than more detailed ones. Landscapes and portraits are more effective than city or industrial scenes.

Fig 55 – Applying a broad brush gives a rather bland, mottled result, but it is a good basis for further work.

Fig 56 – By painting over the initial broad-brushed canvas we can restore some of the finer detail, but it still gives a great impressionist look.

IMPROVING SELECTION TECHNIQUES

IMPROVING SELECTION TECHNIQUES

In this chapter we will:

- **Look more closely at the practical use of selection tools.**
- **Study ways of making selections more precise or more effective.**
- **Examine masks and extraction tools more closely.**
- **Gain an understanding of ways to modify and transform selections.**
- **Explore practical examples of effective selections.**

"Simple but effective" is a term often used to describe the selection tools. Often, however, the practical emphasis is on the "simple". That's the line we've taken so far but to really understand and exploit these tools we need to discover more about how they work. We also need to understand the circumstances in which they don't deliver the results we might expect.

EXPLORING THE SELECTION TOOLS
The Magnetic Lasso

Though the Magnetic Lasso was something of a late entrant to the selection tool arsenal (in Photoshop, if not other applications) it has rapidly become the default option for many users. It's easy to see why: it makes selections simple – just drag around the edge of your intended selection and the job's done. And you don't even have to hold a mouse button down. You simply draw around the perimeter.

The mechanics of the tool are such that you need define only a start point, then you can release the mouse button. As you describe the perimeter of the selection, anchor points – fixed points along the selection edge – are automatically added. You can also add additional anchor points manually by clicking with the mouse, or you can remove anchor points (such as those that have anchored

themselves to a point other than on your chosen course) by pressing the backspace button.

For anyone who has used the Magnetic Lasso, this description will sound simplistic. True, this is an easy-to-use tool but, unless you are very fortunate, it's unlikely that you'll be able to make a selection precisely matching the border of your subject first time. As the tool does not detect an edge as such – rather, it detects an area of high-contrast change (which normally signifies an edge) – it can be fooled when your intended edge is low in contrast. Here's a typical selection that might be appropriate for the Magnetic Lasso (see fig 1). We want to select this girl but we don't want any of the background.

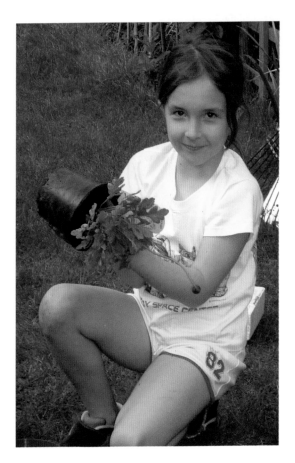

Fig 1

Fig 2

Fig 3

Fig 4

Fig 5

1. Begin to make the selection by clicking on a convenient point at the edge of the selection. Drag the Lasso along the boundary (you don't have to follow it precisely – even if you are a few pixels away, the Lasso's selection line will "jump" to the nominated edge. This is easy when following the boundary between the white shirt and grass, and the girl's face (but a forced anchor point has been placed at the inner corner where face and shirt meet to ensure the corner remains crisp. (see fig 2)

2. When we get to the hair, the contrast levels fall and it becomes harder for the Magnetic Lasso to determine which course it should follow. Though it makes a very good guess, it is clearly off the mark in quite a few places. We can overcome the problems here either by making extensive use of forced anchor points (clicking frequently around the selection boundary) or we can reduce the Edge Contrast level in the Tool Options bar. Set a lower level and edge detection will be more precise under these conditions but it will also be more sensitive to edges generally – and it can still follow the wrong edge (see fig 3).

3. When we come to the white box behind the girl, the contrast between the box and the grass is greater than that between the box and the girl's shirt, so this is the course the Lasso instinctively follows. To make it adopt the intended path we need to anchor the first point manually on the boundary between the box and the shirt; after this the lower-contrast edge here will be detected and followed (see fig 4).

4. Where there's a number of different paths the Magnetic Lasso could jump to, you can increase the Frequency on the Tool Options bar. Now the Magnetic Lasso will analyze the image area for edge contrast more frequently. This will make it more likely to follow a precise course and less likely to "jump" to a more obvious course that may be nearby. Here we can even select the plant this girl is holding, even though it is the same colour as the background and exhibits very small contrast changes from the background (see fig 5).

Magnetic Lasso summary

- Set manual anchor points to secure the path where there is a risk of error (such as sharp corners or multiple possible paths).
- Use the default Edge Contrast setting as a matter of course, but reduce it for accurate determination in low-contrast areas.
- Set the Frequency control to a higher level where there is low contrast or multiple paths. This will increase the frequency of analysis, thus making it easier to follow indistinct paths.
- If the overall selection is difficult using the Magnetic Lasso, don't be afraid to add to the selection using a different tool.

Fig 6

The Magic Wand

Perhaps second only to the Lasso in terms of use, the Magic Wand is a great selection tool for those selections that comprise areas of constant colour. So far we've identified where to use this tool and the basics of how it works. But, like the Magnetic Lasso, successful use requires a little more understanding of the mechanics of the tool's operation. It also requires awareness of small-scale detail in the digital image.

When using the Magic Wand it's possible to be a little blasé. We see, for example, an area of clear colour and click on it. By refining the Tolerance setting we can apparently append the whole of the coloured area with one, or perhaps two, clicks. But when we then apply the effect for which the selection has been made, we are often disappointed to find that, at the macro scale, our selection has not been as effective as we might have thought.

To understand this we need to look closely at an image. Here's a flower that has broadly similar coloured petals (see fig 6).

We can make a selection using the Magnetic Wand tool. Because of colour variations we need either to adjust the Tolerance setting or add to the original selection to achieve what appears to be a complete selection of the coloured area (see fig 7).

We can now use the Hue/Saturation control to change the colour. Immediately we notice that, although the hue change is effective, there is a problem – some of the original colour is still visible (see fig 8).

Move in a little closer and the nature of the problem is revealed. There are isolated pixels that were not visible in the original selection that still retain the original colour; by our original selection criteria they were not selected at all (see fig 9).

The reason is simple: at pixel level there is noise and random fluctuations in colour that push individual pixels beyond the permitted tolerance. And if we have stored our image as a JPEG we are likely to find that the

Fig 7

Fig 8

Fig 9

Fig 10

- Append any pixels that remain by using the Smooth command. We'll explore this later in the chapter.
- Always try to use the smallest Tolerance value possible. In the same way that we can "miss" some pixels so, with a high tolerance (and with the Contiguous option turned off) errant pixels that fall within the tolerance range outside the main selection can end up being appended.

compression regime has introduced other colour artefacts that similarly create pixels that are outside of our colour range. Here's a close-up of the original image showing some of these exceptional pixels. (see fig 10)

It's important to recognize that many areas of apparently continuous colour are, in fact, quite pronounced colour gradients. Clear blue sky is an obvious example (and one that we tackle in this book) where both the colour saturation and tone can vary imperceptibly but sufficiently to require multiple selection with the Magic Wand tool.

Magic Wand summary
- If you want to ensure only those pixels of a single subject are selected, make sure the Contiguous option in the Tool Options bar is selected; otherwise you will select pixels from throughout the image.
- Use Color Range (see the following section) in preference to Magic Wand if you want to select pixels partially for transparent effects.
- If you want to select colours from the current layer of the image only, make sure that the Use All Layers button is not selected; to base the colour selection on all the layers in the image, make sure the option is selected.

The soft touch

You can smooth the hard edges of a selection to make composites more effective. The key tools for this, which can normally be selected from the Tool Options bar, are Feathering and Anti-aliasing.

Feathering We've discussed feathering already (see page 58). It's the process that blurs any sharp edge by creating a transitional gradient over a number of pixels that you determine and describe as the feather radius.

When you enter an amount in the box on the Tool Options bar, this amount will be applied to any selection that you subsequently make. If you have already made a selection but have not specified a feather radius (or have specified an inappropriate amount) you can enter an amount retrospectively using the Select⋯⟩Feather menu option.

Anti-aliasing The anti-aliasing function is designed to smooth jagged edges of a selection that occur as a direct consequence of the pixel nature of an image. Because an image comprises discrete pixels, close inspection of an edge will reveal the stepwise transition. Apply anti-aliasing and the colour transitions are softened. This affects only the edge pixels and hence there is no radius that can be specified. You must also specify this option prior to making any selection, as it cannot be applied afterward.

Color Range

When we use the Magic Wand command with the Contiguous option not selected, pixels throughout the image that correspond to the tolerance level set will be selected. The Color Range feature (Select···➤Color Range) is an evolution of this command that lets us specify a certain colour but vary the tolerance more easily, by using a Fuzziness slider. The more fuzziness we specify the greater the tolerance and the more pixels that are appended to the selection.

We can use the Color Range command to select a specific colour (or colours) from within a current selection or from an entire image. Here's how we can exploit it for making precise selection.

1. Open the dialogue box by choosing Select···➤Color Range. The Color Range dialogue box will open. Be sure that you don't have a selection active on the image if you want to make a new selection using this command (see fig 11).

2. Click on one of the two radio buttons. Clicking on Selection will display a thumbnail only of the selected pixels as we create our selection. Click on Image if you want to preview the entire image. This is useful when working with large images and you want to select a colour or region that is not currently displayed (see fig 12).

3. Click on the area (or colour) that you want to preview. You can do this either on the image itself or the dialogue box thumbnail (see fig 13).

4. Use the Fuzziness slider to increase or decrease the range of colours appended. The crucial difference between Fuzziness and Tolerance is that increasing the tolerance amount will increase the range of colours that are fully selected, whereas the fuzziness control can partially select pixels that are at the extreme of the fuzziness scale. This can lead to smoother results when effects are applied to the selected pixels (see fig 14).

5. We can now modify the selection using the eyedropper tools on the dialogue box. To add colours (which can be similar to the original selection, or different) click on the plus eyedropper and then the selected colour. Remove colours by selecting the minus eyedropper and then clicking on the colours to remove (see fig 15).

6. Once we have made our selection we can click on the OK button to apply the selection to the image. We can also save this colour range for later use (much in the same way that we can save a selection made by any of the selection tools) (see fig 16).

7. When we now apply our effect to the selection it will be applied to the pixels including any transparent pixels. This simple blue fill (which is unlikely to be the effect we would actually apply, but helps clearly to illustrate the results) shows this, with partially selected pixels taking on a blue hazy appearance (see fig 17).

Fig 11

Fig 12

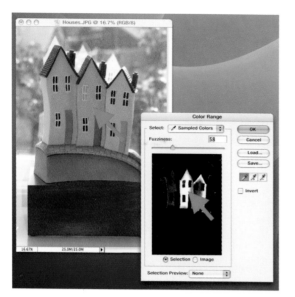

Fig 13

Fig 16

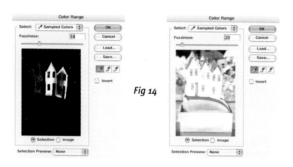

Fig 14

Fig 17

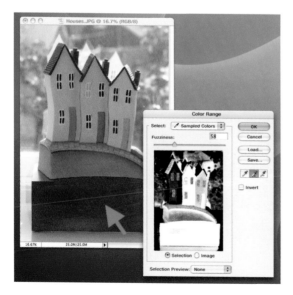

Fig 15

Modifying selections

The Modify option in the Select menu provides four additional tools to modify your selection further. These are Border, Smooth, Expand, Contract.

Expand and Contract are likely to be the tools that are used most. Select either of these and you'll be prompted to enter the number of pixels by which you want a selection expanded or contracted. The selection boundary will be increased or decreased by the appropriate number of pixels, measured radially out from the geometric centre of the selection.

Fig 18

Fig 19

Fig 20

Fig 21

selection boundary and that defined by the border amount remains selected. This command is more useful for presentational use rather than for refining a selection. You can, for example, use it to give decorative keyline around a selection, as shown here (see figs 20 & 21).

THE QUICK MASK

The selection tools, between them, do a great job of making selections simple, but there will always be cases where, even when they are used in combination, they will not provide the ideal solution for you. The Quick Mask feature is designed to work with the selection tools to make selections more precise. Once we've made our approximate selection using whatever combination of selection tools we wish, we can switch to Quick Mask and see our selection represented by a mask. It is then comparatively simple to adjust the mask, adding to or subtracting from it, to modify our selection.

Using Quick Mask

Selecting people in an image is often a difficult job for the selection tools. Colours vary too much to use the Magic Wand and the edge contrast is too low for the Magnetic Lasso. You can add to this the difficulty of capturing both smooth edges (represented by clothing) and softer edges (such as hair). We can use the Quick Mask here to select the subject of this informal portrait (see fig 22).

1. Rather than painstakingly using the Lasso tool to describe the edge of the subject, draw a loose selection around the subject. This really can be very approximate. Try not to cross over on to the subject but if you do, don't worry – you can correct the error later (see fig 23).
2. Click on the Quick Mask button on the toolbar. The area outside our selection is now shown with the characteristic red masking tint. (You can double click on the Quick Mask button to open the corresponding dialogue box, where you can

Contract is the more useful. It's ideal for removing the colour fringing that often results when a selection is made from a subject standing against a strong, contrasting colour. The edge pixels inevitably incorporate some of the pixels that are discoloured by the background colour. Contracting the boundary by just one or two pixels can remove this colour fringing without any obvious effect on the edge of the subject itself (see fig 18).

The Smooth command is ideal for cleaning up selections where there are stray pixels that have not been included in a selection. Every selected pixel is analyzed to find any adjacent pixels (within the specified radius) that have not been selected but fall within the specified tolerance range. Then, if the majority of pixels are selected, any remaining ones will be appended to the selection. If there are more unselected pixels than selected, the selected pixels become unselected. The net result is a smoothed selection. Here (see fig 19), those pixels of similar colour to the main selection have been appended, while the boundary of other selection areas have been smoothed.

The Border command produces a frame around a selection with a width corresponding to a specified number of pixels. After applying the command, only the area corresponding to that between the original

change the density and colour of the mask. You can even change the shading to cover the selection rather than the unselected area). (See fig 24).

3. Now we can make our selection more precise. Select the Paint Brush tool and a hard-edged paintbrush. In Quick Mask mode the paintbrush will add to the masked area when painting with black, and remove the mask when painting with white. If you select an intermediate grey area you will partially select pixels, giving a semi-transparent mask. Gently add to the mask in those areas where the selection needs a harder edge. Adjust the size of the brush to attend to finer details (see fig 25).

4. Switch to a soft-edged brush to refine the selection around softer parts of the image, such as hair and loose-textured fabric. Use a fine brush for this, otherwise you risk the transparent area at the selection boundary being too large. This would result in any effect applied to the selection also affecting this area of the background, which, ideally, you would not want affected (see fig 26).

5. Once you've completed the selection, switch back to Normal mode by clicking on the button next to the Quick Mask button. You'll see your new selection displayed by the usual marching ants. This may not look entirely as you expected: where you used the soft-edged brush, or if you used a grey paint colour, the selection boundary will actually indicate that part of the image where 50% or more pixels have been selected (see fig 27).

Fig 22

Fig 23

Fig 24

Fig 25

Fig 26

Fig 27

Fig 28

Fig 29

6. If you are happy with the selection, now is a good idea to save it. This means you'll be able to recall it in the future and if you accidentally deselect it at any point, choose Select⋯Save Selection. Give the selection a name and you're done. Your selection will be displayed as a new channel (an alpha channel) on the Channels palette (see fig 28).

7. Now you can proceed with the modification or manipulation that prompted the original selection. In this example, to add prominence to the girl the photographer has reduced the colour saturation in the background surroundings and added a little blurring (see fig 29).

When not to use Quick Mask

The Quick Mask is an expedient method of honing a selection, but it tends to work best when a selection is being made to apply an effect to part of an image. It is not necessarily a good tool to use when you want to select an image element for use in a montage or collage. Because of the way the soft-edged brush and painting with greys handles transparency, when you select in this way colour and texture from the edges of the original image will be transferred to the montage. For a more effective treatment of image elements in montage work, use an image-extraction utility, such as Mask Pro, Knockout or even Photoshop's Extract. We'll take a look at this option on page 102.

SELECTION BY PIXEL REMOVAL

So far, our selections have been based on defining those pixels that will comprise the selection and then applying an effect to those pixels or copying them to use in another image or composite. But we can also isolate a selection by removing unwanted pixels. That is, deleting any pixels that are not required for the selection. Clearly this very destructive method is best applied to a copy of an image rather than the original copy.

We'll explore two similar tools for doing this semi-automatically – Photoshop's Extract commands and Extensis's Mask Pro. But we'll begin with the simpler (and somewhat rudimentary) Eraser tools.

The Eraser tools

The standard default eraser is a simple tool that tends to belie the power on offer with other variations. Apply it to a single layer image and it'll rub away image pixels to reveal the currently active background colour. Apply it to a layer in a multi-layer image and it will rub through the layer to reveal the pixels of the layer – or layers – beneath. You can also rub back to a previous history state by clicking on the button in the Tool Options bar. The only other controls here are Opacity and Flow to determine how

much of each layer is removed when the brush is applied (see fig 30).

Option 2, the Background Eraser, is a quick way to remove the background to a subject. It deletes all those pixels that match the colour of the Hot Spot. When we select a brush size for the tool, the Hot Spot is indicated by a cross at the centre of the brush. As we brush the Eraser around the edge of a subject the colour of the background will be picked up by the Hot Spot and the corresponding pixels deleted. Though effective in subjects such as that shown here (see fig 31), the Background Eraser is less successful where the subject itself contains colours similar to those in the background. In this case the tool will not isolate the subject.

Extending the concept of the Background Eraser, the Magic Eraser works rather like the Magic Wand. When we click on part of the background all those pixels of a similar colour (and those that fall within the Tolerance set on the Tool Options bar) will be selected and deleted. We can click multiply to delete further arrays of pixels, as shown here (see fig 32). Assuming that the background colours are exclusive to the background, we can quickly delete the background to leave, in the case of a single-layer image such as this, just a transparent background.

With the Magic Eraser it's usually safest to leave the Contiguous box selected. When unselected, pixels throughout the image that conform to the tolerance will be deleted.

Fig 30 – The default Eraser deletes pixels of the currently selected layer through to the underlying pixels, or background. But as a selection tool it's rather fiddly and it's not the most practical.

Fig 31 – As the Background Eraser is passed around the edge of this building the Hot Spot picks up the blues, whites and greys of the sky and deletes all corresponding pixels to isolate the building and landscape.

Fig 32 – The Magic Eraser quickly deletes areas of background but can, particularly if the Contiguous button is not selected, also append parts of the subject; it then becomes an indiscriminate tool. Here (see right), roof tiles that match the grey in the clouds have been identified and deleted.

Fig 33

Fig 34

Fig 35

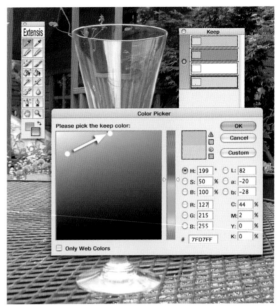

Fig 36

MASK PRO

Mask Pro from Extensis is an ideal tool if you spend a lot of time extracting subjects from backgrounds and find Eraser tools imprecise. It scores in being able to extract subjects accurately no matter how difficult. It's even reasonably simple to extract transparent objects. This glass, for example (see fig 33) – we can remove the background that here not only surrounds the subject but is also visible though it.

1. Begin by selecting the green Eyedropper. This is the Keep Eyedropper and defines the colours in the image that we wish to retain. Click with this on one of the most prominent parts of the glass (see fig 34).

2. Next, click on the New Color button in the Keep Colors palette to add a new blank colour swatch. Click on another colour in the glass. Repeat with any further colours. Be careful not to select colours that are in the background and visible through the glass (see fig 35).

3. Click on each colour swatch in turn and, when the colour picker opens, increase the colour saturation. This will ensure that only those colours that are in the glass are kept, not those that may

Fig 37

Fig 38

Fig 39

Fig 40

Fig 41

also be in the background (see fig 36).

4. Now repeat this process, but using the Drop Color Eyedropper and selecting those colours that feature in the glass that you want to remove (see fig 37).

5. Take the red Drop Highlighter from the toolbox and draw around the glass, as close as possible without actually touching it. The closer you can get the better, but err on the side of caution – if you stray on to the selection you'll need to start again (see fig 38).

6. The background can now be removed. Select the Magic Brush and brush over the selected area and around it. The background will, as the tool alludes, magically disappear. If the disappearance is not complete you may need to refine the Magic Brush

by adjusting the sliders. Move the Threshold and Transition sliders to the right. (see fig 39)

7. You can now copy your image to the new image. When in place on this new image, the transparency is obvious, but the distortion normally caused by the thickness of the glass is not present (see fig 40).

8. To render the image more convincing, a square of the background immediately behind the glass was selected and copied into a new layer, between the background and glass layers. The Transform tools were used to push this into a triangular shape to mimic that of the glass. In situations such as this, it can help to return to the original image to check on how transparent objects distort light (see fig 41).

Fig 42

Photoshop's Extract (fig 42)

Photoshop boasts its own image-extraction tool that does a fair job of emulating much of that achieved by Mask Pro. You'll find it under the Filter menu heading. You extract subjects using a similar highlighter pen to Mask Pro to define the colours inside the selection. Edge touch-up tools can then be used to refine the selection boundaries. It's easy to use but I've never found it as comprehensively successful in performing difficult selections as Mask Pro. But it does come free with Photoshop and is worth experimenting with.

SELECTION MASTERY:
NEW SKIES AND REFLECTIONS
Assessing skies

When it comes to applying a new sky to an image I like to assess the scene to see which of three difficulty classes the image falls under.

Images in class 1 I regard as those having a crisp horizon and the sky limited to only one continuous area. In this class you don't have to worry about discontinuous areas – parcels of sky visible through foliage, for example – nor are there any reflections (either in water or windows) to worry about. We can make a simple selection of the sky and paste in our new one. Cityscapes are perhaps one of the few subjects that fall into this class (see figs 43 & 44).

Class 2 adds that discontinuity mentioned above and is probably the most common type of image requiring attention. Most landscapes can be found here because even if there is a distant tree-lined horizon you will find small areas of sky visible through the branches and these will need to be appended to any selection. Failure to do so will be all too obvious. You also need to be attentive to the edge of your selections. Natural subjects tend to have a softer edge. When you make a selection of the sky in this case, you can leave an intermediate edge that has colour and tone that falls between the original sky colour and that of the landscape. Expanding the selection by 1 or 2 pixels is often sufficient to prevent this, but take care: any more can isolate clumps of foliage and maroon them in the new sky (see figs 45–47).

Fig 43

Fig 44

Fig 45

Fig 46

Fig 47

Class 3 adds reflections to the equation. In principle, this should never prove difficult but realism depends on how you interpret the reflection. You will need to position it accurately with respect to the horizon and also allow sufficient texture from the original surface to show through. No reflection is truly mirror like. The following example illustrates how we handle a class 3 reflection.

This example makes great use of the Magic Wand tool and shows the effectiveness of layer masking. We'll take this image of a bright, colourful landscape with a rather lacklustre sky and introduce a new sky (see figs 48 & 49). As there is water in the scene, we will also have to ensure that we provide a "new" reflection.

1. Begin by selecting the sky. Select the sky area to the left of the tree using the Magic Wand with a Tolerance setting of about 40. Ensure that the Add to Selection button is pressed and add to the selection until the entire area of the sky to the left of the tree is selected (see fig 50).

Fig 48 – Our new sky.

Fig 49 – Original Landscape.

Fig 50

Fig 51

Fig 52

Fig 53

Fig 54

2. Use Similar (Select····}Similar) to append all similar pixels in the scene. This will select the remaining parts of the sky, including those non-contiguous regions that are visible through the foliage and branches of the tree. It also appends the reflection of the sky in the river; remove this from the selection by using the Lasso or Rectangular Marquee to encircle all of this area, with the Subtract from Selection button pressed (see fig 51).

3. Open the image containing the new, "donor" sky, Select the entire image (Edit····}Copy), and then paste it into the selected sky area in the landscape. It's important that you use Edit····}Paste Into rather than Paste. Paste Into creates a mask over the unselected parts of the image and allows the sky to be seen only in the selected area (see fig 52).

4. The skyscape was slightly small in resolution terms than the landscape, so it will need to be stretched to fit. Use Transform····}Scale to widen the image to fill the full width of the landscape's selection. It's normally not recommended to enlarge an image to fit a selection, but here the sky contains little detail that could be compromised by the action (see fig 53).

5. Look closely at the image and you will see that the tree is rather ragged. This is an artefact of the Magic Wand selection process. It is rather abrupt in selecting or not selecting pixels, leading to this very rough outline. Click on the mask in the layers palette and soften the edge using the Gaussian blur filter. This will give a more natural edge to the mask and make the result more natural (see fig 54).

6. Choose Deselect (Select····}Deselect) to remove the selection and select the area of the river that is reflecting the sky. Do this in the same way as in steps 1 and 2, but this time deselecting the sky area that gets selected again by the Similar command (see fig 55).

7. Invert the sky image to create a mirror image reflection of itself. Do this by selecting Image····}

Fig 55

Fig 57

Fig 56

Fig 58

Fig 59

Rotate Canvas⋯⋗Flip Vertically (see fig 56).

8. Copy and paste this into the selection. You will need to adjust the width again and also move the sky vertically so that the reflected area represents an accurate reflection of our new sky. Soften the edges of the selection (which again are somewhat abrupt) in the same way as we did for the tree – using the Gaussian blur on the mask (see fig 57).

9. Our reflected sky looks too obvious at the moment. We need to make it adopt something of the texture and form of the river. To do this, use the Layer palette-opacity control to make this sky semi-transparent by moving the slider to the left. You'll have to use your own judgement as to what is the best; around 50–70% is often about right (see fig 58).

10. Because you still have all the layers preserved in the image, along with the masking, you can change the position of the sky image (and, consequently will need to reposition the reflection) by clicking on the appropriate thumbnail and using the Move tool to reposition. You can also change the opacity of sky and reflection or vary the saturation of each to better mimic the landscape's colour and saturation (see fig 59).

Fig 60

Fig 61

Fig 62

Fig 63

TRANSFORMING SELECTIONS

Once we've made a selection we can copy it, paste it into another part of an image or even into an entirely different image. We can also apply transformations to the selection. We've already touched on transformations when, for example, we transformed a crop to compensate for perspective effects (see page 76). But the Transform tools allow us to do much more than this. Over the next few pages we'll explore how we can manipulate a selection to rebuild an image and also how we can combine the Transform tools with Pasting tools to produce composite images.

The red car: reflective transformations

At a classic car show a photographer took a picture of the front of this red car (see fig 60). It's a good image that has been selected because it will be a great way to illustrate, in Chapter 10, the Radial Blur filter. However, the car's right-hand engine cover has been raised, making this an implausible image to use to illustrate motion. But can we digitally close the cover? Of course!

1. As the image of the car has been taken pretty nearly square on to the front we could take the left hand engine cover and manipulate it to produce a symmetrical reflection. Select the engine cover using the Rectangular Marquee. In fact, to copy accurately all the elements needed we would have to use three intersecting Rectangular selections, as shown here, with the new selection pasted in its own layer and dragged to the new position (see fig 61).

Fig 64

2. We can use the Transform tool to convert the selection from a left-hand piece to a right-hand one. Select edit····}Transform····}Flip Horizontal. This produces the required piece to mask the open engine bay (see fig 62).

3. Drag the new piece, using the Move tool, into position. At first glance it looks like a perfect fit but closer inspection of the edges shows the alignment is not perfect on all sides. We could use the Transform tool again, this time selecting other modes, such as Skew or Distort, to make the match better, but as the inaccuracies are minor we can attend to them later using the Eraser tool (see fig 63).

4. To complete the job we've now also copied over (and reflected) the lower dashboard, to hide the engine cover section that rises above the bonnet

line. In addition, to prevent the symmetry being too obvious the Smudge tool has been dragged over the new bonnet cover to blur the reflections. As a final fix, the car's rear-view mirror has been made complete by copying one side to the other (see fig 64).

The Transform tools

In the Transform submenu you'll find the following options. Here's an overview of what they do.

- *Scale* This changes the scale of a selection and it is useful for refining the size of a selection to make it better fit its new location – but take care not to overly enlarge a selection as it will lose resolution very quickly.
- *Rotate* This rotates the selection about a central axis. Grab any corner with a mouse and drag it around to the appropriate position (see fig 65).
- *Skew* Using this option you can push or pull the horizontal or vertical axes to create trapezoidal shapes (see fig 66).
- *Distort* Here you can push or pull horizontal and/or vertical axes to change the perimeter of the selection in any way (see fig 67).
- *Perspective* This allows you to achieve perspective corrections or exaggerations (as when using Crop in Perspective).

Fig 65

Fig 66

Fig 67

Fig 68

Fig 69

Fig 70

Back to the drawing board

Here's an example (see fig 68) that uses the Transform tools more fully, both in freeform mode and also when pasting into selections.

Fig 71

Our source image in this case is a girl sitting at an architect's drawing board. By the end, we'll make it look as if she has used this board as the basis of a painting and also give a view from the window that corresponds to the painting.

1. Use the Lasso tool to select the surface of the drawing board. Switching to Polygonal Lasso is the easiest way to select this areas. This image of dolphins is the one we will be placing on the board, although clearly it is not now in the correct form for the effect to be convincing (see fig 69).

2. Select the image of the dolphins and use the Paste Into command on the drawing board image to paste the image into the selection. Only part of the image will be visible. Select Image····⊁ Transform····⊁Distort. An outline of the full image will be visible with adjustment handles (corner and mid-line points) for reshaping the selection (see fig 70).

3. Push and pull the handles until the shape of the selection matches that of the drawing board. It's probably better to make the selection slightly larger; this will prevent any problem of the drawing board surface appearing at the edges (see fig 71).

4. As an additional flourish, a pen has been placed in the girl's hand. This was done by drawing a fine rectangle selection and then filling it with a grey/white gradient. There's no need to be too precise with this as it will be very small in the final image (see fig 72).

5. Now we can turn our attention to the view through the window. We need to select all the glass areas of the window panes. The Polygonal Lasso is ideal for this, aided if necessary (as it was here) by switching to Quick Mask mode to refine the selection (see fig 73).

6. Here's the image that we'll be pasting behind the windows. Don't be put off by the strange composition. Remember this is not meant to be an image in its own right, but merely part of the backdrop. All that we do need to consider (and

make adjustments for if appropriate) is that the colour balance is similar to that of the rest of the image. For this we can use the Color Balance or Match Color commands (see fig 74).

7. We can now repeat the Paste Into process to incorporate this image in the scene. We can switch to the Move tool if necessary to adjust the position of this image. There's no need to use the Transform tools here because we were careful to ensure that perspective issues were taken care of prior to compositing the image. By looking at the Layers Palette we can see how the layers have stacked, and also the masking that has been applied to achieve the composite (see fig 75).

8. The final image. No, it does not exist in reality, but it could. And that is the secret of successful digital imaging (see fig 76).

Fig 72

Fig 73

Fig 74

Fig 75

Fig 76

::EFFECTIV

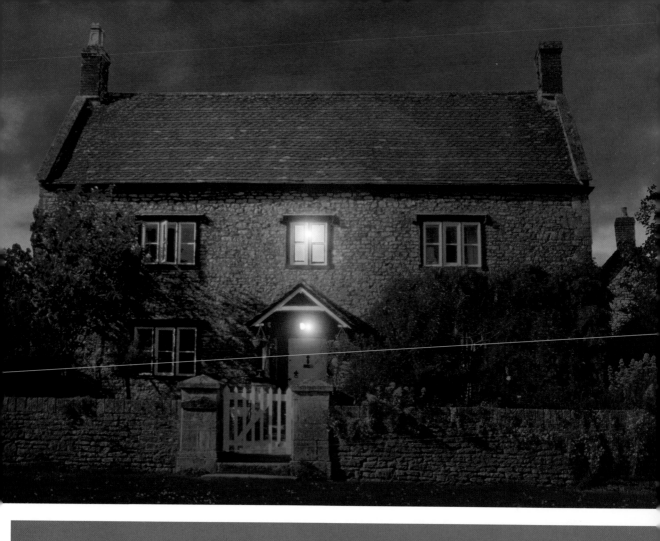

EFFECTIVE CLONING

EFFECTIVE CLONING

.::EFFECTIVE CLONING::.

In this chapter we will:

- **Undertake a complete image repair and modification using the Clone tools.**
- **Examine more ways of cloning pixels for creative purposes.**
- **Look at solutions for more expedient image repairing using Clone tools.**

The Clone tools, as we've seen earlier (see pages 60–61), are remarkably potent and for many people represent the key feature of image manipulation. But an understanding of the tools is only part of the process. As with using all corrective tools, part of the process involves a thorough and complete analysis of the image and having a vision for what the end result should be. We'll explore the mechanics and ethos of cloning in the following project – The Country Cottage – before looking at what other ways we can exploit the concept of cloning.

CLONING PROJECT: THE COUNTRY COTTAGE

It may be a cliché, but the Clone toolset comes into its own when we attempt to manipulate images of traditional landscape scenes. Take a good look around and you will find plenty of those idyllic scenes that, superficially, could be described as "chocolate box". On closer inspection, however, many show at least some of the scars brought about by time and "progress". And we are not talking just about the natural decay that sometimes adds charm to the scene. It's the deliberate changes – some say disfigurements – brought about by the need to provide electricity, telephone lines, TV transmitter masts, satellite dishes and so on, along with the painted lines and street furniture of contemporary urban life, which all seem to conspire against the beauty of the landscape.

So when we take on a project like this our work is certainly cut out for us and what's called for is a period of evaluation. We need to assess what needs to be done and whether, in the case of cloning tasks, we have the means to achieve all our corrections.

Some scenes could defeat us not through any lack of skill or the appropriate manipulative tools, but because we don't have sufficient material to achieve our objectives. If, for example, a stone wall is so disfigured by spurious accoutrements that these is insufficient remaining that can be used to clone from, then what do we do? With a paucity of source material we may have either to accept the damage (and perhaps effect only minor corrections) or possibly use another image with similar structure to apply corrections.

Let's examine a real image – one that is perhaps typical of many we may find in picturesque villages. At first sight this image appears pretty much all right (see fig 1). But look closer and we begin to notice that as well as the obvious airborne wiring there is a collection of TV aerials attached to the chimneys and also a number of cables crossing the roof and dropping down the front wall of the house. We may not be able to see the underground water supply pipes but their presence is betrayed by the signs against the front wall. Not immediately obvious is the new house to the left of the building, clearly of twentieth-century vintage.

Fig 1

Fig 2

Fig 3

Fig 4

Fig 5

A close-up of the left chimney stack (see fig 2) shows the amount of paraphernalia that will need to be removed if we are to restore the cottage to what might be described as its original state. Fortunately, although there appears to be a significant amount of ironmongery on the stack there is sufficient undisturbed image structure to make cloning possible.

By taking a section of the chimney stack below where the aerials are fixed as our "clone-from" point and using these to paint over the aerials themselves, we can easily remove these (see fig 3). If we were to examine the image very closely we would see that we've repeated the clone-from point a couple of times but, given the small size of the stack in the image, this is not of any consequence. Sometimes we fall on our feet and discover that chimneys feature several caps or pots – making it easy to clone one from another.

Removing the wiring at the front of the house involves cloning from nearby brickwork using a soft-edged brush. Fortunately in this case, the brickwork is actually fairly haphazard so we don't have to worry about matching up courses of bricks (as would

be the case if the brickwork were more regular). It helps to zoom in to the area being worked on. Then we would see, as here (see fig 4), that there are shadows cast by the security light that also need attention by cloning if a completely convincing effect is to be achieved.

The signs indicating the water supply hydrants can be given a similar treatment – selecting a nearby part of the wall and cloning from it. We need to be careful about alignment to achieve a clean – and level – edge to the wall in the area we are hiding. If we are not sufficiently precise here it would be a sure sign that manipulation had taken place (see fig 5).

You might have wondered why we have not paid any attention yet to the telephone and electricity wires criss-crossing the scene. In fact, removing these is rarely the simple task you might think; the sky, which appears constant blue in colour, actually varies in colour over very small distances. Because this change in colour is steady we don't really notice it. But start cloning over the cables using pixels from close by and you will quickly see the problem. So, instead, we will attend to this as part of the bigger

Fig 6

Fig 7

Fig 8

task of removing the modern house – we'll replace the entire sky along with the house.

Use the Magic Wand tool to select the sky. Make sure that the Contiguous button is left unselected. In this way we can also append those pixels that are visible through the foliage in the tree to the right of the image. Now, also append the house to the selection (using, say, the Lasso tool). We can switch to Quick Mask mode to check that we have appended all the region that we wish (see fig 6).

When we are happy with the selection it's time to apply a new sky. This could be a different "real" sky culled from another image or, as in this case, a simulated sky (see fig 7). For the foreground and background colours, sample the real sky colours from the top of the image and that closer to the horizon

respectively. Then use the Gradient tool to apply a gradient over the selected area. The result is a new, clear blue sky. Often a pure painted result looks too obviously false so it's a good idea to use the Noise filter to add a little realistic texture to the sky area.

We are now in the home stretch. We've removed all the clues that indicate that the picture was taken in the present day, but there is still a somewhat incongruous roadway outside the front gate. Wouldn't the house look better presented if it were to be placed in a meadow? Unfortunately this is a situation where we can't use extant imagery to clone over the foreground. But, fortunately, there is another image containing some meadow grassland that was easily transplanted by cloning from that image on to the one being worked on here. Only a modest amount of colour correction was then needed to give a convincing effect (see fig 8).

Alternative interpretations

It is only occasionally that cloning alone produces a final result. Rather, cloning is more often used to give a partial means to an end. In the case of our cottage example, the photographer not only wanted to remove unattractive and modern intrusions, but also wanted to show the scene at different times of the day.

In this first case the replacement sky, rather than being artificial, was taken from a photograph taken in mid-afternoon. No other changes have been made, but the atmosphere to the shot has changed from the morning freshness of our original composite (see fig 9).

For the next interpretation, the sky has been replaced with that from an evening scene (see fig 10). To compensate for the change of sky, the photographer also slightly altered the colour balance. Using the Color Balance command, the Midtones were adjusted to increase the yellow and the Shadows adjusted by increasing the blues.

Finally, in a much more obvious change, a late-evening sky has been substituted (see fig 11). This time the foreground has been heavily modified. To give a moonlit effect the Blue Omni lighting effect (Filter⋯⟩Render⋯⟩Lighting Effects) has been applied, adjusted to give offset illumination. The room lighting was achieved by selecting the window

panes and then painting them with a yellow paint. The lighting uses the Lens Flare filter applied with a modest setting to give a convincing amount of scattered light.

Fig 9

Fig 10

Fig 11

BETTER PORTRAITS WITH THE PATCH TOOL

We've seen how the Heal and Patch tool can be use to remove spots and blemishes (see page 62), but the Patch tool has another string to its bow: it can be used to clean up those snatched portraits to correct blemishes we either missed or are beyond our control.

This charming wedding portrait (see fig 12), which has been taken to illustrate how accessory reflectors can help illuminate an image, in this case a Lastolite reflector, would look fine in any album, but can we make it even better? By now, we know that the answer is obviously: "Yes".

Clearly the subject has been standing for some time in the heat of the sun as her skin has taken on a mild amount of shine. There are also some minor wrinkles and folds (which I'm sure she would not mind losing) and some spots (see fig 13). We can use the Patch tool to remove all of these. Best of all, that patch of clear, perfect skin on the subject's chest provides an ideal "clone-from" area. This is a terrific bonus as well as the stumbling point for many Patch corrections.

1. Let's begin with a simple correction – smoothing out the skin on the woman's lower lip. After selecting the Patch tool, describe a shape on her chest that approximates the shape of the lower lip and then drag this patch into position (see fig 14).

2. Position the patch close to the lower lip, but not overlapping it. If you do overlap an area such as the lip, or perhaps some strands of hair, then the colour of this area will be incorporated into the average for the patched area, and the result is unwanted discoloration (see fig 15).

3. Now repeat this process to create patches to go under each of the eyes. Again, take care when moving the patch not to contaminate the colour by positioning it over the eyelashes. You can worry less if you move over, say, the bridge of the nose or the outline of the jaw (see fig 16).

4. A shiny nose and shiny cheeks can be treated in exactly the same way (see fig 17).

5. Finally, some tidying up involves removing spots and ensuring that skin texture is consistent throughout (see fig 18).

6. Though it has nothing to do with the cloning tools, we can finish off the photograph by applying a soft-focus effect. This is something covered in more detail on pages 160-1, but it's a useful trick to add a romantic feel to an image (see fig 19).

Fig 12

Fig 13

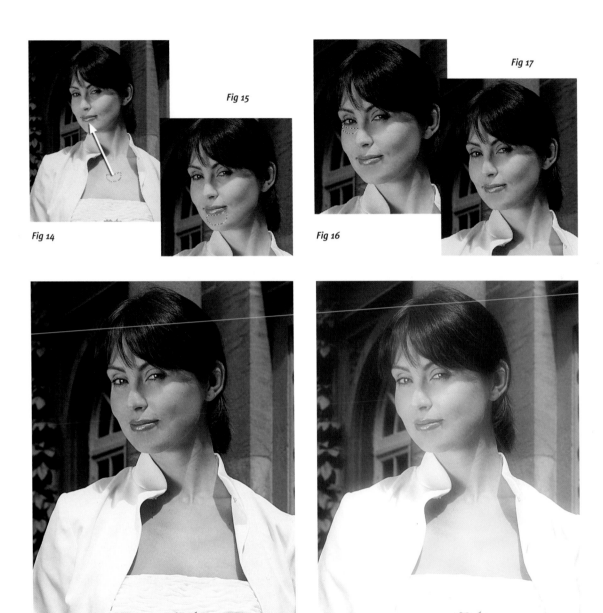

Fig 14

Fig 15

Fig 16

Fig 17

Fig 18

Fig 19

CLONING WITHOUT THE CLONE TOOL

That cloning is a powerful feature of image-manipulation software is without doubt. But beyond the obvious Clone and Rubber Stamp tools there are other opportunities to clone – either to conceal problems or to be more creative.

The History Brush, for example, lets us clone on to the current version of the image using pixels and elements from a previous history state. This is extremely useful if you need to reapply a texture or scene element that has been modified or removed when applying subsequent processes.

The "Erase to History" mode of the Eraser tool actually lets us repaint an image with those pixels from a previous history state (that is, at a stage prior to our most recent manipulations) by returning selected pixels to their previous state. It's important to recognize that you can't clone pixels from another part of the image using this technique, only restore pixels to their previous colour or tone.

Fig 20 – The Impressionist option of the History Brush lets you clone in an artistic way from a chosen history state.

Those who retain their older versions of Photoshop (5 or 5.5) when upgrading will have an additional tool at their disposal – the Impressionist option of the History Brush. This allows (or allowed) a previous history state to be used to clone and paint to give the allusion of being hand painted. Fortunately for devotees, the feature lives on in Photoshop Elements (see fig 20).

The Color Replacement tool (fig 21).

Hidden from the sight of all, apart from the most curious of Toolbar explorers, is the Color Replacement tool, which you'll find sharing a position on the bar with Heal and Patch. Despite its fanciful name, it is nothing other than a red-eye remover. Many applications provide red-eye removing features that are dedicated, for obvious reasons, to desaturating red. Color Replacement will also, should you find the need, remove any selected colour (excellent news if you take portraits of cats and dogs, which are both prone to green eye). Here's how to use it on a pet, facing this unfortunate affliction.

1. After selecting the Color Replacement tool from the Toolbar, choose a brush from the Options bar. A small head about ⅔ the size of the area to be treated is a good choice.
2. Choose a Sampling option. This could be:
 - *Continuous* – if you want to sample colours as you drag.
 - *Once* – to replace a single, targeted colour (typical for the red-eye option).
 - *Background Swatch* – only erases those areas containing the currently selected background colour.
3. Set the Limits option:
 - *Discontiguous* – replaces the sampled colour anywhere in the image where it occurs, subject to rubbing over it with the mouse pointer.
 - *Contiguous* – replaces the colour contiguous with that currently under the pointer (again, the red-eye option)
 - *Find Edges* – replaces connected areas but preserves any sharpness in edge areas.
4. Select a foreground colour to be used as a replacement for that to be removed and then select the colour to be removed.

5. Drag across the area you wish to correct. That's it!

Of course, the best cure for red eye is to avoid it happening in the first place. The direct lighting from the camera flash never gives the most flattering lighting, so use bounce or ambient flash wherever possible.

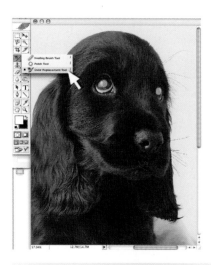

Fig 21 –
Replace Color allows any selected colour to be replaced.

IMAGE DOCTORING

There is no doubt that successful cloning is an acquired skill. So it comes as no surprise that enterprising software houses have seen an opportunity to semi-automate the process and make cloning simpler for those of us terrified by the practicalities. Alien Skin Software's Image Doctor is one such application. It's actually a suite of four programs designed to make traditional cloning processes a cinch.

The first, JPEG Repair, is concerned with image cosmetics. We've noted that the JPEG compression routine is successful at compressing files to a truly small size, but it does so by compromising image quality. The image is broken into blocks and the colour information averaged. Enlarge a JPEG – even one that has been compressed to a modest degree – and you'll see the damage that has been done. It becomes particularly noticeable where there are areas of colour change and near edges.

JPEG Repair analyzes the image on the basis of the JPEG artefacts and, by counteracting the compression algorithm's averaging technique, can successfully remove them. Simple and effective. It won't restore an image to its state prior to compression; detail is also lost through the averaging process and this simply can't be restored, but otherwise you will end up with an image that appears to be invisibly repaired.

Spot Lifter deals with cosmetic damage to your subjects. It's designed to remove slight skin blemishes, such as spots, freckles and – assuming it's not too severe – acne. It will also work to remove physical damage on original images – such as mould marks. It's very similar to Photoshop 7+'s Healing

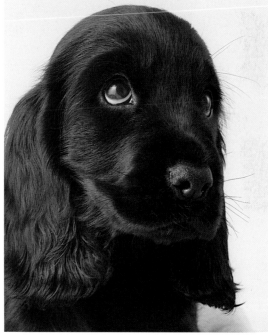

Brush but works more efficiently and can also be used to make skin look younger by removing small lines and wrinkles.

When the contrast of marks is higher – as would be the case with dust and scratches, for example – we can employ Scratch Remover. It is a simple tool to use that involves ring-fencing the scratch. Then the scratch and surrounding pixels are identified and the latter are used to overpaint the scratch. It is particularly successful with major marks and blemishes that can be difficult to remove using simple cloning tools. The averaging used ensures

that any gradients required in colouration exactly match the background. You can also use Scratch Remover to remove text from an image or even the time/date stamps imprinted by some conventional cameras' databacks.

Completing Image Doctor's quartet is Smart Fill, and this is where the software shows itself to be a true, intelligent cloning tool. With this we can remove major distractions – road signs, a car or telegraph poles – at a stroke. You can even remove those people who so thoughtlessly wandered into your shot. In principle, it works rather like Scratch Remover but this time Image Doctor analyzes the colour and the texture of the surrounding background and generates a new, random texture based on these characteristics. It then infills with this texture.

With Smart Fill you get cloned texture without the tell-tale signs normally associated with cloning – elements of texture sampled from elsewhere in the scene, for example. You also get near-seamless results, with the cloned texture and the original background blended together (see figs 22–25).

Fig 22 – Image Doctor's Smart Fill achieves a cloning effect on a par with that of an experienced digital artist, covering unwanted areas with novel texture and colour that exactly matches and blends with the surroundings.

Fig 23 – Given its potency, the Smart Fill dialogue is surprisingly uncluttered. Getting spot-on results requires fine tuning of only the Contract/Expand and Texture controls.

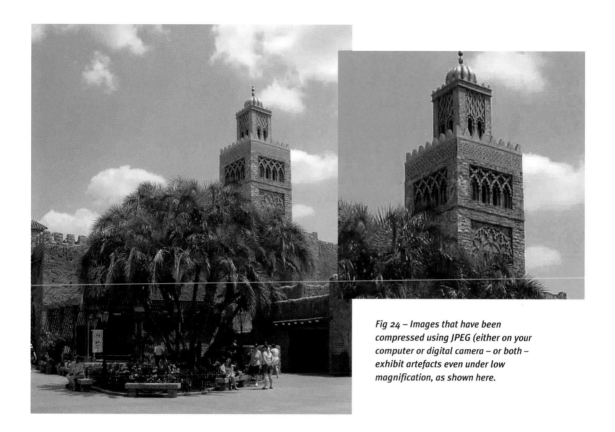

Fig 24 – Images that have been compressed using JPEG (either on your computer or digital camera – or both – exhibit artefacts even under low magnification, as shown here.

Fig 25 – JPEG Repair corrects these artefacts without otherwise affecting the image.

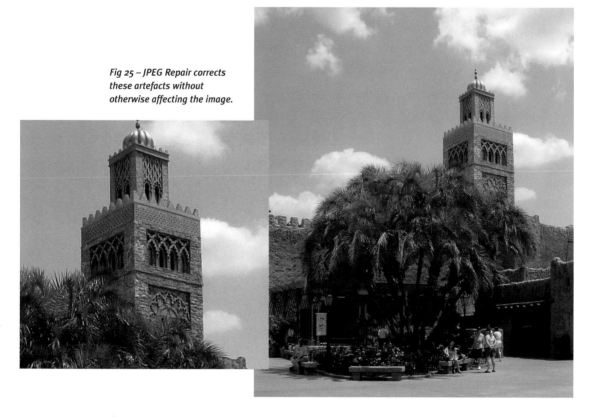

EFFECTS

EFFECTS FILTERS WITH ATTITUDE

EFFECTS FILTERS WITH ATTITUDE

In this chapter we will:

- **Experiment more with filters.**
- **Look at how to exploit filters.**
- **Study how to create powerful images with filter plug-ins.**
- **Discover how filters can improve visual defects in images.**

Filters are the most overt manifestation of digital image manipulation. That we've already said. So, given that our approach is photographic rather than graphic, should we sidestep filters altogether? That's a view taken by many photographers who consider the effects of even the most subtle of filters too obvious. They argue that a good photograph does not become a great one by the application of a contrived filter. While respecting this opinion we also acknowledge that with careful use filters can produce very effective visual effects.

It's also important to recognize that among the ranks of filter effects are Sharpen and Blur filters. These, however, do have clear and obvious photographic application so we will examine these more closely later in the book (see chapter 10).

PHOTOGRAPHY INTO ART: THE ARTISTIC FILTERS

Most prominent among the ranks of effects filters provided with virtually every image-editing application are the so-called Artistic filters. Dating from the earliest days of image manipulation, these endeavour to simulate the effects of natural media painting, drawing and brush use. They are often the first stop for those new to digital photography because they appear to offer, at a stroke, powerful effects and turn their images into artworks.

The trouble with many of these filters, however, is that the effects they produce bear only scant similarity to those they seek to emulate. Add to this the fact that photographic-quality images don't necessarily lend themselves to the application of an

artistic effect and you can see why such filters are often held in contempt by photographers. But if we acknowledge these imperfections, and even learn to exploit them, we can notch up some noticeable artistic success.

Identification

Perhaps the most basic requirement for using these filters successfully needs to be the identification of a technique that will enhance a particular subject. When you examine the list of effects offered by the Artistic filters (which include those filters listed under the subheading of Brush Strokes and Sketch), consider those subjects you know to benefit from this treatment. Watercolour, for example, is often used for landscapes and portraits. Likewise, pastels. Neon and neon-like effects should be reserved for punchy subjects: contemporary subjects and portraits designed to shock.

Fig 1

Application

As you begin to explore the opportunities of the filter menu it seems as if every filter has its own distinct dialogue box. In many cases this is true: quite a number of effects require a unique range of control parameters to govern, for example, the length of paint stroke, amount of blurring, black/white balance and so on.

Perhaps as recognition of this and in an effort to introduce a degree of standardization, later versions of Photoshop include an effects browser – a standard dialogue that allows the image to be previewed with the effect applied to the left, and the controls adjusted to the right. The centre of the pane includes literal thumbnails of effects that can be applied in each submenu. It's no easier to compose an image in this format but it does make it easier to quickly change from one effect to another should the original selection not "work" (see fig 1).

To be honest there are no short cuts here: getting the look of an image right depends on adjusting the control sliders. Fortunately, as the changes you make are mirrored immediately in the preview pane, you can assess results as you perform them.

Application opportunities

The obvious way to apply a filter is over the whole image. But this is often not the most appropriate course to take as it gives little control in modulating the strength of the filter (other than by using the rather crude Fade Filter command). It's usually preferable to apply any filtration in a more selective way.

Selections Once we've made a selection in an image we can choose to apply that filter to it – or perhaps to apply the filter to the surroundings, leaving the subject untouched.

In this first example, the Lasso has been used to apply a very rough outline to the singer. Then the Palette Knife filter has been applied to the selection. To add further emphasis and make the composition less cluttered, the background has been reduced to monochrome (using the Desaturate command) and blurred using Gaussian Blur. The area behind the singer's head has also been lightened to make her hair outline more obvious (see fig 2).

Fig 2

Fig 3

Fig 4

Fig 5

In this second example, the idea of the photographer was to add emphasis to the subject by making it appear to be set against a painting background. The original also suffered from high contrast, which meant there were strong shadows compromising image quality (see fig 3).

Applying the Highlight/Shadow feature will even out the exposure, although this also compromises image quality. As a standard image, this is unacceptable (see fig 4).

But when we now select the background (by selecting the carving and then inverting the selection) and apply the Crosshatch brush filter (increasing the settings by 50%) we get a very effective result (see fig 5).

Of course, you could extend this concept to a montage: the montaged elements could comprise filtered and unfiltered subjects and background. It's a good idea in this case to keep to a single effect: a composite scene comprising multiple elements each with a different effect applied will look chaotic.

Layers Using a Brushstroke filter, as in the case of the gnome carving, can work well in reducing the impact of a background, but when we use a similar filter for the entire image the result can be to produce a general blur – unless it is viewed close up. In these cases, it often helps first to copy the background into a layer (Layer····▷Duplicate Layer) and then apply the effect to that layer. Controversially, do so with a stronger effect, nudging the sliders slightly to the right. Then, change the opacity of the layer from 100% to around 67%. This helps to add definition to the image by allowing the

Fig 6 Fig 7

Fig 8

Fig 9

sharpness of the original to show though but permit the effect in the layer still to be clearly visible (see fig 6).

Similarly, for very potent (in terms of colour and form) subjects: using the opacity slider here gives the image definition yet the filter (Dry Brush, in this case) gives the colours a solid, graphic appearance (see fig 7).

Though the use of multiple filters is often, for good reason, eschewed, it can sometimes lead to dramatic and successful results. Here, two copies of the background layer have been created. The background was sharpened using the Unsharp Mask filter to add to the perceived sharpness. Then the first layer was, as before, subjected to the Dry Brush filter and its opacity reduced to 50% (see fig 8).

The unusual Plastic Wrap filter has been applied to the top layer here, and again the opacity reduced, this time to 60%. The Plastic Wrap filter in its default state gives images the appearance of having shrink-wrap plastic applied but here, by reducing the intensity, it gives the impression that paint of finite thickness has been applied to a canvas (see fig 9).

Other opportunities In a similar manner to applying a filter to a layer, you can also apply a filter to an individual channel. Open the Channels palette and then click on a single channel to select it. Then apply the filter.

Gradients and gradient masks allow you to apply the filter in a graduated way. In this way you could, for example, add a grain-type filter that becomes more obvious across the frame, concentrating attention on, say, foreground subjects.

PHOTOGRAPHIC FILTERS

Digital implementations of conventional photographic filters have rarely made an appearance in image-manipulation applications. With the host of other techniques on offer they have long been deemed irrelevant. But in recent releases of software applications bespoke tools for emulating filters have appeared – and have been well received by photographers who have found both corrective and creative uses for them.

Photo filter (figs 10 & 11)

Photoshop's implementation of the corrective photographic filter feature is called, unsurprisingly, Photo Filter. More surprisingly, you won't find it in the filter section but, rather, under Image---> Adjustments. You'll find a range of filters provided in the pull-down menu. Select the appropriate one and

Fig 10 – When the original shot (see left) was taken, the photographer hadn't reset the white balance of the digital camera from the Tungsten light setting. The result is a bluish cast that is easily removed using the Warm Up filter 81 with a density of around 40% (see right).

 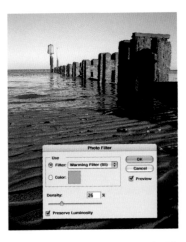 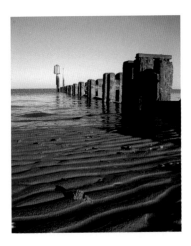

Fig 11 – Photo Filter can also be used to alter the lighting mood in a scene. This original image (see left) is correct in terms of colour balance. But applying a strong Warm Up filter (85A) we get an effect more in keeping with a late afternoon shot. Reducing the density ensures that we don't too much of a sepia effect (see right?).

apply it. I tend to find the strength of the filter rather high and it pays to reduce the intensity, using the slider, to obtain the best results.

Filter-SIM (figs 12 & 13)

In some applications – and Photo-Brush is a very good example – filters are implemented in a literal and very visual way. The Filter-SIM feature in Photo-Brush overlays a metaphorical filter on the basic image, illustrating the correction within the filter ring. You can reposition the ring to assess the correction over different parts of the image.

The range of filters offered in Photo-Brush closely follows the colour-compensation (CC) range offered by most filter manufacturers and denoted by the near-universal Wratten number (this is the number of the filters in Kodak's Wratten gelatine series, well known to professional users requiring precise colour compensation).

A useful feature of Filter-SIM is the ability to apply the filter to a black and white image. Now when we apply the same range of filters we get effects that emulate the use of colour filters with black and white film. Use a deep red filter – for example, a Kodak Wratten 24 – and blue skies will be rendered dark, almost black, while red objects are lightened and green objects are little affected.

Colour-correction filters vs. other corrections

The more practised image manipulator may spot a potential conflict in the photographic filter features. It is all well and good providing colour correction tool but aren't these somewhat redundant given that all image-manipulation applications feature one, or in some cases several, colour-correction features already.

Those behind Photo-Brush and Filter-SIM are up front about it: it's for correcting wrongly set white balances (on digital cameras) and adjusting the colour balance of conventional films used in the wrong circumstances (for example, outdoor film used indoors under domestic tungsten lighting). They also suggest an educational use for the filters, useful in interpreting their effect on an image.

In practice, these filters are useful both for making quick corrections where the colour cast is obvious in nature and also for applying colour casts where they are wanted for creative purposes. The warm-up filters, particularly, are ideal for injecting warmth into those shots taken in the early morning or late evening sunlight where the auto white balance might remove any natural warmth in the scene.

LIGHTNING

Electrical storms are one of the most spectacular of natural phenomena, but also, in photographic terms, one of the most elusive. Though some locations can boast storms on a basis that may be as regular as clockwork, successfully recording them can raise

Fig 12 – Filter-SIM (Image····⊱Adjust····⊱Filter-SIM, in Photo-Brush) clearly illustrates the effect of applying a filter over a portion of an image. You can choose from one of many presets mostly corresponding to Wratten presets. The descriptive panel at the base of the dialogue gives a description of each filter.

Fig 13 – Corrective filters allow corrections such as this, for underwater shots. Underwater photography with digital cameras is increasingly popular, but water introduces colour casts. Filter – SIM helps negate these casts at a stroke.

problems. Lightning strikes last only microseconds and the chance of that coinciding with the camera's exposure are small indeed. But digital techniques make it possible to add a bolt of lightning to almost any landscape.

Alien Skin's Lightning filter is a plug-in from the Xenofex collection. Lightning allows you to place lightning into any scene, although clearly, for authenticity's sake, scenes should be chosen that give credible results: dark clouds, stormy sunlight and so on.

The filter lets you alter the characteristics of the lightning. You can, for example, increase or decrease the amount of branching in the lightning fork, or you can increase the amount of spread in branching and also how jagged the fork is. Like a

real lightning event, you can also add glow to the top of the bolt, illuminating the cloud from which it appears to emanate.

1. This scene with ominous storm clouds and colourful sunset will be ideal for our lightning effect. But we can make it better still (see fig 14).
2. Use the Layers command to make a copy of the image and paste it into a new Layer (Layer····⊱Duplicate Layer). In the Layers palette, change the Blend mode from Normal to Multiply. This gives an effect similar to sandwiching two copies of a transparency together: a darker, more intensely coloured one results (see fig 15).
3. We only want our lightning bolt against the sky, not the foreground. To achieve this, begin by selecting the foreground using the Magic Wand tool. As it's virtually black here, this is relatively simple (see fig 16).

Fig 14

Fig 15

Fig 16

4. Add a new layer to the image (Layer⟶New⟶ Layer) and then select the Lightning filter. The dialog box looks like this. Because we have applied it to a new, empty layer, you won't see the image. The two targets can be moved to define the start and end points of the lightning (see fig 17).

5. Apply the filter and then press the delete button. This will delete that part of the lightning that has been applied over the foreground (see fig 18).

6. By changing the parameters in the filter dialogue box we can achieve a quite different result. Like real lightning, the randomizing feature of the filter ensures that applications are unique (see fig 19).

For more ambitious results you can create the effect of lightning reflected in water. To create this scene (see below) the photographer copied the image layer containing the lightning and then used the Transform tools to invert it before positioning it. To complete the illusion a minor amount of rippling (created using the Ripple filter) was applied so that the texture of the reflected lightning matched that of the water's surface (see fig 20).

USING FILTERS TO ENHANCE NATURE

Some filters are subtle in their effects, others extreme. Extreme filters can deliver eye-popping graphic effects, while others can deliver photo-graphically accurate embellishments difficult or impossible to create any other way.

It is hard to categorize Flaming Pear's Flood filter. It's so overt in nature that it demands being consigned to the "cliché" category. But this easy-to-use filter is so effective you may well find many an

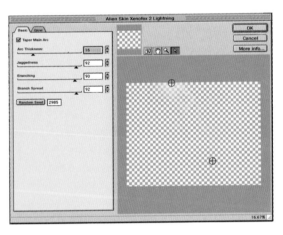

Fig 17

Fig 18

Fig 19

Fig 20

excuse to do just that. And since it is clearly designed to enhance the photographic nature of images, it's worth closer inspection.

What it does is literally create a flood in your image or selection. But this flood is extremely effective, mimicking both the look of real water (whether lake, river or sea) and giving reflections that are utterly realistic.

As with most filters, the key to successful implementation is thinking about the end result first. Here's an image where we can use the filter to great effect (see 21). Obviously playing to the camera, these two girls are sitting in their land-locked canoes at a sculpture park. Apart for a short period in the autumn and winter, the canoes sit on ground that is merely damp. But even when the conditions get wetter the ground becomes only a modest stream. We can change that, however, and cast them adrift in a virtual lake.

Fig 21

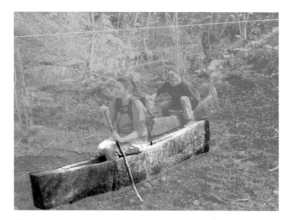

Fig 22

1. We need to apply the filter to give the impression of water beneath the closer canoe and also lapping up the sides. Begin by using any appropriate selection tools to nominate the parts of the canoe you want to remain out of the water. Here a combination of Freehand and Magnetic Lasso tools proved the most effective. Switching to Quick Mask mode, this is the effect of the selection (see fig 22).

2. Invert the selection (Select···▸Inverse). We want everything but the girl and canoe to be the selected area for the application of the filter. When the Flood filter is selected, we get a comprehensively specified dialogue on screen. Note that the non-selected canoe is absent from the image shown in the dialogue (see fig 23).

3. The dialogue contains a number of controls, most of which are best explored by trial and error (bearing in mind there is no "right" or "wrong" with filters of this type), but the most useful is the View set. Here you can position the water relative to the frame and also vary your own viewpoint on the water to ensure that it matches the perspective of the scene (see fig 24).

4. Apply the filter. The result, as you can see, is remarkably convincing. To make it more so, here we've used the History Brush to remove some of

Fig 23

Fig 24

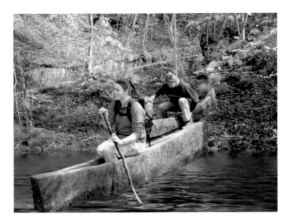

Fig 25

Fig 26

the reflection around the base of the "oar" and the same brush (at a lower opacity setting) to soften the edges of the water against the canoe (see fig 25).

5. Did your notice the small dice icon in the Flood filter's dialogue box? This randomly alters the filter settings to produce different water effects. If you are uncertain about how you should configure the settings, this is a great way to cycle around a good

Fig 27

collection of presets. A couple of presses and this more tranquil setting for our canoe image was produced (see fig 26).

We can be as dramatic or subtle as we like with a filter such as Flood. We can use it to enhance a scene – such as the case of our canoeists – or to create results impossible in nature.

The Potala at Lhasa in Tibet is built on a high hillside that, as far as I know, never suffers from flooding. But with a little judicious use of the Flood filter we can transform it into a waterside scene. To make the deceit more realistic, the foreground foliage was excluded from the filter effect (see fig 27).

TIPS

- Successful use of filters such as Flood depend on getting the context right. You need to establish how water would appear were it actually to flood the scene, taking note of where you would and where you wouldn't expect to find it.
- Flood is more useful than many extreme, filters but again don't use it too often. A shot or two in a collection could be eye-popping, but transforming every other scene just won't work.

A PUZZLING FILTER

Some digital effects filters, like their optical counterparts, appear to have a rather dubious raison d'être. Either their effects are so esoteric as to defy credible use or so overt as to betray their origins. Does this mean that we should ignore them? No, with sensible and, perhaps, sensitive use even the most

apparently absurd filter can find a useful application.

The Puzzle filter, one of the Xenofex collection, is a case in point. It applies a jigsaw puzzle overlay to an image to give a result that looks exactly like a completed jigsaw puzzle. It does a remarkably good job: rather than a simple overlay that merely marks the edge of the pieces, it gives texture to the edges, producing a real impression of a die-cut puzzle with shading and highlights giving each "cut" a more three-dimensional look (see fig 28).

But we can go one better and, with just a few minutes work, make the puzzle look incomplete. We can – digitally – remove a piece of the jigsaw and leave it scattered, apparently aimlessly, elsewhere on the image. Here's how.

1. Begin by applying the Puzzle filter. If you don't have a copy of Xenofex you can do much the same using a sharp-edged paintbrush tool. Use the Magnetic Lasso tool to draw around the edge of your chosen piece of puzzle. You'll find that, unless you are aiming to select a particularly dark piece of the image, that the default settings are sufficient to quickly describe the perimeter of the piece (see fig 29).

2. Copy this selection and paste it back into the image. It will appear in a new layer. You can now use the Move tool and Transform tool to place this piece elsewhere in the image and rotate it at will (see fig 30).

3. Apply Drop Shadow (Layer····⟩Layer Effects····⟩Drop Shadow) to the piece to add to the realism and make it appear to be resting on the surface of the puzzle. You will need to adjust the angle of the lighting, using the light wheel in the dialogue box, to ensure that the lighting effect matches that of the rest of the image (see fig 31).

4. Now we need to create a "hole" where the original piece came from. Choose Select····⟩Reselect to restore the selection boundary to the original piece. Next, select a background colour that would be appropriate (like the brown, here) and then press the Delete or Backspace key. The selection will disappear, leaving the background colour exposed (see fig 32).

5. You may need to give this hole the drop shadow treatment as well, but make sure that the lighting

Fig 28

Fig 29 Fig 30

Fig 31 Fig 32

Fig 33

direction is 180 degrees different from that applied to the puzzle piece. This will give the effect of a hole through the puzzle rather than another object on top (see fig 33).

With a little more work you could remove other pieces and produce a more casual, semi-complete puzzle effect.

But even now that we have found an effective use for this filter, it does not mean that it should be used to often. Such overt filters as this do tend to give results that border on the clichéd and test the patience of those viewing your images. The first time they may think it clever; on each repeat, they will probably just groan ...

USING FILTERS FOR CORRECTING DISTORTIONS

The lenses that we tend to take for granted on our cameras are, for the most part, very precisely configured and represent the zenith of decades of optical design. The production of specialized glass types and computer-aided design has led to increasingly more versatile lenses, and optics that were once considered exotic can now be found in the most humble of gadget bags.

But pushing lens technology to the limits has not been without its problems. It's not unusual, even in the case of some mid-market cameras and optics, to find that the extreme flexibility in optical terms comes with a degree of image distortion that critical users may find verging on the unacceptable. This is the unfortunate side-effect of compromises that have to be made, first, to deliver a product at an acceptable cost and, second, to deliver the lens in a compact size. The most pronounced lens distortions are pincushion and barrel and they manifest themselves most visibly when there are rectangular elements in the scene. Pincushion distortion renders rectangles with rather pronounced corners and convex sides. Barrel distortion, conversely, bows the sides outward in a ballooning effect.

Both of these effects are at their most noticeable when zoom lenses are used at the extremes of their focal lengths: pincushion at the telephoto end and barrel at the wide-angle end. The latter problem tends to be made worse because barrel distortion is also a natural consequence of photographing regular-shaped objects close-up with wide-angle lenses.

Fortunately we can correct images that fall victim to these problems relatively easily using dedicated filters. Here we're using the Barrel Distortion feature in Photo-Brush. This has a very clear representation of the correction that makes precise adjustments simple. You can type in the amount of correction in the appropriate box or use the incrementors to increase or decrease the amount until the correction is made to your satisfaction.

Fig 34

Fig 35

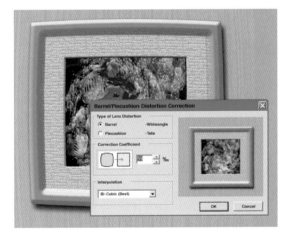

Fig 36

Fig 37

Fig 38

Photographing artwork up close (copyright permitting) will really test the mettle of your lens and immediately show up any distortions. In this image (see fig 34) there is a modest (but significant) amount of barrel distortion due to the need to use a wide-angle lens to record this image. The bowing of the sides of the image and the frame are unacceptable.

Selecting Barrel Distortion brings up the appropriate dialogue box and we can then make the necessary corrections. Click on the Barrel button first and then enter an amount in the window (see fig 35).

Our corrected image features straight sides – both horizontally and vertically – and the stripes on the wallpaper, too, are linear (see fig 36). You can always use a grid to establish a precise alignment.

Although a corrective tool, distortion tools such as Barrel Distortion can also be used to create dramatic wrap-around effects. Applying extreme

amounts of distortion to a conventional image can, for example, replicate fish-eye lens effects or wild multiple-reflection effects. In this example (see fig 37), an image with no notional distortion has been subject to the same Barrel Distortion feature as used in the previous example. This time the controls have been set to an extreme level (the maximum allowed is 1000%).

The image that results is undoubtedly eyecatching (see fig 38). It is one of those effects you'll find works well with some images and not at all with others; it's also an effect to use sparingly. Once is eyecatching, twice is tedious.

Photoshop's Liquify filter (fig 39)

Liquify is a free format-distortion filter that applies a mesh warp surface over an image in order to correct – or exaggerate – distortion. Unlike those filters designed for the specific correction of barrel or pincushion distortion, the tools in Liquify allow the distortions to be applied with a brush. As such, the effect can be applied to the whole image (like Barrel Distortion) or can be more local in its application. In Photoshop parlance, the Pucker tool corrects barrel distortion and Bloat, pincushion.

Fig 39 – Liquify is ideal for correcting distortions but many users prefer to exploit the ability to add distortion to the creative limit.

LAYERS
AND LAYER
............LAYER

LAYERS AND LAYERED IMAGES

LAYERS AND LAYERED IMAGES

In this chapter we will:

- **Learn to understand the importance of layered images.**
- **Explore the different types of layers that can comprise an image.**
- **Discover the importance and uses of layer blend modes.**

We've seen in several of the worked-through examples in this book the importance of layers. Layers make it possible to produce composite images that can be manipulated and have elements juxtaposed even after we have saved our images to disk. The best description of layers is to think of them as transparent sheets of acetate. On each sheet we can place selections or objects. Then we can arrange these acetates in any chosen order over a background and alter the order of the acetates in the stack.

In fact, thinking of layers in this fashion works very well when we turn to the Layers palette, which is the palette that figuratively illustrates the layer composition of an image (see fig 1).

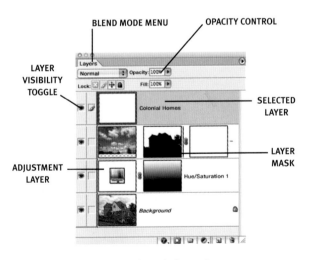

Fig 1 – The Layer palette shows the layers that compose an image but can also be use to manipulate those layers and make it possible to hide, reveal, delete and create layers.

When we copy a selection to an image (by dragging it from another, or using Copy/Paste) a new layer is automatically created. But a layer containing an image element is just one of the range of layers, a range that also includes adjustment layers, fill layers and layer styles. Let's explore each of these in turn.

Flattening images and merging layers

There's no doubt that preserving layers makes the manipulation and refinement of images simpler. A flattened image – one in which the layers have been removed and all image elements indelibly added to the background – would be hard to manipulate in all but the most rudimentary of ways. But multilayer images are more demanding on disk space, often requiring many times that of a flattened image. Some image file formats (such as JPEG and older versions of the TIFF format) will automatically flatten an image when it is saved. To ensure that layers are preserved you'll need to save files in the native file format of the application (.PSD in the case of Photoshop) or in a TIFF format that supports layers.

Be aware that if you save a multilayer image in the native format of one application you may be able to retrieve the layer information if you open it in another application, if the file format is supported in that application. But this is not always the case so it is worth checking when sharing files.

If you want partially to flatten an image – flattening those image elements that you might want to manipulate together – you can do so by using the Merge Visible command in the Layer menu. Make those layers that you don't want to flatten together invisible by clicking on the eye icon adjacent to the layer. Then choose Merge Visible. Now when you make the invisible layers visible again you'll be left with your reduced set of layers.

With adjustment layers we can vary colour, tonal and other parameters of our image layers without applying any irrevocable changes.

Creating adjustment layers

Adjustment layers are identical in many respects to conventional image layers. We can move them relative to the other layers in a stack and can also hide, copy and delete them.

Creating an adjustment layer is simple. Click on the New Adjustment Layer on the base of the Layers palette. A menu list opens and you can choose the type of adjustment layer. You can open the same list by selecting Layer⋯≻New Adjustment Layer (see fig 2).

When an adjustment layer has been created you can use it as you would the corresponding feature. For example, if we selected a Levels adjustment layer, the Levels dialogue box opens and permits us to make any adjustments to the levels required (see fig 3).

We can also make a selection first, if we only want the adjustment layer's effects to be applied selectively to parts of an image. We will see those parts of the image to which the adjustment layer's effects are not applied masked in the thumbnail in the Layers palette. Here (see fig 4), a Color Balance layer has been applied only to parts of the subjects of this image.

Fig 2 – You can invoke a new adjustment layer via the Layers palette (see above) or Layers menu (see left).

ADJUSTMENT LAYERS

Layers, then, are considered virtually essential not only for creating obvious image composites but also for a wide range of image effects. Their key competence is that you can, in a multilayered image, reconfigure that image by rearranging the layers or manipulating them.

But what if you don't just want to rearrange or manipulate them; assume instead that you want to remove or change an effect (such as a change to the levels or colour balance) that was previously applied to the layer? The simple answer is you can't. But if we had the foresight to apply effects to a layer using an "adjustment layer", such changes would be simple.

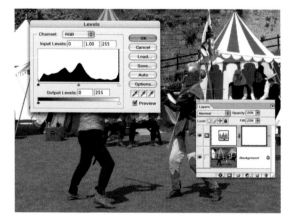

Fig 3

Fig 4

FILL LAYERS

Like adjustment layers, fill layers apply effects that can be altered or even discarded at a later point. Fill layers allow us to add colours, gradients or patterns quickly to an image. But, unlike adjustment layers, fill layers don't affect the layers below.

LAYER STYLES

Sometimes called layer effects, layer styles take the interaction of layers a step further and allow us to produce shadow effects, glows and patterns. Layer styles don't exist as separate, distinct layers but rather they are effects that modulate the appearance of an existing layer. A layer that contains layer styles is indicated by a small "f" symbol to the right of the layer's name; click on this and you'll see a list of the layer styles associated with the layer. You can remove any of these by dragging them to the wastebin icon at the base of the palette (see fig 5).

Although it was introduced with Photoshop Elements, Photoshop CS introduced a Styles palette that includes a number of pre-configured layer styles. You can see a basic set by opening the Styles palette (Window····≀Styles) and can append further ranges by selecting the set from the pull-out menu – click on the small arrowhead to the top right of the palette (see fig 6).

But most photographers will consider all the options available here as rather contrived in nature and lacking subtlety. It's often better to create your own using the Layer Styles dialogue. Select Layer····≀Layer Styles to open the default dialogue (see fig 7).

The make-up of the dialogue box will depend on the nature of the layer style selected. In the case of the Drop Shadow, shown here, you can alter the direction of light (which obviously affects the direction of the shadow), the distance of the shadow from the selection, the spread of the shadow and the density.

The light direction figures extensively in layer styles and it's important to ensure that if your apply multiple styles, or if you apply a similar style to multiple layers, that the lighting always appears to be coming from the same direction. You could do this by adjusting the lighting angle in each and every layer style or take a short cut: select Layer····≀Layer Style····≀Global Light and you can set a lighting angle for the entire scene.

Layer styles and text

Photographers tend to use little of the comprehensive text capabilities of most image-manipulation applications. When we create images we often consider text – even when used for captioning – as despoilers. But there will be times when text can be used with an image, such as when we create posters, greetings cards and even postcards. Clichés though these may be, the use of layer styles can lift the results above the prosaic and aid legibility and composition.

Here's a rundown of the most appropriate layer styles to use with text. You can use one, two or even more together, but make sure that you don't hinder legibility through overuse. In addition, stick with

Fig 5

Fig 6

Fig 7

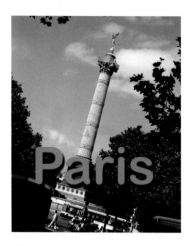

Fig 8

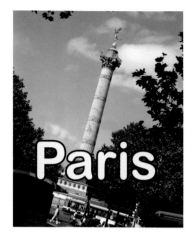

Fig 9

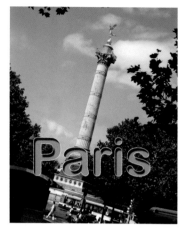

Fig 10

Fig 11

Fig 12

the simpler styles of typeface, such as Arial or Verdana, to improve legibility.

- *Drop Shadow* Excellent for visibly "lifting" text clear of the image. You can vary the opacity, position and spread of the shadow according to the subject. You can also use different shadow depths to emphasize different pieces of text (see fig 8).
- *Stroke* A stroked line around the edge of letters helps to improve legibility where the colour of the text and that of the background are similar. Choose a simple colour, such as white, black or grey, for clarity, or a complementary colour for more dramatic impact (see fig 9).

- *Inner Shadow* This gives the look of text being punched through the image, apparently revealing a background colour behind. Don't use this with dropped shadows, but it can be combined, as here (see fig 10), with a stroke for emphasis.
- *Inner and Outer Glows* Use these for a more dramatic emphasis than the previous layer styles. Bright, luminous colours offer the most powerful results, but they should be used with care (see fig 11).
- *Bevel and Emboss* Great for pseudo-3D effects. Again, go for simple styles rather than the more complex of profiles (see fig 12).

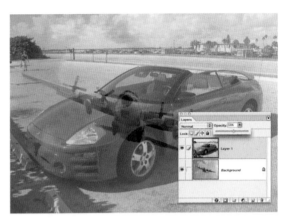

Fig 13 – An image in Normal mode with the opacity set to 100% and 50%, respectively.

LAYER BLEND MODES

No matter where you are in Photoshop you are never far from a blend mode dialogue or blend mode pull-down menu. Click on one of these and you'll see an initially baffling array of options. Despite being so prolific, it will be on the Layers palette that you'll most often encounter and user blend modes, which is why the term layer blend modes is also often ascribed to them.

Part of the reason blend modes appear so baffling is because of the number of them, which seems to increase with each new Photoshop version – CS boasts no fewer than 23. But the principal reason we find them bewildering is that their effects appear, at best, idiosyncratic. Some seem to deliver very similar results, others vary wildly as you change the opacity of one layer and according to the content of the image.

In truth, most photographers find the whole collection perplexing and tend to use only a select few. Once mastered, they will be used extensively and the power of blend modes quickly becomes obvious.

We'll take a look as some of the key blend modes – the ones that will become useful in our day-to-day image creation. For the more ambitious there's a description of the others in the panel (see page 146),

Fig 14– A good sunset becomes more impressive when combined with a copy of itself blended using Multiply. Repeating the process gives an even richer result.

Fig 15 – Adding a moon to a landscape is a simple job – if you know how to use the Screen blend mode (see page 147).

but the best way to explore their capabilities is to try them out on different images and image combinations.

Layer blend modes determine how a layer interacts with the background. We generally describe the layer as the paint layer, although you may also see the terms blend layer, donor layer or even source layer used in some texts. Likewise, the background layer on which changes are enacted by the paint layer is sometimes known as the base, lower or destination.

- *Normal* This is an easy one – it is the default setting and in this setting a paint layer will, unless there are any transparent pixels or the opacity is set to anything other than 100%, totally obscure the background (see fig 13).
- *Multiply* A darkening mode. The best analogy is that it's like the effect you get when combining two transparencies in the same mount. Dark areas in the background or paint layer will always obscure elements in the complementary layer. Combining an image with a duplicate layer will result in a darker image with more saturated colours. It's ideal for building up density in a sunset, for example (see fig 14).
- *Screen* Imagine projecting two transparencies from different projectors on to the same spot. This is the net result of using Screen. The resulting image will always be brighter and less dense than either original (see fig 15).
- *Color* Adds the colour and saturation only of the image layer to the background. It's most effective whey you are trying to tint or hand colour a monochrome image. By painting on a layer (or series of layers) you can produce authentic-looking results and control the amount of colour by using the opacity slider (see fig 16).

Fig 16 – A hand-coloured result is possible by careful use of the paint brush and then applying the Color blend mode.

Fig 17

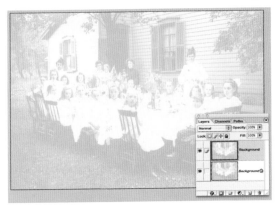

Fig 18

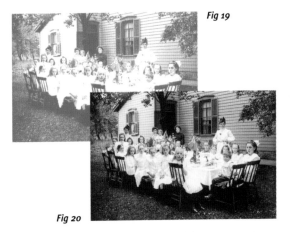

Fig 19

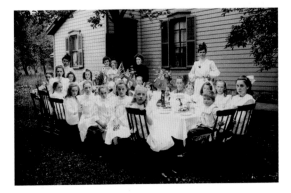

Fig 20

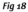

Fig 21

More blend modes

- *Dissolve* One to avoid! Gives a Powerpoint transition-like effect that has little if any pictorial merit.
- *Soft Light* Good for blending two images; altering the opacity varies the domination of layer over the background.
- *Overlay* A stronger form of Soft Light.
- *Hard Light* An even stronger version of Soft Light.
- *Pin Light* Varies the replacement of colours in the background based on the blend colour. One of the more unpredictable modes.
- *Color Dodge* Uses greys to dodge the background; white makes the background lighter but with added contrast. Black has no effect.
- *Colour Burn* The converse of Color Dodge. Darker greys and black burn in the underlying layer.
- *Hue, Saturation and Luminosity* Hue will apply the hue of the paint layer to the background but not affect the background's saturation or luminosity; similarly, Saturation will apply the saturation of the layer to the background and Luminosity the paint layer's luminosity.

Using blend modes

Here are a couple of examples of using blend modes. In the first, we'll look at how we can use Multiply to add density to a faded image without needing to resort to more abrupt tools, such as Contrast. In the second, we'll look more closely at the case of placing the moon in a new sky, demonstrating the Screen blend mode.

Improving contrast

1. This image is badly faded. Our first reaction would be to use the Brightness/Contrast command to boost the contrast. Unfortunately, this image has such low contrast in the first place it won't be too successful (see fig 17).

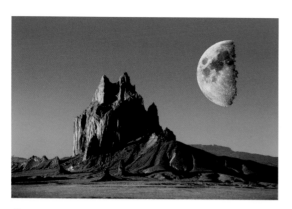

Fig 22

Fig 23

Fig 24

Fig 25

2. Instead, Select Layer⟶Duplicate Layer... to add a duplicate of this layer to the image. At this stage, you'll notice no change in the image itself (see fig 18).

3. Switch the blend mode from Normal to Multiply. Multiply, as you will recall from earlier, gives the result similar to that of combining two transparencies in the same mount. It was successful in boosting a sunset and here it will add density to the image while having little effect on those parts that should be light or white (see fig 19).

4. In extreme cases, a single application will have some success but will not result in a full tonal range. Unlike many effects (where we suggest only one application), here we can repeat and get a more substantial increase in density (see fig 20).

5. For a final adjustment (and to ensure that the full tonal range is included in the image) use the Levels dialogue or (if you are in a hurry) Auto Levels (see fig 21).

The moonlit sky

1. At first it would seem simple to place an image of the moon in a twilight sky. Trim around the shape of the moon and paste it on to the new background sky. But the result is unconvincing. Why? There are parts of the lunar image that are black but for realism's sake we should have no part of the image that is darker than the sky itself (see fig 22).

2. Instead, paste the image of the moon into the sky in its own layer. Again, don't worry about the look at this stage. We will remove the black at the next step (see fig 23).

3. Switch blend modes to Screen. Now only those parts of the lunar image that are brighter than the background sky are painted to the background: all the black and dark shadows adopt the colour of the background sky (see fig 24).

4. Switching to Lighten blend mode can sometimes give a better effect. Study both blend modes and judge for yourself which gives the best pictorially pleasing results (see fig 25).

Fig 26

Fig 27

Fig 28

MAKING MONTAGED IMAGES WORK

It's crucial when compositing a montage that all the disparate image elements work, visually, as a whole. This means it's important to get the appearance of each element correct, not only individually but also as part of the whole. This means paying close attention to the following aspects of the image.

- *Resolution* A composited image element must be of the same, or better, resolution than the background or main scene.
- *Colour* The colour balance of elements taken from photographs taken at different times in different places and in different circumstances will need to be made similar to that of the scene. Often it is considered easiest to reduce all elements and the background to a neutral condition but this may not be appropriate to the work. In Photoshop CS you can use the Match Color command to match the colour balance between image elements placed in different layers.
- *Tonality* The tonal range of the image elements will vary but will also need to be adjusted with regard to their new setting. For example, the tonality should match the lighting in the new scene and be appropriate for the position. In general, the closer an object is to the camera, the higher the contrast it exhibits. And objects positioned in the shadows will exhibit different

characteristics to those in direct lighting.
- *Texture and grain* To even out discrepancies in grain structure and resolution, grain (or noise) can be added to give the whole image a coherence. Only the minimum amount required should be applied.
- *Lighting* It's crucial to analyze the lighting conditions of all elements and make any relevant corrections. When elements are drawn from different sources it is inevitable that the lighting – in type and direction – will differ. Contrast and colour corrections can make good differences in lighting types, but lighting direction errors can be more difficult to put right. Flipping an image element or applying dodge or burn effects can often be the solution in such situations.

Let's now put these rules into practice with a montage that is notionally a simple one, but is useful for demonstrating these techniques. We've taken a shot of a traditional Chinese doll (see fig 26). Lighting was poor – a mix of muted daylight and incandescent bulbs. In fact, it was shot on a shelf in a toy shop.

The object of this exercise is to place her in this Yellow River landscape, shot in bright, summer sunshine. (see fig 27)

Extracting the doll from her plain background should be a relatively simple task now. We could use the Magnetic Lasso, Background Eraser, or

Fig 29

Fig 30

Fig 31

even the Magic Eraser. The latter two proved the easiest, as we can see from this work-in-progress shot (see fig 28).

We can now copy the girl on to our landscape. As both images were taken with the same camera and have been composed full frame, there will be no resolution issues. If there was a dramatic difference between the two images we would have needed to adjust the resolution of one or the other to ensure consistent quality throughout (see fig 29).

The front-to-back focus is often a dead giveaway with montaged images. If we really had shot this scene as a single image, even with the smallest lens aperture, we would have been unable to get both a close up doll and distant landscape in critically sharp focus. We would normally produce depth of field effects for the landscape but here, as it is all essentially at a similar distance, we can simply apply a modest Gaussian Blur to the background (see fig 30).

We now need to attend to the lighting. The doll is brighter lit from the front, while the background is sidelit. We can overcome much of this imbalance by applying a simple correction using the Shadow/Highlight command. We also have to invoked Match Color to ensure that there is a better colour balance between both layers (see fig 31).

Now that we have even lighting throughout the scene we need to ensure that the lighting directions match. With light coming in from the left, shadows

are being cast on the right. But the front-lit doll needs to have shadows added using the Burn tool. Use a low exposure amount and build up shadow areas gradually to the right of the face, right side of the kimono and where there are folds of fabric (see fig 32).

Fig 32

::SHARPEN:

SHARPENING AND BLURRING

SHARPENING AND BLURRING

In this chapter we will:

- Learn why blurring occurs and how it needs to be corrected.
- Get to love the Unsharp Mask filter.
- Use deliberate blurring to create depth of field effects and soft-focus portraits.
- Use modified blurring features, including Motion Blurring and Radial Blurring.

Blurring is often seen as an image defect and sharpening its cure. But in the digital world all is not quite what it might seem. Blurring and sharpening can both be used as a creative tool as well as a corrective measure, as we shall see.

IMAGE SHARPENING

One of the cardinal rules of photography is that some part of the image should be sharp. Except where blurring is used deliberately for creative impact, it's essential that an image – in whole or part – is sharp. To this effect, many digital cameras include special algorithms that automatically apply a degree of sharpening to an image either to compensate for modest amounts of camera shake or to overcome – dare we suggest it – slight lens softness.

Often, however, it's best to dispense with any in-camera corrections of this sort and use the sharpening filters included in the image-manipulation application. But there is much more to sharpening an image than simply applying a sharpening filter. So we need to begin by understanding the rationale for sharpening and see where image softness is introduced.

Low-pass blurring (fig 1)

Let's start with the camera itself. Whether we chose a bargain-counter special or the latest super-resolution digital SLR, CCD sensors of digital cameras feature a low-pass filter placed immediately in front of the imaging surface. This acts to improve the image in several ways, the most significant being a reduction in noise levels; the filter tends to even out random fluctuations in noise levels in the pixels. Filtration can also remove moiré fringing, which is the colour line patterning that can result when an image features repeating detail of the same scale (when imaged by the lens) as the width of the pixels making up the CCD chip.

Fig 1 – Without low-pass filtering, moiré patterning can compromise an image, giving it an appearance similar to half-tone screening used when printing images in magazines and books.

Fig 2 – Manipulative sharpening can be very subtle but the deteriorative effect on an image is more obvious and (with additional edits) cumulative. The original image (left) was opened and saved in Photoshop five times. Already the detail of the stamens in this macro shot of a flower are lost (right).

Manipulative softening (fig 2)

It's unfortunate that some of the techniques we use ostensibly to improve our images actually cause degradation due to image softening. Often this occurs as a consequence of interpolation. When we change the size of an image – whether enlarging or reducing – new image pixels are created by averaging the values of those in the original image. In this process we tend to lose the critical sharpness of the original image. The effect is even more marked if we use a tool such as Rotate to change the alignment of an image, whether to correct a slanting horizon or when producing a creative crop.

Output softening

Even if we are successful in maintaining sharpness throughout the manipulation process we can still fall at the final hurdle: printing. When we send an image to a printer the physical process of laying ink on to paper causes modest amounts of softening. We can't avoid this, although we can compensate by applying an equally modest amount of oversharpening prior to printing.

When to sharpen

Sharpening, so many image experts tell us, should be the final stage in your image-editing regime. This makes good sense, as we are introducing sharpening after applying other techniques that could (and probably would) soften the image. The same wisdom also demands that any sharpening is undertaken just once – the argument being that compound and multiple sharpening will introduce artefacts that, while adding perceived sharpness, actually degrade the overall image.

The most successful sharpening policy that I have discovered suggests a two-stage approach. The first stage compensates for low-pass filter softening and manipulative softening. This is applied before we adjust the size and resolution of the image for printing (or sending to the web), but after we have imported and manipulated the image.

The second stage is a more modest affair, used to compensate for the final output softening. This two-stage regime presumes that no in-camera sharpening has occurred.

Fig 3 – It's the three interdependent parameter sliders that frighten so many users from exploiting the Unsharp Mask (USM) filter.

Using sharpening tools

Filters such as Sharpen or Sharpen More sound the ideal panacea for a soft image. But these simple filters, which can be found in virtually every image-manipulation application, will confer no favours on your images. Both (Sharpen More is identical to Sharpen, but applies its effect about four times more strongly) give an image a sharpened look but do so without fear or favour of the content of the image. In doing so they can achieve our objective in certain parts of the image but enhance and exacerbate defects and artefacts in other parts. No, our ideal image-sharpening tool is one that can be applied in a controlled fashion, delivering the appropriate amount of sharpening for specific elements of an image. And we find this in the Unsharp Mask filter.

The Unsharp Mask is not the easiest of filters to master. Unlike the simpler sharpening tools it features three control parameters that need to be subtly and crucially adjusted to get the best from the image. These are Amount, Radius and Threshold (see fig 3).

- *Amount* Perhaps obviously, this describes the amount of sharpening effect applied. It's important to recognize that the process of sharpening doesn't restore any missing image detail (that is lost for good and nothing can be done about it), but adds edge contrast to give the perception of sharpness. Adjusting the Amount slider will determine how much edge contrast is applied.
- *Radius* Adjust this and we increase the distance in pixels from an edge over which edge contrast

Fig 4 – To sharpen this informal portrait, which is a low-frequency image (see left), we set the Amount to 110, the Radius to 2 and the Threshold to 10. This is sufficient to avoid sharpening to the skin but ensures that the clothes and hair are rendered with sufficient crispness (see centre). Increasing the Radius to 3 and the Amount to 200, in the final image, gives an oversharp result. Sharpening artefacts are visible on the face, while the hair and grass take on an unnatural look (see right).

is enhanced. As we increase the radius, more pronounced sharpening is achieved that rapidly gives way to halo effects, signifying oversharpening.

- *Threshold* There will be some areas in an image where we don't want the contrast enhanced to give an edge effect. Think of blue sky, for example, or soft skin tones. With no threshold specified there will be a risk that previously unnoticed noise in these regions of an image will be enhanced and made significantly more obvious. A good threshold setting avoids sharpening being applied to these areas, but allows those areas with "real" transitional edges to have the sharpening effect applied.

Unsharp Mask filter settings (figs 4 & 5)

The precise settings used will vary from image to image and will also depend on the resolution of the image. High-resolution images will require a greater radius setting, for example, to achieve a visually similar effect to the same image at a lower resolution. But we need to define some start points from which we can then hone and refine the settings to achieve the best results. This is most easily done by distinguishing between two different types of image.

The first are dubbed high-frequency images. By high frequency, we actually mean those images that contain a lot of fine detail, fine detail that it is important to render as sharp as possible. Images in this class would comprise landscapes – especially those with large amounts of foliage where individual (or clumps) of leaves need to be discriminated. Rooftop cityscapes, where we see a large number of buildings each with a considerable amount of detail also fall into this class. For these we need to apply sharpening to all parts of the image and so we set the Threshold to 0. To preserve small-scale detail we need sharpening to take place over a small scale and so we must set the Radius to 0.5. The Amount setting will vary between 125% and 250%, depending on the subject matter (cityscapes respond best to higher values)

Our second class principally includes portraits. We call these low-frequency images. A portrait needs to be critically sharp, but parts of the face and skin react adversely to sharpening, introducing artefacts and giving an unflattering appearance. For these we would take as our start point an Amount of 100, a Radius of 3 pixels and a Threshold of between 5 and 15. This threshold ensures that random colour and tone fluctuations in the skin are not exaggerated by the sharpening process.

MODIFYING DEPTH OF FIELD (FIG 6)

Harnessing the power of a lens's depth of field (the perceived area of sharpness both in front of and

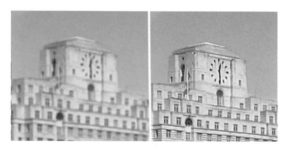

Fig 5 – For this cityscape (see top) – which also includes a certain amount of foliage for good measure – settings of Amount 150, Radius 0.5 and a Threshold of 0 gives an appropriate sharpening effect (see centre). The actual effect is more clearly seen by examining the close up of the clock on the Portland Stone building (see above).

benefits, not least being you can be pretty certain that shots will be in focus even if the focusing system of the camera did not precisely target the key subject. It also improves the perceived quality of the shot. We instinctively consider a sharp shot "better" than one that is slightly soft in focus terms.

If you have a compact camera or simply need to exaggerate the shallowness of the depth of field in an image, there are two ways to achieve the result. The first is manually to select and blur specific regions in an image. It sounds complex and a little fiddly and, up to a point, it is, but the task is by no means onerous. It also allows you to get the most controlled effects. We'll use that in a moment to discover how best to implement the technique.

Fig 6 – Left to their own devices, many cameras strive to deliver the greatest depth of field (see top). In cluttered scenes such as this it makes it difficult for the eye to settle on a key element. Increasing the depth of field helps to draw attention to just one element (see above).

behind the point actually focused on) is a powerful tool. Shallow depth of field can help to isolate a subject and draw attention to it without unduly separating it from that environment. The trouble with many digital cameras (along with many conventional compact cameras) is that their lenses offer a very extensive depth of field. This has many

Fig 7

Fig 8

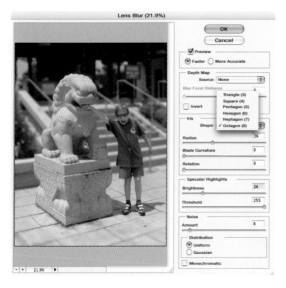

Fig 9

Fig 10

The Lens Blur filter

Users of Photoshop CS have an additional, semi-automated alternative in the form of the Lens Blur filter, which is one of the Blur filter set. In its simplest form, you select that part of the image that you want to remain in sharp focus (normally the main subject) and the filter will blur the surroundings. For more sophisticated and realistic effects you need to create a depth map of the image. This indicates to the filter which parts of the scene are further away and hence need to be blurred more.

In this example, the subject is the child and the dragon statue (see fig 7). We need to select this first. Moreover, we also need to select all those parts of the image that are equidistant from the camera. These are those parts of the image that would also be in focus were the depth of field effects in this image for real. In this case it's the paving beneath both the child and statue that needs to be included. They are shown here shaded blue (see fig 8).

The Lens Blur filter allows us to emulate the blurring produced by different lens irises. The number of blades in a lens's iris will determine the actual type of blurring and the options provided let us apply blurring from irises with three to eight blades. For most people, this is extremely pedantic; the look of the blurring invoked by each is different, but subtly so. Where the feature comes into its own is where there are lots of specular (mirror-like) highlights. This doesn't have a particularly pronounced effect in images such as this – but if we were applying blurring to a backlit shot of a seascape, for example, then we would notice a difference as each highlight on each wave was blurred into a shape dictated by the shape of the iris (see fig 9).

The end result of applying Lens Blur is remarkably effective (see fig 10). If we had taken the time to create a depth map then we could have got even better results with those parts of the image that are more distant (the gateway in this case) blurred further.

Fig 11 LENS BLUR 0 LENS BLUR 20 LENS BLUR 40 LENS BLUR 80

More about the Lens Blur filter (fig 11)

With the Lens Blur filter it is easy to adjust and compare the effect of blurring by moving the Iris Radius slider. Here, for comparison, is the same image with 0, 20, 40 and 80 pixels radius blurring applied. No setting is correct but each has a different effect on the image.

DIY adjustment

Whether we are going to create a depth map (the full details of which are beyond the scope of this book but are detailed in Photoshop's copious help menu) or manually alter the focus in an image, we need to begin by analyzing the image and breaking it into different "focus zones". These will be areas to which progressively more blurring is applied. By feathering the selection of these we can produce results that are pretty much seamless.

Take a look at the schematic (see fig 12). The camera, at "A" is taking a photograph of the subject at "C". There is foreground detail at "B", and background detail at "D". In the distance we also have the cityscape at "E".

In the majority images it is the most distant parts of the image that are the most unfocused. Middle-distance objects will also be less in focus. But the amount of blurring that needs to be applied to foreground objects is different to that which needs to be applied to those further away. The red shading shows, approximately, how the amount of blurring changes with distance. Here we would apply a similar amount of blurring to the foreground elements at "b" as we would to the background "d" even though the latter is considerably further from the subject. Items very close to the camera (such as overhanging foliage) would need to be rendered very much out of focus.

Let's apply this theory to this image (see fig 13). It's a small-scale one and we might have expected even a compact camera to give a narrow depth of field. But alas, no! We'll need to accentuate it ourselves.

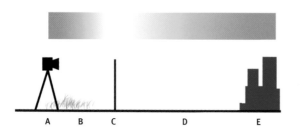

Fig 12

Fig 13

Fig 14

Fig 15

Fig 16

Fig 17

Fig 18

Fig 19

Fig 20

Fig 21

1. Select the table and the cereal packet. Though the latter is already slightly blurred we will need to make it more so. The Magnetic Lasso works well for this but set a Feather amount of around 5 pixels to avoid sharp boundaries. If we were to switch to Quick Mask mode this is how the image would look (see fig 14).

2. Apply a Gaussian Blur of about 2 or 3 pixels. If the blurring looks too much, reduce it. Similarly, if the effect is too mild, increase the amount. Gaussian blurring is based in absolute pixel dimensions so the amount you apply will depend on the resolution of the image (see fig 15).

3. Select only the cereal box. Though this is not substantially closer than the table, the closeness to the camera does demand a greater degree of blurring. In this case, it is particularly important that you feather the edge of the selection so that there are no abrupt boundaries (see fig 16).

4. Apply a similar amount of Gaussian Blurring to the selection. This will soften the already blurred box further and give a strong out-of-focus result

(see fig 17).

5. Now we can turn to the background. The near background, though some way behind the subject, needs only a modest amount of blurring. This equates to the region "d" in the focus diagram (see fig 12) and should be a little less than that applied to the table in step 1. Select all the background and then apply our modest amount of Gaussian Blur (see figs 18 & 19).

6. Our final mask contains only the more distant parts of the room. Granted, in scene like this there will be little in the way of "distant" but for maximum effect we can apply a further modest amount of blurring to the furthest reaches of the room (see fig 20).

7. The net result is a convincing image with shallow depth of field. As a result, it is an image where the emphasis on the subject is strongly enhanced (see fig 21).

SOFT FOCUS

Prized by the portrait photographer, soft-focus effects are key to a romantic, dreamy style of

portraiture. But often the effect is often misinterpreted. Soft focus doesn't mean out of focus. On many occasions photographers have attempted to achieve the subtle, dream-like look by simply defocusing the lens slightly. Sadly the results are never anything more than what they are – blurred. The irony is that creating a genuine soft-focus result is a simple process.

The essence of soft focus is to record a critically sharp image of the subject but combine it with a soft, out-of-focus image of the same subject. The result is an image in which we see the subject in sharp focus but, by virtue of the overlaid softened image, fine detail becomes softened and the whole image given a romantic mistiness.

Over the years, a number of solutions to soft focus have been produced. We've seen soft-focus lenses that deliberately soften images by not correcting some of the (normally) damaging aberrations and distortions introduced by optical systems. Hasselblad – with their Softar range – and others have produced soft-focus filters. These use a pattern of glass blisters over the surface of a clear-glass lens to produce the image softening. But all these in-camera solutions have one problem – once you've taken the shot, you are stuck with that degree of softening. A digital darkroom solution gives

Fig 22

far greater control. We'll examine this approach by applying it to an informal portrait.

1. Choose the image you want to soften. We've selected this girl with a seal. But the background is cluttered and intrusive and less than inspiring. Let's begin by cutting the girl from this image and placing it in another (see fig 22).
2. A combination of the Magnetic Lasso and the Quick Mask (to give a soft edge to the child's hairline) was used here (see fig 23).
3. This is the image we will use for the new background. Since both images were taken within minutes of each other, the colour balance needs little attention and the scaling of both is similar (see fig 24).
4. We can now copy our selection from the first image and place it on the second, verifying our presumptions about the colour balance. We can, at this stage, adjust the position of the child and crop the image if required, to improve the composition (see fig 25).
5. To emphasize the child – before applying the soft focus – we can deliberately blur the background. Make sure that the background layer is selected and apply the Gaussian Blur filter. The amount will vary according to the resolution of the image. You need to apply sufficient to blur the detail but not so much that the scene looks unrealistic (see fig 26).
6. Now we can produce the soft-focus effect. Flatten the image and make a duplicate copy of it (Layer⋯⇒Duplicate Layer). Blur this layer using the Gaussian Blur. Make this blur greater than that

Fig 23

Fig 24

Fig 25

Fig 26

Fig 27

Fig 28

Fig 29

you applied to the background. Don't worry that at this stage the whole image now appears blurred (see fig 27).

7. On the Layers palette, ensure that the new layer is selected and move the opacity slider to the left. A setting between 35% and 55% will give the result we are after. This will give sufficient blurring to soften the image but with enough of the original image showing through to maintain sharpness (see fig 28).

8. In this case, we can embellish the effect by adding a further layer, a copy of the blurred one. This time, rather than change the opacity we will change the blend mode. Change it from Normal to Screen or Lighten. This gives a modest high-key look to the portrait (see fig 29).

Looking at the image in close-up shows the difference between a blurred and a softened image. In the blurred image (see fig 30) there is softness but no detail. The softened image preserves all but the finest detail but combines it with a soft glow. The finest, low-contrast detail that is lost

Fig 30 – The original and final image details compared.

tends to be that which is least flattering – skin blemishes or unwanted texture for example.

CREATIVE BLURRING

We tend to consider blurring as a negative – the result of poor technique or using a camera outside its sensible operating range for the conditions. Hand-held long exposures and the use of extreme telephoto lenses without adequate support both tend to produce fundamentally unsharp images due to camera movement. But blurring can also be introduced in a controlled way to emphasize movement and increase the dramatic impact. We traditionally do this by panning the camera with a subject to keep the subject sharp and render the surroundings blurred. Or we may chose to do the converse – keeping the camera rigidly mounted and allowing the subject to move and blur as it is recorded.

Blurring techniques can often be a hit and miss affair: get the timing fractionally wrong and results will be unacceptable. Digital blurring gives us far more control and only requires that we take a sharp original. We can choose later the type of blurring we want – subject or background – and even its extent. Furthermore, we can be even more selective in our blurring as this first example shows.

Enhancing motion

1. Shooting a subject like this roller-coaster (see fig 31) illustrates how problematic it can be to convey a sense of movement through blurring. To fill the frame you need to get close to the action; but at this distance there will be a modest amount of blurring even when high shutter speeds are chosen. The result is an image that looks compromised. We do have blurring due to the motion, but this does not appear to the viewer as a creative technique – rather, the image simply looks unsharp.

2. Let's begin by enhancing the motion. Use the standard Lasso tool and select a Feather amount.

Fig 31

Fig 32

dialogue box to adjust the angle of motion to ensure that it aligns with the direction of the roller-coaster. We can also use the slider to increase or decrease the amount of blurring (see fig 34).

Fig 33

This should not be too large in this case: what we want to do is select the cars but without making the selection too abrupt. For this 4 megapixel image, a radius of 10 has been selected. Anything more will partially select too much of the background, causing problems later (see fig 32).

3. We can now copy this into a new layer by choosing Edit·····⟩Copy and then Edit·····⟩Copy. If we click on the little eye icon in the Layers palette corresponding to the background of the original image, we can see our selection in isolation (see fig 33).

4. Apply the Motion Blur filter (Filters·····⟩Blur·····⟩ Motion Blur). This will blur the selection only in a chosen direction. Use the little wheel icon in the

5. Now we can combine our new layer with the original background to achieve a result that more clearly illustrates the motion. The result is much more powerful and by feathering the edge of the selection the result is a very smooth graduation between the moving and non-moving parts of the scene. The problem, though, is that in blurring the roller-coaster – the subject of the photograph – we have taken away the detail of this key subject. Look at the photograph and the eye tends to drift around the scene and doesn't settle on any one point (see fig 35).

6. So, we need to restore a central subject to the image. We can do this by selecting some of the riders on the roller-coaster and making them appear less blurred. Use the Lasso tool again and draw around a pair, or perhaps two pairs, of riders. Use Edit·····⟩Copy and Edit·····⟩Paste again to paste this selection into a new Layer. This new layer should appear at the top of the stack, but if not drag the layer upward. Turning off (with the eye icon) the background and blurred layers now reveals our pasted selection (see fig 36).

Fig 34

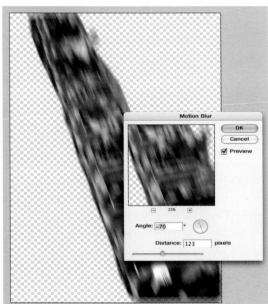

Fig 35

Fig 36

Fig 37

Fig 38

7. If we were to apply a modest amount of blurring to this selection we would still have a blurred result and, in compositional terms, there would be little improvement. Instead, use the slider on the Layers palette to reduce the opacity of this new selection so that we retain the sharpness of this layer but allow a slightly blurred copy to show through (see fig 37).

8. The net result of our efforts is a much more compelling image: we have conveyed the speed of

Fig 39

the roller-coaster but also retained detail that gives a more personal view of the action (see fig 38).

Rotational blurring and motion

Photoshop doesn't just give us the Motion Blur tool to help in our movement deceit; it also provides the Radial Blur filter. This is, if anything, more powerful than its stablemate when it comes to producing motion effects. It boasts two modes, Spin and Zoom.

Zoom applies axial blurring that simulates the effect we might achieve were we to operate the camera's zoom lens feature when making an exposure. The image appears to explode from the centre. It's great for concentrating attention and is widely used in sports photography and in car advertising to imply strong motion toward or away from the observer. It's an unsettling filter: the sense of movement can make for dramatic impact that really grabs attention, but it's not an image technique that you would want to use for images you intend to view for long periods (see fig 39).

We can achieve more intriguing effects using the Spin mode, particularly if we need to inject motion into a scene where there was actually no motion at all. The Spin mode produces rotational effects that can, for example, make static wheels look as if they are rotating. For best results you need to work with an image of a vehicle taken from the side, as square-on as possible. Our target image is this rear quarter of an MG sportscar (see fig 40).

Use the Elliptical Marquee tool to select the wheel and tyre. Because we are square-on, this will be a circle, or very nearly so. Applying a grid over the image can help in accurately defining the circle (see fig 41).

We could apply the spin directly to this selection. Unfortunately, getting the centre of the spin corresponding precisely to the centre of the wheel

axle can be difficult, if not impossible, to achieve. I find it easier to copy the selection and paste it into a new image. When you do this you create a new image that exactly fits the wheel and so the axle will be dead centre. Note that there are still some stray areas of grass visible beneath the tyre and through the wheel spokes (see fig 42). Don't worry about these – they will be of no consequence in our final image.

Apply the Radial Blur filter (see fig 43). Vary the amount using the slider to get the amount of spin you require. For convincing motion, I find an amount of 30 a good starting point. The spin is not previewed as you nominate it, so you will need to apply and then use Edit⋯⟩Step Backward to return to apply a different amount. Use Draft quality when testing the amount of spin but use Best quality for the final application. Draft takes considerably less time to render the image.

We can now paste the spinning wheel back into the original image. It may be necessary to trim the position slightly using the Move tool. The spinning effect is remarkably realistic because we were able to achieve precision in the spin centre's position. Sadly, though, the scene is rather spoilt by the obviously static ground (see fig 44).

To overcome this, select the grass area under the wheel using the Lasso tool and copy and paste it into a new layer. This layer should be positioned between the background and our new spinning wheel (see fig 45). We can then apply Motion blurring to this layer to give a better impression of motion.

Motion blur can be applied in exactly the same way as we did with the roller coaster. By placing this blur layer between that of the background and the spinning wheel, we ensure that we don't get any blur smearing of the grass region over the top of the wheel, giving a true perspective to the image (see fig 46).

If you were attempting a whole car you'd need to apply spin to both visible wheels of course but you'd also need to ensure that any of the surroundings visible through the car windows was blurred as well.

Fig 40

Fig 41

Fig 42

Fig 43

Fig 44

Fig 45

Fig 46

::CREATIV
T

CREATIVE IMAGE TECHNIQUES

CREATIVE IMAGE TECHNIQUES

In this chapter we will:

- **Explore the potential of adding grain to images.**
- **Look at ways of reducing the colour in an image for added emphasis.**
- **Discover opportunities in panoramic and stereo photography.**
- **Look more closely at the techniques and creative workflow required in image restoration.**

Creating a great image with our computer-based skills and knowledge of photographic technique is not just a matter of applying a digital filter or any other digital effect, creative or corrective, it's also about seeing and exploring the potential of the immense toolset that we now have at our disposal. Through this chapter we'll explore some useful techniques and opportunities. We'll work by exploring new techniques but also exploit those that we have gained an understanding of already. We'll start by looking at how we can add mood to an image though the creative use of grain.

ADDING MOOD WITH GRAIN

Photographers have always viewed grain (the visible appearance of the dye clouds or clumps of silver halides that make up the image-carrying layer of conventional films with a certain ambivalence. One argument considers it a necessary evil. It exists but we do our best to conceal it. We can do this through using a fine-grained film, such as the low-speed Kodachromes and Fuji's Velvia, or we can process the film in a way that reduces the appearance of any grain.

A counter argument defines grain as essential and the key to making an image successful.

Of course, in general photography there will be situations where grain does add to an image's mood or potency and others where it simply detracts. We

can think of, for example, the sun-drenched beach scenes where we seek to capture areas of pure colour, unadulterated by any texture. Conversely,

Fig 1

Fig 2

Fig 3

there will be times when we want to convey grittiness, whether in a landscape or in a portrait. Here, the grain can actively contribute to the success of the image.

In our digital world we have traded grain for pixels. Benefit or loss? Sadly, pixelation doesn't seem to have as much emotional power as grain. But, answering the cries of many photographers,

image-manipulation applications include at least one way to add grain to an image. And that grain can mimic the characteristics of almost any film and do much more besides, giving images a unique texture.

Applying grain

Some subjects positively cry out for the addition of grain. We can probably think of many of these instantly, but to exploit the mood successfully is not as simple as applying an appropriate filter. Here we've an image of some amateur engineers working on a small-scale locomotive (see fig 1). Taken with a high-resolution digital camera, it boasts that almost pixel-free look so prized in many types of photography.

BLUE

GREEN

Fig 4 **RED**

1. Begin by applying a simple grain structure to the image. But rather than the Grain filter, here we've used the Add Noise option of the Noise filter submenu. This allows us to apply a controlled amount of random noise to the image (see fig 2).

2. The grain – or rather, noise – has given the image that grittiness that so ideally suits the subject matter. But, and unusually for such a subject, the result is still rather colourful. There is too much colour in the image competing with the grain and the overall composition. Let's reduce the colour range by selecting the Hue/Saturation command and lowering the saturation of yellow and magenta. Use the Edit pull-down menu to select each colour and then move the Saturation slider to the left (see fig 3).

3. With only the essential colours preserved, the image is much more balanced. But we can go further. We can split the image into its component channels and see it in red, green or blue light. Viewing the images, as monochrome images, in each of these colours, gives quite a different look. In the blue channel image, for example, the blue of the locomotive becomes white, whereas in the red channel it becomes virtually black. Split the image into separate images by selecting Split Channels from the pull-out menu on the Channels palette (see fig 4).

4. Though we lose the locomotive colour it is probably the blue channel that gives the most

Fig 5

Fig 6

successful result, more so than the red (the green channel almost invariably proves somewhat lacklustre). In particular, the people's faces have more character and colour in this version (see fig 5).

Tips

- Grain can be successfully used in montaged images. Where elements of an image have come from different sources, or you have added areas of continuous colour (using a painting tool, for example), results can look obviously jarring. Adding a very mild amount of grain or noise can help give the image an integrity it was previously lacking.
- Alternative treatments can give intriguing results. This is the Grain filter, set to Contrasty. The result is almost a graphic, posterized image (see fig 6).

REDUCED COLOUR IMAGES:
BRINGING SEPIA INTO THE NEW CENTURY

Digital sepia toning is something I have personally shied away from. It's partly because the effect is so overdone to have become a digital cliché. And, in many cases it serves no useful purpose. It is rarely that an image is given greater impact by the simple replacement of a panchromatic palette with a simple colour tone, no matter what the devotees of monochrome might suggest. Giving an antique, heirloom print this treatment may work for some but not for me. Part of my aversion to the technique is that, in the digital world, it's something of a cop-out. We can take a mediocre image, apply a monochrome

tint and feign that the result has merit by pretending it is older than it is.

Digital technology really does offer us the opportunity to do much more than this. But whatever technique we choose it's important to begin with an image that is at least competent and that will benefit from the changes made. Reduced-colour images need to have not only technical potency but also artistic merit.

A useful shortcut to the former that also delivers the latter comes in the form of a Photoshop filter plug-in from Flaming Pear Software. Called the Melancholytron, Flaming Pear suggest that it imbues images with a "certain sadness". Whether sadness is a quality of photographs (rather than their content) is debatable but there is no doubting that the Melancholyton is adept at transforming the mood, colour palette and focus characteristics of an image. The result is a range of effects that can be likened to sepia tones but which are free from the hackneyed associations.

The Melancholytron interface

Giving an image the dreamlike aged quality requires one of those apparently intimidating interfaces that we explored with Alien Skin's Lightning filter (see page 132) and Melancholytron's stablemate, Flood (see pages 133–134). Understanding how it works is best done by breaking the controls into groups (see fig 7).

The top pair of sliders control the shape of the area over which effects will be applied. This could be a central vignette or soft, horizontal or

vertical bands. The extent of the vignette or width of the bands can be altered by using the second of the sliders.

The next set of controls labelled Focus affect, naturally enough, the focus of the effect. These comprise the amount of overall blurring and also the degree and width of colour blurring.

In the Saturation controls we can change the saturation of the modified colours and the colour of the vignetting. The Sepia slider determines how much sepia is introduced into the image. There's no getting away from this colour, but at least here it's being used in a creative sense. The Glue pull-down menu offers a range of features that are, essentially blending modes.

With this wide range of controls on offer it can be perplexing to configure for a particular image. So the button at the bottom of the dialogue marked with a dice lets you make random settings. Each selection can be previewed in the dialogue. Find one that you like and you can adjust the sliders to make

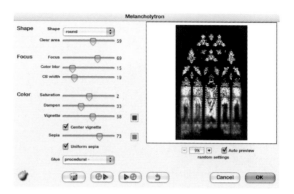

Fig 7

a more precise configuration.

Bear in mind that with filters as overt as this, there is no right or wrong. If the results look good to you then they probably are; just try a few tweaks to the settings to see if you can further improve the results. Just as an example, here are four random interpretations of images of a church interior and exterior (see fig 8).

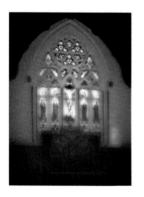

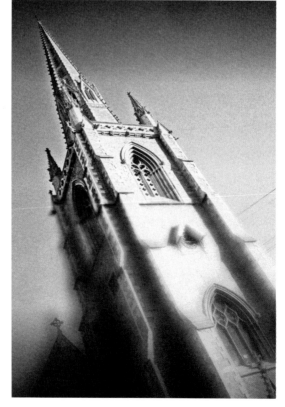

Fig 8

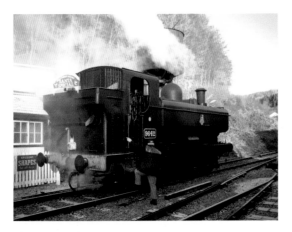

Fig 9 – Original image.

Fig 10 – Colorized image.

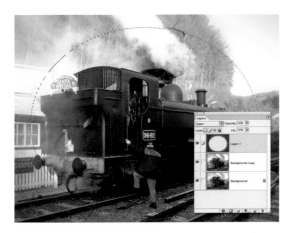

Fig 11 – Layered image.

Fig 12 – Final, reduced-colour image.

Reduced colour from your image editor

If you don't have Melancholytron you can still produce reduced-colour results using conventional tools. To produce an atmospheric interpretation of this image of an old steam train (see fig 9), we first produced a duplicate layer and then, using the Hue/Saturation dialogue, clicked on the Colorize box. The result is a sepia-toned image (move the Hue slider to obtain the precise colour you want).

Next the opacity of this layer was reduced to allow the original image to show through. With a vignette applied, using the Elliptical Marquee, the borders were blurred with the Gaussian Blur. Finally, a brown gradient was applied to the vignette in a new layer and the Blend mode changed from Normal to Color, to give the brown tint to the blurred borders (see figs 10–12).

PANORAMIC PHOTOGRAPHY (FIGS 13–16)

Panoramic photography is one of those holistic photographic subjects where it is impossible to divorce the taking of photographs and the visualization of a scene from the darkroom work we need to perform to create the final results.

But before we begin, let's spend a little time on the terminology of landscape photography. We need to begin by looking at the different types of panorama and being a little more explicit about the term – the word "panorama" tends to be bandied around whenever a picture is substantially wider than it is tall.

The generally accepted definition of a panorama is an image that shows, widthwise, a view that is at least as wide as the eye is capable of seeing. This can extend all the way to a 360° view. This would

typically be wider than the view given by a widescreen TV (which has a ratio of width to height of 16:9 – called the aspect ratio) and more so than the 20:9 ratio used in widescreen movie films. But aspect ratio alone is a rather ambiguous way of describing a panorama. If we use a conventional 35mm camera with a 50mm lens (or the digital equivalent in terms of field of view a 360° panorama will produce an image with an aspect ratio of around 6:1. Use a wider angle lens and this ratio falls. With an 18mm lens it becomes 4:1. The wide-angle view will contain the same view as the standard lens but will also show a greater amount above and below.

The extreme panorama will capture 360° horizontally and 180° vertically. This, known as a spherical panorama, will have an aspect ratio of 2:1 and will capture everything in sight from the viewpoint of the camera.

We've said here that a panorama is a wide, horizontal image. This is perhaps being a too pedantic as it is possible to produce panoramas that are tall and vertical. For our purposes here, we'll regard both horizontal and vertical images as panoramas and the techniques apply equally both.

Cameras for panoramic photography

Panoramas can be shot with any camera, digital or conventional. And because our final image will be produced by joining multiple images together, we can achieve high-resolution results from digital cameras with comparatively modest resolutions.

You can, if you are serious about panoramas, buy dedicated cameras that will photograph an entire panorama in a single shot. These tend to divide themselves into fixed- and swing-lens types. All commercially available swing-lens cameras are film-based.

The fixed-lens panoramic camera simply offers a wide-angle field of view. The most common of these will have aspect ratios of 2:1 (which is relatively modest) through to 3:1. Fujifilm's 6 x 17 (cm) camera is probably the best known of these.

Fig 13 – 16:9 aspect: similar to a widescreen television.

Fig 43 – 20:9 aspect: a widescreen movie film.

Fig 53 – 6:1 aspect: panoramic image from a "standard" lens.

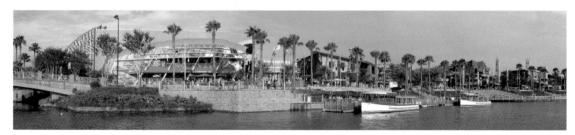

Fig 16 – 4:1 aspect: panoramic image from a wide-angle (18mm) lens.

This rangefinder-type model also has inter-changeable lenses. The benefit of a fixed lens (the term "fixed lens" describes a lens that is fixed in relation to the film, not permanently fixed to the camera) is that you can take shots of moving objects easily. Shots are instantaneous and capture the entire scene in one go.

Swing-lens cameras, popularized by the Russian Horizon and Horizont models use a lens that, during the exposure, scans through an angle of 120-150°, creating an image along a curved path on conventional film. Because it takes some time to swing the lens, up to 10 seconds for 150° (and even longer for those cameras offering 360°), recording motion can be problematic.

Both these types of camera deliver a conventional – albeit wide – image that can be digitized and manipulated as any other conventional image. The type of panoramic photography that concerns us here is that which employs conventional cameras and involves digitally joining shots together to produce a panoramic effect.

Shooting images for a panorama

Getting the shots for a panorama involves shooting images side by side around the whole of the chosen view. Each of these should overlap by as much as 50% (though 40% is more usual). It makes good

sense to use a tripod when shooting to ensure that all the shots are level and to allow you to concentrate on getting the consecutive shots correctly positioned (though the precise amount of overlap is of little consequence).

You'll also need to ensure that the camera is set for a wide depth of field, using as small a lens aperture as possible (if your camera permits). Lock the focus, too, if possible, to prevent the camera autofocusing on different distances in consecutive shots and ruining the overall effect.

When using a digital camera it's important to keep the same colour balance throughout. When swinging the camera through wide angles there is every likelihood that the colour balance – as evaluated by the camera's automatic white-balance control – will adjust to different elements in the scene, thus giving entirely different colour shifts in different shots. Set the camera to an appropriate daylight or indoor setting and keep it constant throughout.

Exposure changes can cause a similar problem between shots, especially on sunny days when changes of four or more lens apertures or shutter speeds can occur in the same sequence. Locking the exposure is one solution but when there is such a potentially wide exposure latitude there is a risk of some frames becoming hopelessly over-

Fig 17

in some image-editing applications that provide panorama stitching. So, for our first foray we'll use the one in Photoshop, called PhotoMerge. This debuted in Photoshop Elements and made its way into Photoshop itself shortly after. In terms of complexity it's fairly basic, but it's successful in automatically stitching together images so that only minimal remedial attention is required.

Like most applications, the first step is to load the images; it's a simple matter of loading each, from left to right, and then pressing OK. Then the application will automatically conjoin the images, presuming that there is sufficient information to do so (see Where panoramas go wrong, overleaf).

or underexposed. I tend to keep the exposure on automatic and make the corrections (to balance the scene) later.

A first panorama

Creating a panorama involves the following steps:

- Shooting the individual pictures.
- Importing the images into the computer and the panorama application.
- Stitching the images together.
- Editing or refining the results.

We'll assume now that we have some images taken using the techniques described above. We now need to import the images into a panorama application.

But what is a panorama application? Like general-purpose image editors there are a number of packages out there ranging from the basic through to the very complex. There are also modules

1. Once the images have been joined you'll see this dialogue (see fig 17). You can see that, position-wise, the images have been successfully joined, but not seamlessly. Notice how the sky has some soft but obvious join marks.

2. Tick the Advanced Blending box and there will be a better attempt made. This makes an improvement but doesn't make the joins invisible (see fig 18).

3. The errors are even more obvious when the image is saved. There are overlap artefacts and, visible at the top and bottom edges, alignment problems (see fig 19). These illustrate the virtue of using a tripod.

Fig 19

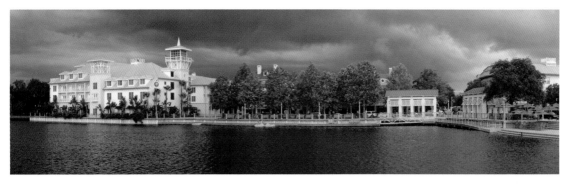

Fig 20

4. With a little sleight of hand via the Clone tool we can correct all of these errors, cropping the image to remove the top and bottom edges (see fig 20).

5. To finalize the image (see fig 21) we have increased the colour saturation using the unsharp colour technique discussed earlier on pages 82–83.

Photomerge is simpler than some programs in that it analyzes the picture and makes appropriate assumptions without the user needing to intervene. In some applications you can manually adjust the relative positions of different images (for those rare occasions when the auto algorithms have failed to link the images successfully). You may also need to specify the lens used to take the images. This will ensure that the angle of views and any corrections made echo those of the original lens type.

Where panoramas go wrong

Panorama creation is pretty straightforward, but things can go wrong. Here are a few examples, along with the remedial steps you need to take to correct them.

- Images don't stitch together, or don't stitch together well. There is not enough overlap between adjacent images or there are confusing details in the images. Manually correct (or retake the images if possible).

- Join artefacts are visible in areas of flat colour. The brightness levels between adjacent images are too high for the program to correct. Use the Clone tool for minor corrections or replace areas of flat colour (such as the sky).

- Badly distorted images. You've specified the wrong lens type and the program is trying to compensate. Rerun the panorama generation using an alternate setting.

- Very stretched panorama. The program is trying to produce a 360° panorama. Uncheck the 360° box.

THREE-DIMENSIONAL PHOTOGRAPHY

Three-dimensional (3-D) photography has much in common with panoramic photography. It, too, needs specialized equipment totake photographs. But, again like panoramic photography, we can use

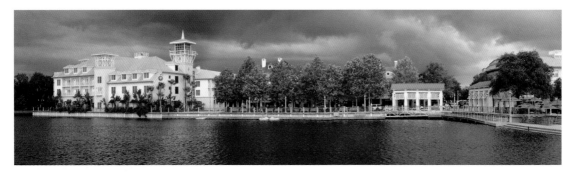

Fig 21

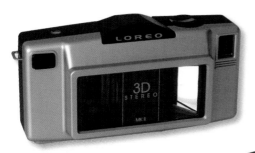

Fig 22 – Kits of cameras and viewers make it possible to both take and view 3-D images using conventional media. These examples are by the prolific exponents of 3-D photography, Loreo.

eyed to see the combined image, you need to focus on a point beyond the images and then let your eyes regain focus on the near images. It is harder to achieve but is generally more restful on the eyes and gives a better effect.

Anaglyph images separate the images for each eye by using complementary colours (usually red and blue or red and cyan) and tinting each image appropriately. By wearing glasses with the corresponding tints, each eye will see only the image with that tint, the other being darkened. In fact you will see some ghosting because the colour tint is never precise and so some of the complementary image will be visible to each eye.

Shutter Glass images are rather like anaglyphs, but the separation is not achieved by colour – instead images are alternated on the on screen. Using a high screen-refresh ratio on the computer monitor, each image is displayed for around 1/25 second. With special LCD shutter glasses each eye can see only the appropriate image before the LCD turns black to blank out the alternating image. This tends to give great imagery in full colour. The drawbacks are that it only works generally with CRT monitors – LCD displays tend to have an image lag that means it is not possible to swap images fast enough for the effect to work. Costs, too, are also high.

simple, conventional equipment and produce the unique imagery by using digital techniques.

To get a 3-D effect – to re-create the depth of the original scene – we need to view the images so that the image corresponding to the view from the left eye is seen only by the left eye and the right view by the right eye. Traditionally this was achieved by mounting the two images side by side and placing them in a viewer that screened the view to opposing eyes. This device is known as a stereo viewer and was popular in the nineteenth century and it uses a similar optical geometry to the Viewmaster viewers that are still available today (see fig 22).

Alternate systems have been devised that do away with some, or all of the cumbersome viewing apparatus. Freeviewing is a technique that is designed to view a pair of side-by-side, 3-D images using no viewing equipment whatsoever. It's a skill that needs to be learned; it involves looking at the two images and then letting your eyes overlap the images while keeping them in focus. The skill comes in keeping the focus: when the images cross over (as when we go cross-eyed) our eyes interpret this as an attempt to focus on a close object (see fig 23).

A variation on this technique is to have the images reversed and use the similar technique of parallel viewing. Rather than needing to go cross-

Fig 23 – With practice, you can train your eyes to superimpose these two images to create a three-dimensional view.

RECORDING THREE-DIMENSIONAL IMAGES

The ideal way to record two identical images to make up our 3-D pair is to use a dedicated 3-D camera. Though there are some models available today they tend to be high-priced, specialized products. There are also older camera that appear in the small ads columns of photographic magazines, and websites and can often be found on eBay. More recent models, such as those from Nimslo, Nishika and ImageTech, were designed for use in lenticular systems (those using a special fine lens-like overlay to the print to help create an image with apparent depth), but can still be used by taking the outermost of the four or three images recorded for each shot.

There are no off-the-shelf 3-D digital cameras. Some pioneers have crafted their own by putting together two identical cameras but these can be problematic in use and, obviously, represent a rather expensive solution. A beamsplitter, which sits over the lens and splits the image into two separate images corresponding to left and right views, will work with full-frame digital SLRs, but this device is not currently suitable for any other camera types (see fig 24).

So, for those of us who can't justify the cost of buying specialized equipment, we need to find an alternate solution. This involves using a single camera and taking two shots. These shots will clearly be separated in time and so are not suitable for moving objects.

The simplest approach is to take one shot of a subject, making sure that your weight and centre of gravity are over your left leg. Then, without moving the viewpoint of the camera, shift your weight toward the right leg and take the second shot. Use a slightly wider-angle lens (or a wider setting on a zoom lens) than would be ideal for the shot. This provides some leeway for trimming the images to account for the inevitable lack of alignment.

For those bitten by the bug there is the Mission 3D kit, which precisely positions the camera for the left and right eye. The bonus of this kit is that it also compensates for macro and long-distance shots.

Creating a three-dimensional image (figs 25–27)

Once we have our two images we need to ensure that they are suitably matched to produce a stereo pair. This applies even if you use a kit such as that from Mission 3D.

1. Load the left-eye image into your image editor and enlarge the canvas slightly (by around 20%).
2. Open the second, right-eye image. Copy and paste it into the left-eye image, where it will appear as a new layer.
3. Reduce the opacity of the layer so that you can see the background through it.
4. Use the Move tool to overlay the central part of the right-eye image over the corresponding part of the left, and then crop the image.
5. Use Canvas Size to double the width of the image and then drag the right-eye image layer over to the right to create the stereo pair.

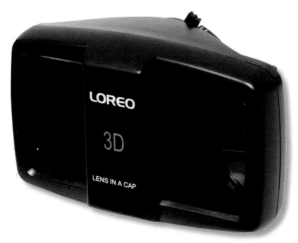

Fig 24 – Beamsplitters currently work only with full-frame digital and conventional SLRs.

Viewing digital images without a viewer

If you don't have a stereo viewer or want to use anaglyph techniques, here's how to view images unaided. It takes some practice, but perseverance will pay off.

1. Display the combined image on screen so that each half is around 12 x 18cm (5 x 7in).
2. Look at these from the normal viewing distance. This is nominally around 50cm (20in).

Fig 25 – Match the central part of the image (or the principle subject) in the two images prior to cropping.

Fig 26 – Your stereo pair is now ready for viewing either in a viewer or using the technique detailed in the box (see below).

Fig 27 – Anaglyphic images – designed to be viewed with appropriately coloured glasses – need to be tinted and then overlaid. This tint should correspond to the colour of the glasses and can be applied using the Photo Filter feature. When the images are overlaid, the opacity of the overlaid image needs to be reduced to 50%.

3. Hold a finger over the join of the two images and bring it toward your eye and keep it in sharp focus.

4. Lower your finger. You will find the two halves of the image superimposed (or nearly so), although very much out of focus.

5. Keep staring at the image but avoid your eyes correcting the displacement. Slowly you will see the images gain focus. You may need to repeat the process several times to build up your ability.

6. Eventually you'll be able to keep both images superimposed and focused. Then you'll see a single, three-dimensional image.

Achieving this is something of a skill – so perseverance is very much a keyword.

Fig 28

Fig 29 – The Detail
dialogue box.

CREATING LARGE IMAGES AND CHANGING IMAGE SCALE

You may know from your days working with conventional images that there is a finite amount you can enlarge an image before the quality – depending on the size of the original negative or transparency – suffers. Enlarge even a good-quality 35mm original to, say 50 x 40cm (20 x 16in) and the grain structure and "softness" in the camera lens compromises results. Any further enlargement will merely enlarge and exacerbate these optical limitations.

Digital images, too, suffer from this finite enlargement limit. Enlarge a digital image beyond its limits and you make the pixel nature of the medium obvious. There are times when this will make no difference. If you are viewing the resulting print from a distance, for example, or the pixel structure is being used for deliberate creative effect, but as a rule there's a top limit to the size of enlargements.

Image-manipulation software allows you to resample an image – that is, create a new version of the image at a higher resolution – with the "new" pixels produced by taking an average value from the fewer original pixels. Rarely is this successful: you

simply can't add detail to an image where there was no such detail in the first place. Resampled images – or those resampled to a larger size – just don't work.

But the designers of digital image-manipulation software are rarely ones to concede defeat and have sought to overcome this constraint. One of the fruits of their labours has been a product called pxl SmartScale, from Extensis. This exists as a plug-in to Photoshop that lets you increase the size (in resolution terms) of an image by up to 1600% without the usual problems and artefacts normally associated with resampling.

When an image is enlarged by resampling, the higher resolution is achieved by, as we've already mentioned, averaging the colour and brightness values for each new pixel from those of the underlying, larger ones. This is more accurate than you might imagine but it does tend to give a soft, unfocused result.

Dedicated applications such as pxl SmartScale give more convincing results by analyzing the image while resizing. It identifies features in the image, such as edges, and also analyzes the image for sharpness. Then, as the image is resized, this sharpness, the edge detail and contrast profiles can

all be preserved. A sharp edge remains a sharp edge, rather than becoming a more gradual transition, as would be the case in a resampled image.

pxl SmartScale uses a Photoshop-like interface to help you enlarge your images. It benefits from having very intuitive controls that let you enlarge an image in terms of pixel dimensions, document size or even by using a smaller-larger slider (see fig 28).

These controls enable your image to be resized, but to get ultimate quality we need to look at the Detail palette (see fig 29). It is here we can refine the image and enhance the details. In particular we can improve:

- Overall sharpness This is how much our "new" image is sharpened or blurred over the original. Sharpness here is perceived sharpness. The more the better, generally, but too much can sometimes cause image artefacts (anomalous noise) to appear.
- Edge contrast Use this to enhance the contrast at all edges in the image. More contrast gives the perception of a sharper edge.
- Edge detail Allows control over the representation of detailing in the edge.
- Extreme edges We'd normally eschew this for photographs. It makes edges very sharp for graphics and computer-generated images. This is too abrupt for natural subjects.

With just a little practice and understanding of these controls it really does become possible to produce very sharp, high-resolution images (see figs 30 & 31).

Tips
- Don't consider applications such as pxl SmartScale as an alternative to sourcing large, high-resolution images. It should be considered something of an emergency tool for those occasions when extra resolution is demanded.
- The more you enlarge an image the less successful even pxl SmartScale will be at rendering. Extensis suggest 1600% as the maximum enlargement amount; you may find that even this is too much but, on occasions, greater enlargement will be possible.

ORIGINAL

Fig 30 – Enlarge a small original by even modest amounts and the results are, at best, disappointing, as this close-up of an image enlarged by 400% shows.

ENLARGED 400%

ENLARGED 600%

ENLARGED 600% USING PXL SMARTSCALE

Fig 31 – Using pxl SmartScale the results are much more acceptable, with edge detail preserved and perceived sharpness increased. This was a 6X (600% increase)

Fig 32 – For this discoloured print we were able to use the Levels command to restore balance. We were lucky: the white snow provided our white point and the dark shadows in the hut, the black point.

IMAGE RESTORATION

The fact that photography has been around so long means that there are an awful lot of pictures out there. Care for them well and they'll last for years. Be negligent, however – even unwittingly – and they can deteriorate quite quickly.

It was on the premise of restoring such pictures that image-editing applications made their name in the early days of digital. The draw of being able to bring back to life old, cherished images was significant and for many marked their first steps in image manipulation.

Before embarking on any restoration it's important to analyze the contributory factors in the original's deterioration. It's also important, if you are undertaking such restortation on behalf of a friend or colleague, to provide reassurance. Though we talk about restoring an old image we should say that we'll be working on a copy of that old image. Though the originals may not be of any intrinsic value, people would still be loth to part with them if they thought any actions might further compromise them.

Let's begin by looking at the causes of deterioration and outline how we can deal with correcting them. We will then look at two restoration projects. The first involves a vintage image: a monochrome picture we might have in our family album dating back to the early decades of the twentieth century. Then we'll look at a more recent colour image. The advent of colour emulsions brought new opportunities for photographers, but also a whole raft of new problems regarding print longevity.

Discoloration (fig 32)

This can be due to a number of causes. If it is a general effect it can result from the action of time on the original chemistry of the image. The sepia toning so beloved of those seeking to emulate heirloom prints is a case in point. Old prints were never meant to turn this colour (no matter how attractive you do or don't consider it to be), but the action of airborne chemicals, deterioration of chemicals in the print itself and many other reasons can produce very similar results over time.

On more recent images, there can be similar effects due to imprecise printing. Those of us who have worked in the conventional darkroom have all been guilty at some time or other of taking shortcuts. Cutting the time a print is in the fixer (after all, it didn't seem to need the full ten minutes, did it?), leaving the last print of a run in the solution overnight, or cutting back on the washing time. All compromise print quality – not today necessarily, but certainly in the years to come.

Localized discoloration can have atmospheric causes, but is more likely to be due to contact with other materials. Photographic emulsion, even years after being used to produce a print, remains sensitive and can be adversely affected by a range of common household substances. Over time, the innocuous adhesives used to attach a print to an album page can cause the print to discolour – as can sticky tape. Even contact with some plastics and board can cause yellowing.

Discolouring can be cured as part of an overall

Fig 33 – With no physical damage, just significant fading, it was easy to use the Levels command to restore balance here. We then boosted the contrast slightly and also applied the Unsharp Mask filter to correct some softness in the original image.

enhancement, neutralizing any colour casts using the Levels commands. In black and white images, we can also restore the contrast range at the same time.

Fading (figs 33 & 34)

The sensitivity of the emulsion is such that, place a print on a board mount or even in a cardboard box and, over time, it can fade. Chemicals in the board slowly leach out and affect the emulsion. This explains why "chemically inert" or "archival" mounting boards for display prints cost so much compared with similar, non-archival boards.

Of course, keeping the prints in the open can cause equal or greater damage as the prints fade due to the effect of atmospheric gases and – most damaging of all – sunlight. The action of sunlight affects different dyes in the print to differing degrees, lightening some and causing a colour shift in others. This requires the greatest degree of analysis before undertaking any restoration.

Fading, like discoloration, can be corrected by restoring the contrast range (the Levels command can be of use here again), but colour shifts need more radical treatment, adjusting each of the primary colour components. There is no way that we can be truly objective about the results that we get in this way, for we only have our own judgement of what should be considered, for example, an accurate blue sky or the correct colour of foliage.

Fig 34 – Not only was this colour print faded (as a result of remarkably little exposure to sunlight), but the magenta and cyan components of the image had become visually stronger. Correction not only involved restoring the contrast range, but also using the colour-balance commands to correct the changes to the colours. Most of this needed to be done by guesstimate as there was no objective data about the colours in the image. Here, skin tone was the determining factor.

Fig 35 – In clear areas, such as the sky here, mould damage is at its most obvious. The simple way to correct this would be to use the light grey colour of the sky and paint over it.

Animal damage (fig 35)

We may know enough to keep images in optimum conditions today, but that probably can't be said of the whole history of your prints. Seasonal and daily changes in temperature and humidity, combined with (from the point of view of insects) the delicious nature of gelatine and other photographic media, can also take their toll. In addition, the ingress of mould and other growths lead to localized damage.

Some damaged can be carefully removed prior to scanning the original. This is something that should be undertaken only if you are completely certain that you will not make the damage worse. Dead surface mould can often be gently brushed away with a paintbrush and similarly any long-departed guests. As this damage is localized, it's often sufficient to use the Clone tools to overpaint the areas of damage.

Crumple zone (fig 36)

Physical damage is inevitable when prints are handled extensively and stored in less than perfect circumstances. Over the years, the folds – in themselves not necessarily major damage – can dry and crack, the image can tear and surface abrasion can remove areas of emulsion. Tears and splits, along with abrasion marks, need cloning to replace the pixels defining the damaged areas. Missing pieces, torn off or cracked away will need more inventive solutions, involving matching the damaged areas with other parts of the image or even re-creating new backgrounds. Where the damage affects a major element of the image, we may need to be artistic as well as creative, repainting or patching these areas.

Fig 36 – Tears, missing pieces, abrasion and scratches have rendered this image in a poor state. But rebuilding the missing pieces and hiding the smaller marks makes the image appear as good as new. Even though the authenticity of the new elements may be questionable, the overall result is aesthetically more than satisfactory.

Fig 37

Fig 38

Fig 39

Fig 40

Fig 41

Fig 42

Restoration 1: Monochrome image

This print (see above) will be typical of many passed down from generation to generation. It has spent some of its time in a frame, some time mounted in an album and some time loose in a box. Other events in its history have also taken their toll, introducing staining.

Our repairs will involve restoring contrast and removing the yellow overall colouring. We will then clone away the marks and scratches (some of which, no doubt, date back to the original printing of the image. We will then repair the missing corner. Finally, we'll review the image and establish whether there are any ways in which we could enhance its final presentation.

1. The original image, taken around the turn of the twentieth century, would have once had solid blacks and a full contrast range (see fig 37).
2. Use the Levels command to restore the contrast range. Click on the White Point eyedropper and then select the missing corner: this is the lightest part of the image. Choose the Black Point eyedropper and select the darkest part of the image. Make sure this is a "real" black; otherwise, if it is merely a dark grey you will lose shadow details (see fig 38).
3. After making the corrections to the contrast we can see that the image is discoloured, particularly

in the corners where sticky tape or album mounting corners have produced noticeable yellow staining. We can remove this residual colour by selecting the Desaturation command. The areas of mould and staining in the top right-hand corner are typical of the effect you get with old pictures that have been handled with greasy fingers. Over time, it produces localized staining and makes an excellent medium for mould growth (see fig 39).

4. Those corner marks are still present. To remove them we can either select them using the Poygonal Lasso and reduce the brightness, clone over them using adjacent donor areas or try a combination of both approaches. Use whichever technique works best in the circumstances (see fig 40).
5. After cloning we have an apparently continuous landscape. Now for that missing corner. Again cloning is the best policy here as it adds texture from the print. You will have to ensure that it is not too obvious where the pixels were cloned from (see fig 41).
6. To finish the print we've given it a black key line to define the edges. Applying a modest amount of Unsharp Masking (Amount 50, Radius 1, Threshold 5) has increased the perceived sharpness of the image and given it an impressive degree of clarity (see fig 42).

Fig 43

Fig 44

Fig 45

Restoration 2: Colour image

In the case of this colour image, the principal defects are related to colour shifting due to fading and chemical discoloration. We need to restore contrast again, but as this will tend to exacerbate any colour shifts we must then correct these shifts (see fig 43).

1. Use the Levels dialogue to restore the tonal range. When you do this you will probably find that colour casts are somewhat more obvious than previously. Note that it is sometimes possible to correct a faded colour print using purely the Levels dialogue, selecting the Black, White and Neutral points (using the appropriate eyedroppers), but because different colours in the image fade or discolour to different degrees, the end result can still feature an unfortunate tint (see fig 44).

2. Use the Colour Balance dialogue to correct the colour balance. The dialogue allows you to change the balance for the image highlights, midtones and shadows. Begin by adjusting the shadow areas modestly (here, setting the Magenta-Green slider to +20). Then adjust the highlights (Magenta-Green to +40 here). Colour correction is an iterative process: you will need to adjust continually until you get a satisfactory result (see fig 45).

Tips

- You can use the Variations command for a more objective comparision. This will compare the image before and after changes so you can follow the progress of the colour corrections (see fig 46).

- Skin tones are often the most difficult to get right. In Photoshop versions from CS (8.0) you can use the Match Color command to match skin tones in the image you are correcting using tones from a reference image (see fig 47).

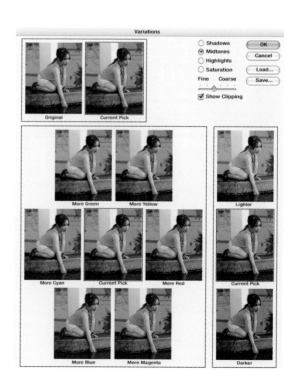

Fig 46

Fig 47

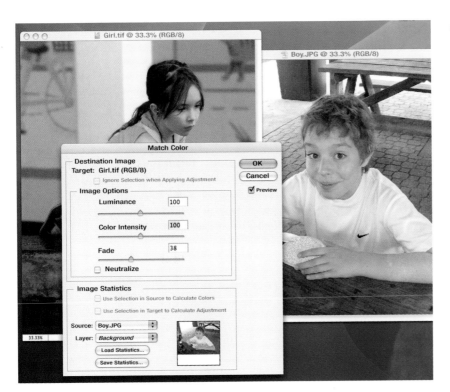

Rescue program (fig 48)

Although you can restore most images, the time the process takes can preclude widespread reparations. So what's the answer if you have many prints to attend to? First, scan all the images to the highest quality. At least with a scan of the image you can be sure that you've a copy before any further deterioration can take place (remember that image degradation is an ongoing process). You'll now have digital files of your cherished images to work on whenever you wish.

Though it does not remedy all problems (especially those of a localized nature), using the Levels command and even Auto Color can perk up images that have undergone fading or discolouring. Badly torn images can be fixed by creative cropping. By cropping more tightly in the central part of the image you can remove those areas – edges and corners particularly – that are most prone to damage and most likely to be dog-eared.

Fig 48 – The badly damaged print we looked at earlier (see page 182) has been given a new lease of life here by merely cropping in more tightly and applying Auto Levels. Only the tramline scratches needed additional attention. Not ideal and not thorough, but quite sufficient to make the print presentable once more.

Printing your restored images

Of course, once you've worked so diligently to restore an image to better than its former glory, you'll want to ensure that your efforts will last. It's unfortunate but the prints you produce are likely to suffer many a similar fate to the original –

Fig 49 – The Xacti is a hybrid camera that offers digital video and digital imaging in a single package. Still imagery of better than 3 megapixels is possible and good quality movies are possible, but the duality of function means that neither mode offers the ultimate in quality.

ORIGINAL

inkjet prints have yet to prove their longevity. To make sure that your efforts can be enjoyed to their full, ensure that:

- You keep at least two copies of the digital image file. This means that should anything happen to the new prints, you can immediately produce new ones
- Use only the recommended inks and papers for your printer, unless your favourite alternative is of proven quality and longevity
- You store the prints away from chemicals and pollutants that can cause discolouring. Look out for "archival"-quality materials which (though more expensive) offer guarantees on permanence.

MOVING IMAGES (FIGS 49–51)

The nature of digital imaging is such that the traditional and rather strict line that marked still cameras and movie cameras as separate (and disparate) product lines has become so blurred as to be, in the eyes of many, irrelevant. Many digital stills cameras are adept at recording digital movie sequences and still images can be recorded on

VGA

Fig 50 – This digital video camera from Sony is capable of multimegapixel still images as well as top quality movie recordings. But the functionality of the camera as a still camera is restricted compared with even a reasonably modest digital still camera.

QVGA

Fig 51 – Movie modes from a digital stills camera produce movies in either VGA or QVGA modes. For those of us used to images of several million pixels this is very low resolution, as the examples here show

Fig 52 – Still photos taken out of an aircraft window can often be disappointing whereas movies can be more inspiring. So combining still images of the ground with movie footage of the flight can produce an intriguing presentation. Here still images and movie clips are used almost interchangeably, with still images regarded as "still" movie frames that are nominally displayed for seven seconds each.

digital video cameras (or can be plucked from digital video sequences).

Most consumer digital cameras feature a movie mode, even many of the models we'd often describe as "budget". Only on those cameras designed for professional use do we see this feature missing. This is undoubtably on the pretext that professional or "serious" users would want the levels of quality only offered by digital video cameras.

Does this mean that we can dispense with a multiplicity of cameras when we head off on that day out or holiday? Probably not. We say "probably" because it depends on your photographic needs. If you want to take great digital photographs and just the odd video clip to record a specific event then a digital stills camera with a movie mode will be fine. If you want the best in digital still images and digital video (the latter perhaps to edit and produce a masterpiece in an application such as iMovie then you'll need to stick with two specialized cameras.

The movie modes offered by digital stills cameras tend to be either VGA (640 x 480 pixels) or one quarter of the, 320 x 240 pixels, or QVGA. QVGA is suitable only for modest applications such as Internet and web pages where the low resolution is excusable on account of the fast downloading.

VGA on the other hand is, technically speaking,

a similar resolution to that of a conventional television picture. A good movie mode will deliver high quality movies though the frame rate may compromise ultimate quality. The frame rate describes the number of consecutive images recorded per second. Many cameras offer only 10 or 15 which can lead to jerky motion; 30 frames per second, offered by an increasing number of cameras, gives smooth motion.

Editing Movie Clips (fig 52)

Once you've recorded your movie clips you'll want to do something meaningful with them. They come into their own when you produce slideshows. Slideshows is something of a misnomer in this context because what we actually mean is a sequence of visuals. Those visuals can be still images or movies.

Applications such as iMovie and offerings from Ulead (to name but two) allow still and movie images to be combined along with commentary or music. Add in features such as the Ken Burns effect (in iMovie) and you can pan and zoom your still images too, to give subtle pseudo movie effects.

Movie Mode Tips

If you get bitten by the movie-mode bug here are a few dos and don'ts for using the mode:

- Use the mode as you would with a conventional movie camera, holding the camera as still as possible and recording each shot for around seven seconds.
- Don't shoot in portrait mode! Sounds obvious, but you'd be surprised how easy it is to do.
- Carry enough memory. Movie clips can consume memory cards at an alarming rate – make sure you have sufficient capacity.
- Use movie editing applications to edit your movies as you would conventional images, cropping and deleting unsatisfactory or unsuitable material to leave only the best in your portfolio.

RESESOURCES

RESOURCES

Now we've come to the end, here are some suggestions for further exploration. All these websites are the best in their fields and great sources of extra information. The web addresses have all been checked at the time of writing but they do occasionally change. If you have difficulty with any, search on the appropriate keywords using Google or your favourite web search engine. Here's to creating great images!

GENERAL DIGITAL PHOTOGRAPHY RESOURCES

Here, in strictly non-alphabetic order to prevent the implication of grace or favour to any, are my favourite websites offering information, advice and resources for the digital photographer.

Steve's Digicams

www.steves-digicams.com
Best known as a source of reviews on just about all hardware on the market – or that has ever existed – and also a great general resource on sources of information on software and links to other sites. One to bookmark.

EPhotozine *www.ephotozine.com*

One-stop resource for photographic news (conventional and digital), reviews and tutorial information. Also tie-ups with retailers and with the UK's leading photo magazine, *Practical Photographer*.

Digital Photography Review

www.dpreview.com
Very detailed camera reviews and a vast selection of digital photography forums.

Photolinks *www.photolinks.com*

Photographic ezine with details of photographers, articles and links to useful sites.

CreativePro *www.creativepro.com*

Not specifically for digital photographers but a site awash with relevant news and Photoshop tutorials.

Photo.net *www.photo.net*

Originally a film-based resource, but now covers digital photography, too. Extensive resources on equipment and technique.

Imaging Resource

www.imaging-resource.com
Reviews and news supported by great "getting started", "better picture" and "how-to" sections.

123di.com *www.123di.com*

A very comprehensive and thorough guide to all aspects of digital imaging delivered as an ebook. Previews are available at the website.

National Association of Photoshop Professionals

www.photoshopuser.com
Portal to the NAPP's resources and information. Some is available to everyone, the remainder to NAPP members.

SOFTWARE

If you're looking to buy software, either from a retail outlet or downloaded from a website, here are the key software houses for the applications used in this book. Even if you are already a user, you may find it worthwhile paying them a visit – they are all great sources of additional information and inspiration.

Photoshop, Photoshop Elements

www.adobe.com
All the background, extras and tutorials to support the Photoshop family.

Paint Shop Pro *www.jasc.com* and

www.digitalworkshop.co.uk
Downloads and support on Paint Shop Pro.

CorelDraw/Corel Graphics Suite

www.corel.com
All the information you'd expect on the Corel range of graphics and image-manipulation applications.

Painter *www.corel.com*

Also from the Corel stable, Painter is the ideal image-manipulation application for those who intend to produce artworks from their images. Find out how here.

Mask Pro *www.extensis.com*

Download trials and support of Extensis's masking supremo.

iPhoto *www.apple.com/iphoto*

Downloads and support on FAQs for Apple's iLife imaging application.

Pictureman *www.stoik.com*

Explore and download this unfairly neglected application – and others from the same stable at the Stoik Software site.

Flaming Pear Software

www.flamingpear.com
Home of useful plug-ins for Photoshop (and compatible applications) such as the Melancholytron, Flood and India Ink.

Alien Skin Software
www.alienskin.com
Drop into this site for information on the Xenofex, Eye Candy and Image Doctor plug-ins. Downloadable trials are available.

iView MediaPro
www.iview-multimedia.com
Image and media management application with limited (but useful) editing and publishing features.

Portfolio *www.extensis.com*
Info and tutorials on this de facto standard in image and asset management and cataloguing.

CAMERAS
A wide range of vendors produce digital cameras, but for serious photographers – or those with serious intent – the choice is slightly more limited. Included here are those manufacturers who produce cameras for the mass market and also for the more serious enthusiast.

Fujifilm *www.fujifilm.com* and *www.fujifilm.co.uk*
Makers of the Finepix cameras used extensively for images in this book.

Nikon *www.nikon.com*
Information on Nikon's conventional, digital (Coolpix) compact cameras and D series digital SLRs.

Canon *www.canon.com* and *www.powershot.com*
All the information on Canon's digital camera range with enhanced information on the Powershot range in the respective website (the latter is a US website, which

includes information on cameras badged as IXUS models in the UK and Europe).

Kodak *www.kodak.com*
Vast photographic portal but useful for information on the Easyshare and DCS digital cameras.

Minolta and Konica
www.minoltakonica.com
Portal for the cameras produced by this new conglomerate under the Dimage and Revio brand names.

Olympus *www.olympus.com*
Home to the Camedia and E series digital cameras.

Panasonic *www.panasonic.com*
Home of the Lumix sub-brand cameras.

PANORAMIC PHOTOGRAPHY
If you've been inspired to explore panoramic photography in more detail, whether to expand the range of your limited digital camera lenses or to create 3-D immersive environments, here are some resources and selected software applications to help you on your way.

Panoguide.net *www.panoguide.net*
Extensive resource with details on equipment, how-tos, software and more (evolution of the very popular Panoguide.com website).

Realviz Stitcher and Stitcher EZ
www.realviz.com
Information, help and support on all of Realviz's panoramic software.

Ulead Cool360 *www.ulead.com*
Information on Ulead's simple but

effective panoramic/stitching software.

Photovista *www.iseemedia.com*
Also published in the past by Roxio and MGI, a simple image-stitching program.

FUN AND MORE
Not fitting easily into any other category is this collection of sites that include online communities, photographic contest sites and more. It's a collection for those of us who otherwise risk taking things too seriously!

Shutterline *www.shutterline.com*
Online community and daily, weekly and monthly photographic contests. Do you dare to enter?

Image Recall *www.imagerecall.com*
Produces Don't Panic 2, one of those software applications you don't realize you need until the worst happens. Retrieves information from faulty/damaged memory cards, saving your holiday memories – or your reputation.

Nature and Outdoor Photography
www.outdooreyes.com
A site for the outdoor photography enthusiast, complete with competitions and information on exotic expeditions.

Web Photo Galleries
www.frameroom.com
Good starting place if you are keen on creating and promoting web photograph galleries, complete with information on software, useful glossary and step-by-step tutorials.

INDEX

A

adjustment layers 141
airbrush 60
alpha channels 45, 63–4
animations 46–8
Anti-aliasing 95
archiving 30–1
art effects 65, 120, 126–9
asset management 29–30
Auto-correction *68*, 69, 79, 80, 86, 185
axial blurring 162

B

Background Eraser 101, *101*
backs, digital 14
backing-up 30–1, 38
barrel distortion 136–7
Bayer pattern filter 16
beamsplitter 176, *176*
Bevel and Emboss *56*, 143
bit depth 40
bitmap images 33
black and white images 82, 86–8,
 130, 181
blend modes 144–7, 169
blurring 64, 152, 154–63, 169
Boolean buttons 58, 62
Border 97, 98
brightness 78
brushes 59–60, *59*

C

calibration 51–3, *53*
cameras 11, 12–14, 152, 155
panoramic 171–2
 3-D 176
 video 186
CCD/CMOS sensor 14, 16, *16*, *17*,
 31, 152
CD-ROM 25, *25*, 31
channels 86, 167–8
 applying filters 129
Channel Mixer 80, 81–2, 87–8
Circular Marquee 56, *56*, 58
cityscapes 104, 154, *155*
cloning 114–23, 183
Clone tool 60–1, *61*, 114–15
 software 121–2

Color Range 57, *57*, 95, 96
Color Replacement 120–1, *121*
colour 16, 49–51
 adjusting 78–82
 boosting 82–4
 reduced 168–70
 rendition 16, 49–51
colour balance 67, 81, 148, 172, *181*
Color Balance 80, 111, 117
colour casts 79, *129*, 130, 181, 184
colour channels 80
colour correction 184
colour dynamics 60, *60*
colour gradients 84, 95
colour management 49–51
colour profile 49–51
colour saturation 79, 82–4, 169
composite images 110–11, 116–17,
 128, 140
composition 72
computer 15, 23–5, 36–8
Contract 95–6
contrast 78, 146–7, 181, 183–4
converging verticals 73, 74, 76–7, *76*
Corel DRAW 29
corrective tools 60–2, 72
cost 12, 14, 28, 53, 76
cropping 56, 72–3, *72–4*, 185
 perspective 76–8, *76*
cursor 39
Curves 79, 80

D

depth map 156
depth of field 88, 149, 154–8
Desaturate 86, *87*
desks and chairs 36–7
direct printer 22, *22*, *23*
discoloration 180–1, 183–5
distortion 65, 109, 136–7, 174
dodge and burn 60, 84–5, 148–9
downsampling 40
Drop Shadow 142, 143
dust and scratches 41, 65, 121–2
DVD 25, *25*, 31
dynamic range 40, 49, 84

E

effects filters 64–5, 126–37

electrical protection 38
enlargements 178–9
Erase to History 119
Eraser tool 100–1, *101*
ergonomics 37
Expand 95
Export Clipboard 39
exposure 84, 172
Extensis *28*, 30, 100, 102–3, 178
Eyedroppers 67, 102

F

fading 181, 184, 185
feathering 58, 62, 95
file compression 18, 42, 44–5, *44*, 58
file format 18, 42–5, 140
file size 31, 39, 43
fill layers 142
film sensor 12
filters: effects 64–5, 126–37
 photographic 19, 81, 129–30, *129*
 scanner 40
FireWire connection 25
fish-eye lens effect 137
Flash SWF files 48
flattening images 140
Flood filter 132–4
Flow 60, 85
focus zones 157
Fuzziness 96

G

gallery, web photo 48–9
gamma setting 53, *53*
Gaussian Blur 64, 83, 88, 106–7, 149,
 158–9
GIF files 48
Glows 143
Golden Section 73–4, *73*
Gradient tool 84, 116, 129
graduate filter 19
grain *17*, 148, 166–8
greyscale 82, *82*, 85, 86, *87*
grids 77, *77*, 137, 162

H

hard drive 24
Heal and Patch tools 61–2, *62*
high-/low-frequency images 154

high-/low-key images 67
Highlight/Shadow 86, *86*, 128
highlights 84–5, 156
histograms 65–7, 69, 79
History Brush 88–9, 119, 120
History log 39, 88–9
horizon 73, 74–5, *75*, 153
Hue/Saturation 78, 79, 80, 82–4, 94,
 167, 170

I

Image Doctor 121–2, *122–3*
image-extraction tool 102–4
image format 73
image-management software 25, 29–30
image optimization 46, 47
Image Previews 39
ImageReady *27*, 31, 45–8, *47*
image size 31, 33, *33*, 46
image softening 153
imaging chip, *see* CCD/CMOS
ink *52*, 53, 186
Inner Shadow 143
interpolation 16, 153
iPhoto 30, *30*
ISO 12

J

jigsaw puzzle effect 135–6
JPEG 42, 44–6, *44*, 140
JPEG 2000 45
JPEG Repair 121, *123*

K

Knockout 100

L

landscapes 104, 114, 154
laptop computer 24–5, *24*
Lasso tool 57–8
 Magnetic 57–8, 62, *63*, 92–4
 Polygonal 57–8, 110–11
layers 45, 100, 140–9, 170
 applying filters 128–9
 blend modes 144–7
 colour 82–3, 131, *144*, 145
 creative blurring 161–2
 file size 39
layer styles 142–3
 masking 105–7
 palette 140, *140*, 144
 soft focus 159–60
LCD 12, 14, 15, 74, 175

lens 14, 33, 136, 156
Lens Blur filter 156–7
Lens Flare filter *65*, 117
Levels 65–6, 69, 79, 81, *180–1*,
 183–4, 185
lighting 65, *65*, 117, *130*
 montages 148, 149
lightning effect 130–2
linearity 73, 74–5
Liquify filter 137
lossy/lossless compression 45
low-pass filter 152, 153
LZW 45

M

Macintosh 23, 24, 38
Mac OS 31, 51, 53
Magic Eraser 101, *101*
Magic Wand 57, 58, 62, 94–5
 replacing sky 105, 116
Magnetic Lasso 57–8, 62, *63*, 92–4
Marquee 56–7, *57*, 58, *72*
Mask Pro 100, 102–3
masks 62–3, *63*, 98–100
 layer 105–7
Match Color 81, 111, 148,
 149, 184
medium format cameras 14
Melancholytron 168–9
memory 25, *25*, 38–9
memory card 18, 187
 card reader 25, *25*
Merge Visible 140
moiré fringing 152, *152*
monitor 7, 24–5
 calibration 51, 53, *53*
 dynamic range 49, *50*
 resolution 32, *32*
monochrome image 145, 167–8
 restoring 183
montage 100, 128, 148–9, 168
moonlight 117, 147
motion blur effects 160–3
mould 182, 183
Move tool 109, 111
movie clips 186–7
multipass scanning 41–2, *41*
multiple image scanning 42

N

native file format 45
noise *41*, 42, 86, 148, 152
 filter 65, 117, 167–8

O

opacity 60, 128–9, 144
optimizing tools 46, *47*

P

Painter 29
painting tools 62–3
Paintshop Pro 29
Palette Knife 127
panoramas 18, *19*, 29, 170–4
paper *52*, 53, 186
Pasting tools 111
Patch tool 62, 118
PDF format 45
perspective 76–8, 109
pets 120
Photo 3D *19*, *19*
Photo-Brush 130, 136
Photodeluxe 28
Photo Filter 81, 129–30, *129*, *130*
photolabs 11, 22
Photoshop 26–8, *26–7*
 blend modes 144
 blurring 156, 162
 colour modification 79–81
 effects filters 65, 127
 Extract 100, 104
 formats 45
 histograms 65, 66
 History Brush 88
 image slicing 46
Photo Filter 81, 129–30
PhotoMerge 173–4
plug-ins 43, 168, 178
 tools 46, *47*, 56, 62, 92
 Web Photo Gallery 48–9
Photoshop Album 30
Photoshop CS 23, 39, 42, 45, 46, 81,
 142, 148, 156
Photoshop Elements *27*, 28, 120,
 142, 173
Photoshop LE 28
PictureMan 29
pincushion distortion 136
pixel 16, *17*, 31, 100, 178
pixels per inch (ppi) 31, 33
pixelation 65, 167
Plastic Wrap filter 129
plug-ins 29, 43, 131, 168, 178
 JPEG 2000 45
polarizer 19
Portfolio (Extensis) *28*, 30

Portfolio Express 29
portraits: Heal and Patch tools
 61–2, 118
 red-eye remover 120–1
 sharpening 154, *154*
 soft focus 159–60
 Spot Lifter 121
Preferences 38–9, *39*, 46, 88
printer 33, 51–3, 186
 direct 22, *22, 23*
printing 12, 49, 67, *67*, 80,
 153, 180
restored images 185–6
prints, scanning 40
processor 24
PSD format 45
Puzzle filter 135–6
pxl SmartScale 178–9

Q

quality 17–18, *18*, 31, 45
Quick Mask 62–3, *63*, 98–100

R

Radial Blur filter 162–3
RAM memory 24, 38, 39
raw data 18, 42–3
red-eye remover 120–1
reduced colour 168–70
reflections 105, 132, 133
reflective transformation 108–9
Replace Color 79, 81
resampling 178
resolution 13, 14, 16–18, *18*, 31–3, *33*
 composite image 148, 149
 cropped image 72
 hardware 32, *32*, 33
 restoration 180–6
RLE 45
rollovers 46, *47*
rotate 42, *43*, 109, 153
rotational effects 162–3
Rubber Stamp, *see* Clone tool
Rule of Thirds 72, 74, *74*

S

saving files 43–5, 140
scale 109
scanner 16, 25, *25*
scanning 40–1, 185
 multipass 41–2, *41*
 multiple image 42
 skew 42, *43*

Scratch Remover 121–2
selection 92–111, 127
 masks and channels 62–4
skies 104–7
 tools 56–9, 92–6
Selective Color 81
sensor resolution 33
sepia toning 168–70, 180
Shadow/Highlight 79, 149
sharpening 64, 80, 152–3, 179
skew 109
sky 84, 95, 104–7, 116–17
Slices 46, 58, *58*
slide scanner 40, 41
slides 12, 40, 41
slideshows 187
SLR camera 11, 14, *15*
Smart Fill 122, *122*
Smooth 95, 96
Smudge tool 109
soft focus 118, 158–60
Spin mode 162
Sponge tool 85
Spot Lifter 121
stereo images 18–19, *19*, 175
Stroke 143
subject: extracting 102–3
 positioning 72–4, *73, 74*
swing-lens camera 172

T

tears and splits 182, 185
text 122, 142–3
texture *56*, 60, 65, 122, 148
 3D effects 18–19, 29, 174–7
TIFF format 39, 42, 45, 140
tilt-and-shift lens 76
tinting 145
tonal range 65–7, *66, 67*, 79,
 148, 184
Transform tool 78, 108–11, 132
transparent effects 95, 102
tripod 18, 172

U

unsharp colouration 82–4
Unsharp Mask 64, *64*, 129, 153–4,
 153, 183
USB lead 25

V

Variations 184
vector graphics 33

viewfinder 14
video clips 186–7
vignette 56, *56*, 168–9, 170
virus software 38

W

warm-up filters *129*, 130, *130*
water: creating 132–4
 reflections 105, 132
web-authoring
 software 27, 31
web images 31, 46–9, 58, *58*
wet edges 60, *60*
white balance 42, *129*, 130
Windows XP 31
workflow 11–12, 78–80
wrap-around effects 137

Z

ZIP files 45
Zoom mode 162

Acknowledgements

The majority of photographs, illustrations and screenshots used in this book come from my own personal archive. However I would like to thank the following sources for their kind permission to reproduce certain pictures in the book: *Apple Computers, Canon, Corel Royalty Free, Digital Vision Royalty Free, Extensis, FujiFilm, HP Compaq, Kodak, Lastolite, Scandisk, Nikon*

Finally, thanks to my family who continue to discover, far too late, that holidays have not been booked for relaxation but as a series of photo opportunities...

Every effort has been made to acknowledge correctly and contact the source and/or copyright holder of each picture and Carlton Books Limited apologizes for any unintentional errors or omissions, which will be corrected in future editions of this book.